FIGURE DRAWING FOR FASHION DESIGN

ELISABETTA DRUDI

TIZIANA PACI

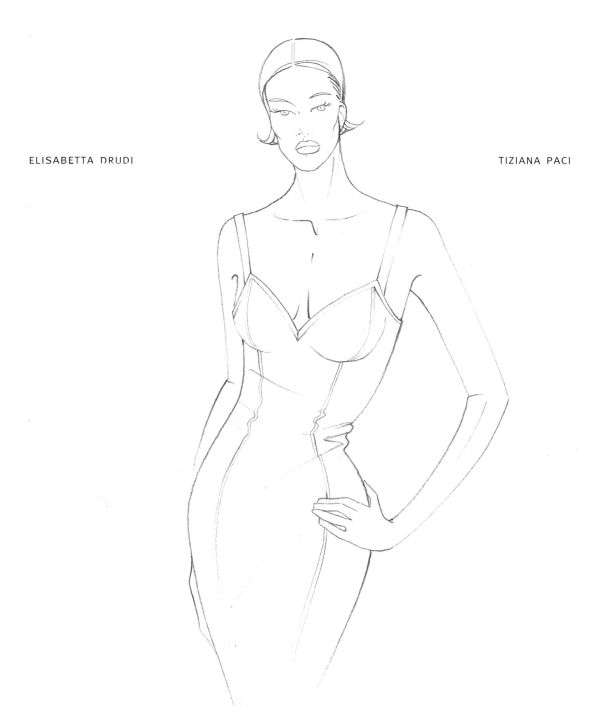

THE PEPIN PRESS

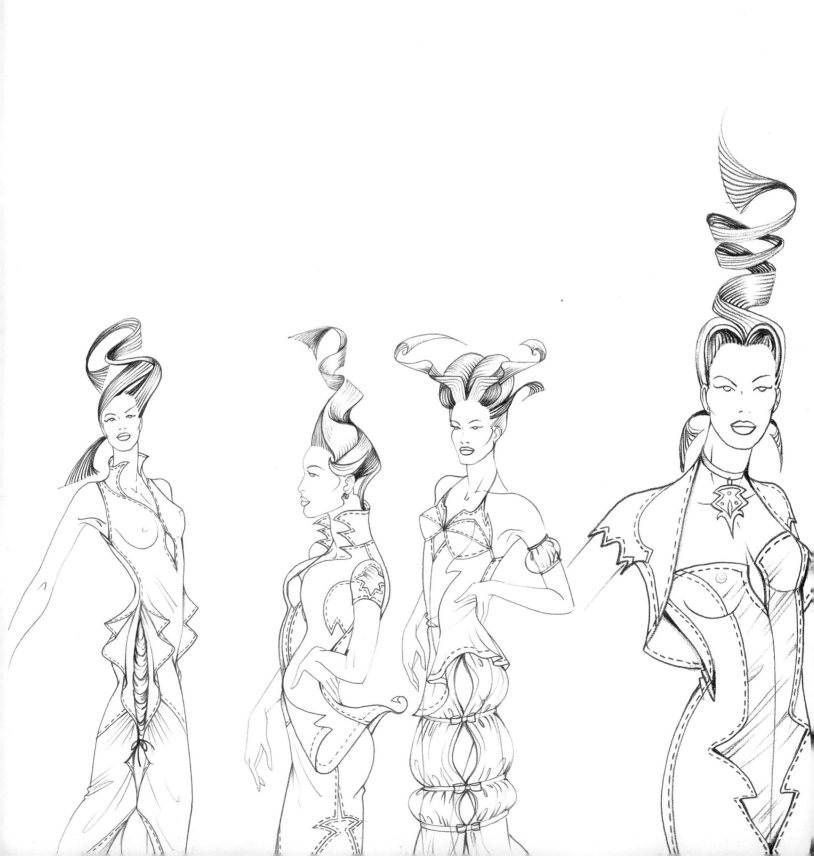

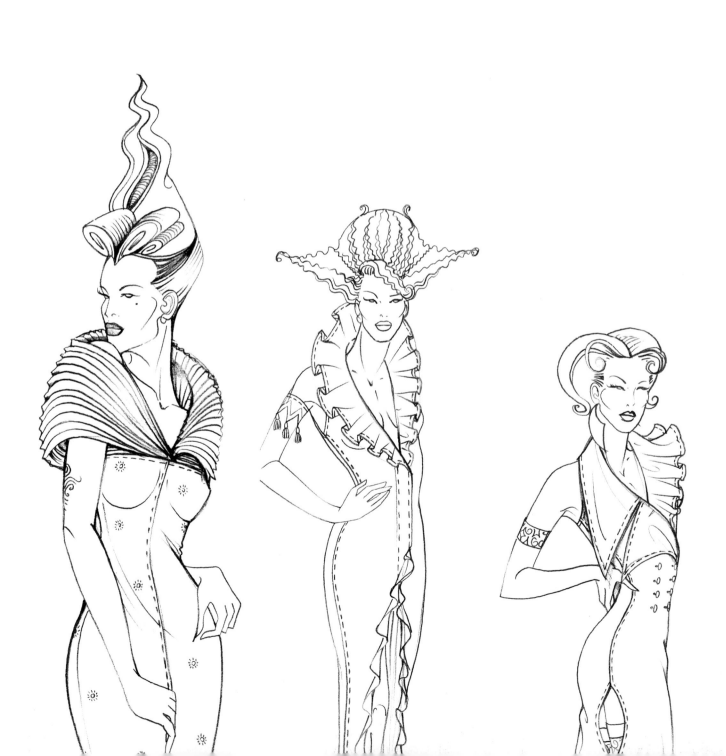

The authors and publishers wish to thank the following
for their advice and contributions to this book:

Prof. Maria Massa
Simona Marcolini
Tatyana van Walsum
Managment, teachers and students at the
Istituto Statale d'Arte 'F. Mengaroni'

This book is an adaption of *La Figura nella Moda*
© Ikon Editrice srl, Milano

ISBN 978 90 5496 080 5

This book is produced by The Pepin Press
in Amsterdam and Singapore.

Design by Pepin van Roojen
Translated from the Italian by Philip Jenkins

The Pepin Press BV
P.O. Box 10349
1001 EH Amsterdam
mail@pepinpress.com
www.pepinpress.com

Printed and bound in Singapore

2008 07
12

The Pepin Press publishes a wide range of books and
book+CD-Rom sets on architecture, ornament, costume,
and various types of design. Some titles of related
interest to this book are:

The Pepin Press Visual Encyclopedia of Costume
A Pictorial History of Costume
Fashion Design 1800–1940
Batik Design
Hats
Fashion Asseccories
Hair Styles
Footwear
Indian Textile Prints
Weaving Patterns
Embroidery Designs
Geometric Patterns
Flower Power
Kimono Patterns
Lace
Baroque Patterns
Fancy Designs 1920
Japanese Patterns
Islamic Designs
Paisley Patterns
Floral Patterns
Bags
Spectacles & Sunglasses
Wrap & Drape Fashion
Art Deco fashion

Many more titles in preparation.

www.pepinpress.com

CONTENTS

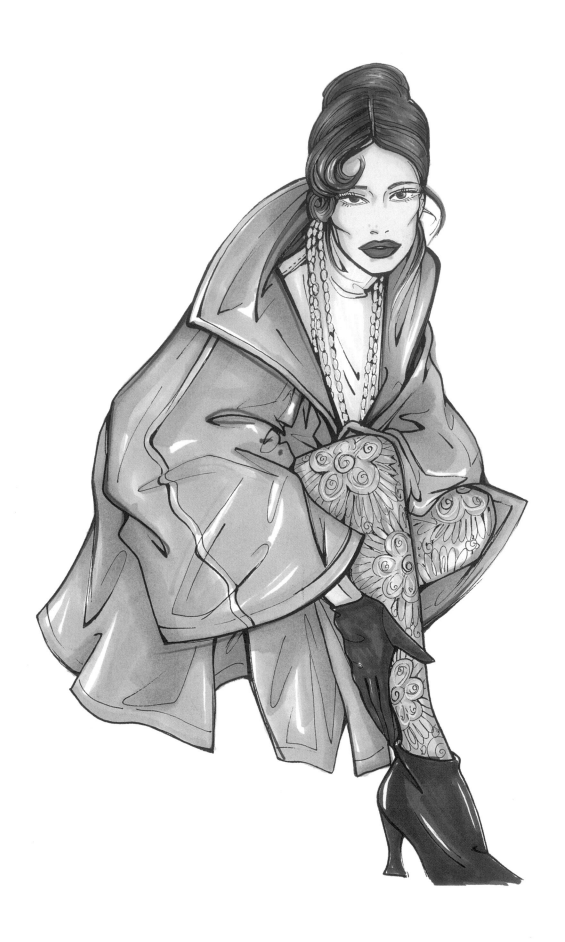

In the same way that a musical instrument needs to be tuned to produce harmonious sounds, the hand has to be 'tuned' by means of patient exercises to achieve a fluid and flexible drawing style.

Before beginning the study of the figure, it is a good idea to carry out exercises to loosen the hand, in order to get rid of any tension or apprehension. Sketch a number of lines, concentric curves, spirals, hatching and cross-hatching until you feel a sense of relaxation both emotionally and physically. These exercises also serve to relax the excessive rigidity common in the wrist of the inexperienced artist. During this phase use various grades of pencils that will allow you to sketch lines of varying thicknesses. Get used to measuring out the pressure of the hand on the paper by sketching some lines with the finest of strokes and others with more incisive ones.

By the systematic study of the drawings presented in this book, the student will find useful support in his training, which will lead him or her to practise at a professional level. We would advise you to work through the book consistently without missing out chapters. Typical exercises to do for each section are to copy the drawings in this book, first on tracing paper, then on drawing paper, and proceed to work free-hand from memory. Practise repeatedly on all the suggested poses, starting with the structural analysis and finishing with the drawing in outline. Finally, draw your own designs, trace them, and colour them in.

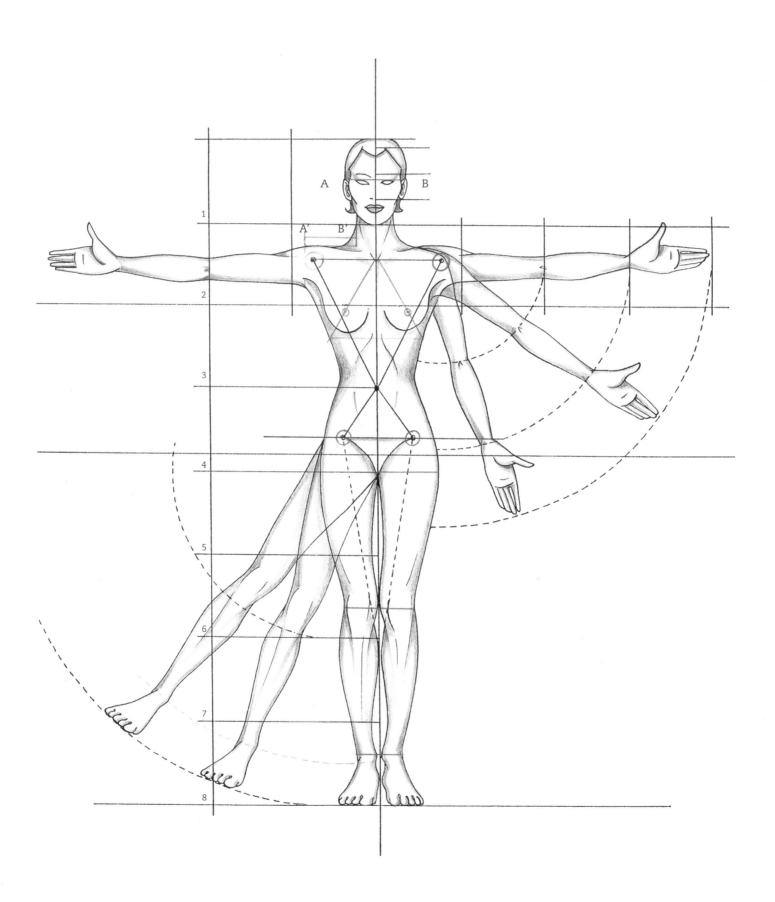

Greek Canon

1) The head measures one-eighth of the height of the body and therefore constitutes a unit of measure.

2) The distance between the temples forms the basis of the width of a shoulder from the base of the neck to the shoulder joint (AB = A'B').

3) When the figure is viewed from the front, the median axis divides the figure perfectly in half.

4) The shoulders are as wide as the pelvis, the waist two-thirds of the width of the shoulders.

5) The shoulders are drawn extending beyond the upper body, with the joint emphasized by drawing a small circle.

6) The elbow corresponds to the waist, the wrist to the pubic region, (in the fashion canon it is below the groin, the pelvis having been shortened) the hand to halfway down the thigh.

7) The width of the thigh is equal to that of the legs.

8) The foot is the length of a unit of measure and is therefore equal to the height of the head.
By dividing the height of the body into two equal parts, we will see that the head and the upper body take up four units of measure, whilst the legs take up the other four.

By canon we mean the guiding code which establishes by means of mathematical rules the ideal proportions of the human body, dividing it into standard units of measure.
From antiquity the human body has been a subject of study for many scientists and artists who have established canons of proportion suitable for the age in which they lived and for the conception of the figure prevailing at the time.
Among the many canons which have been proposed we have chosen the Greek one, because we regard it as the simplest and the one most adapted to our purposes.
In this canon the head is regarded as a unit of measure to establish all the other subdivisions, resulting in a total height of the body of eight units of measure.
In order to achieve a harmonious reproduction of the female figure in accordance with the language of fashion, it has been necessary to modify slightly the relative size of some parts of the body, whilst leaving the overall body and the division into sections unchanged.

By comparing this diagram with the preceding one it will be noted that one half of a unit of measure has been added to the bottom of the feet, as the fashion plate is very often drawn with the foot curved.

This particular and rather unrealistic posture gives more élan and elegance to the leg, moreover allowing visualization in detail of the type of footwear worn when viewed from above.

Another slight modification is the elevation of the waist and of the pubic region shortening the pelvis a little, allowing the figure to appear taller and more slender.

Finally, to accentuate the height further, the bulk of the body has been slimmed down.

We shall call this modified code the fashion canon.

The measurements of this canon serve as a means of creating ideal proportions, hence they are rare in reality.

However, the aim is to find a way to achieve an accurate and harmonious representation of a female figure.

Having made these basic introductory remarks, let us move on to the examination of the various aspects of the canon, outlining the fundamental points in order of occurrence.

Fashion Canon

This diagram provides a further schematization of the outline in geometrical building blocks, making the figure resemble a robot. In order to emphasize better the articulation of the figure, the lower and the upper limbs have been made to rotate around the body.

In this way the shoulder is included in the upper body and the leg in the pelvis as they are raised laterally.

As you can see, the figure has been made thinner and the pelvis is narrower than the shoulders. The half unit of measure which has been added is for the extension of the foot.

All of the joints have been represented by small circles drawn inside the body.

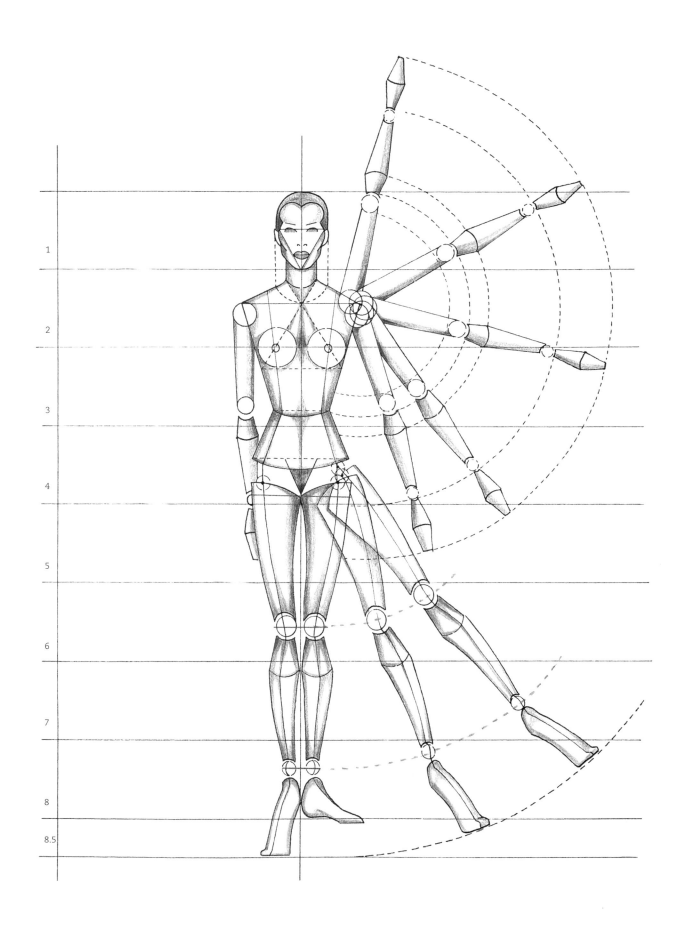

Drawing the diagram

Draw the vertical axis which measures the height of the figure (H) and then the horizontal guidelines.

Draw the median axis, which in this case is parallel to the vertical axis, then the oval shape of the head, being careful not to make it too wide.

The distance between the temples will determine the width of the shoulders, and in their turn the shoulders will determine the width of the pelvis in the fourth segment of the diagram. The pelvis is drawn in a condensed fashion to obtain a more slender figure.

The chest, the waist and the pelvis should be drawn in a schematic way.

Finally the structure of the legs and the arms should be sketched emphasizing all of the joints.

It is also necessary to proceed with this method when working with other positions, always correctly portraying the relationship between one figure and another.

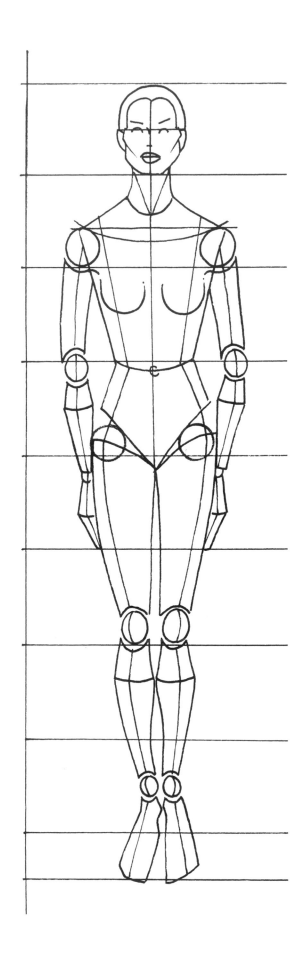

18

The diagram shows the female body in various basic stationary poses. They are static and rigid postures of which the outlines have been greatly simplified so that the body and its constituent parts are better characterized.

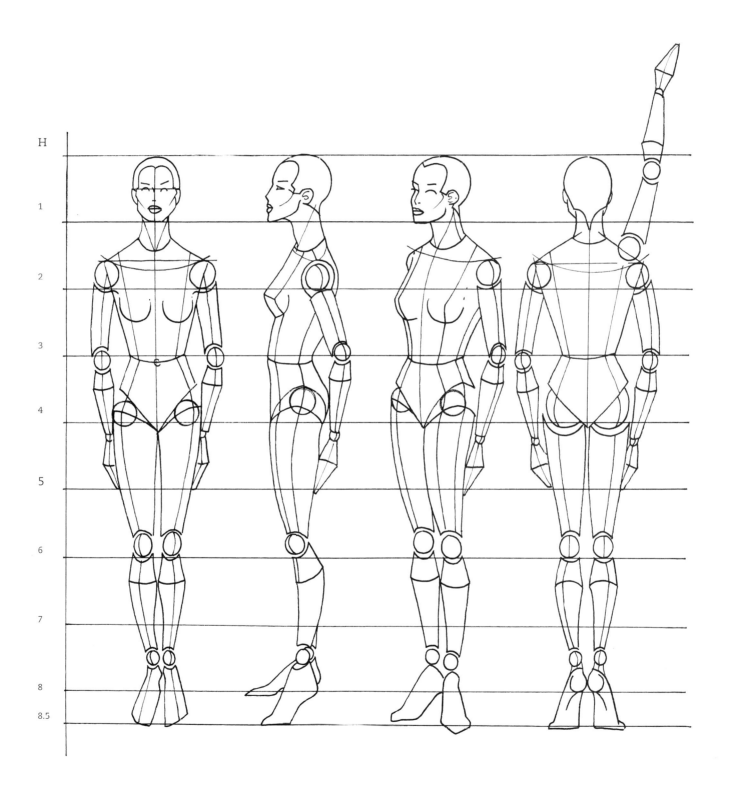

Summing up

Looking at the various diagrams we can conclude that each segment contains:

1 the head
2 the neck and the shoulders
3 the breasts, the lower part of the chest and the waist

4 the pelvis and the pubic region
5 the central part of the thighs
6 the bottom of the thighs, the knee
7 the central part of the leg and the calf
8 the extremity of the legs, the ankle and the feet
8.5 foot extended forward.

The arms and the hands extend from the second to the fifth segment.

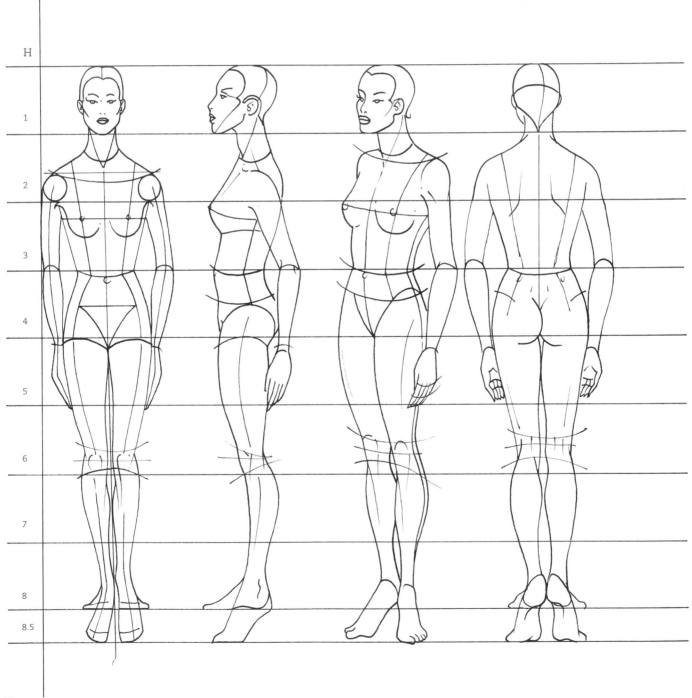

Having considered the analysis of the human body in the Greek canon and the fashion canon, let us move on to examine all of the anatomical components, beginning with the details of the face.

The eyes represent the most emotive part of the face, because they assume an infinite variety of expressions which are capable of communicating the most varied feelings.

In a face the eyes are certainly the most truthful reflection of a state of mind. It is not by chance that the first contact with another person is indeed determined by the eyes. Among the various features of the face they are certainly the most important. It is inconceivable to draw fashion designs without portraying the eyes, as one would be depriving oneself of the soul.

Technically the effect of light is obtained by making small white circles inside the iris and the pupil, whilst giving greater prominence to the shadow which the upper eyelid projects upon the eye.

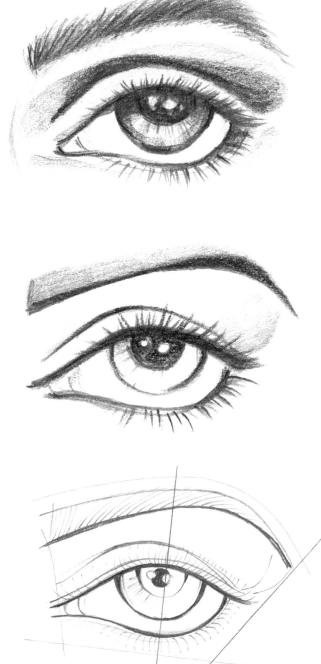

In the first drawing the eye is similar to real life, sketched with darker shadows and half shadows. The second eye is more artificial, the half shadows having been removed.
The third eye is more stylized and has more clearly defined outlines.

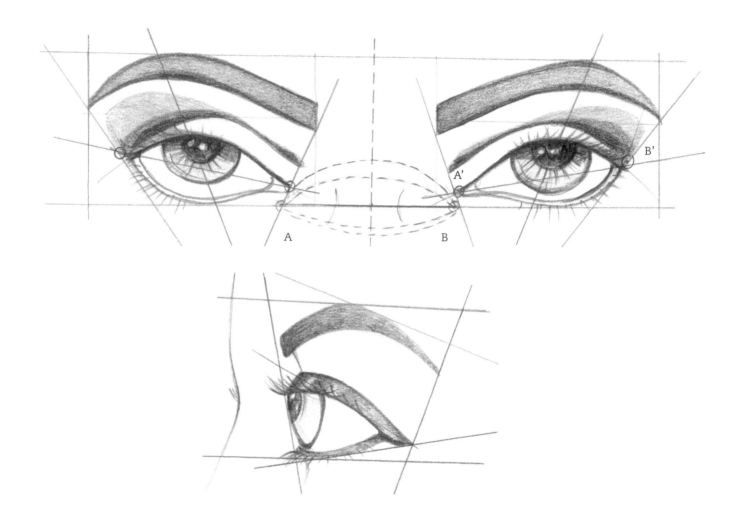

From an anatomical point of view the eye is made up of the perfectly spherical eyeball inside of which we find the iris in various colours and the pupil.
The eye is protected by the eyelids, the upper one being thicker and broader while the lower one is thinner.

Seen from the front, the eye has the shape of an almond, while in profile it assumes a triangular aspect.
The distance between one eye and another corresponds to the width of one of them (AB = A'B').

Important embellishments to the eyes are the eyelashes and the eyebrows, which according to their shape and width lend a profundity to the eyes.
In order to draw the eyes accurately give greater emphasis to the lower edge of the upper eyelid and cast a light shadow across the iris.

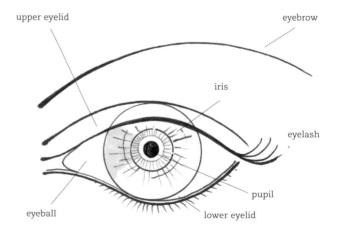

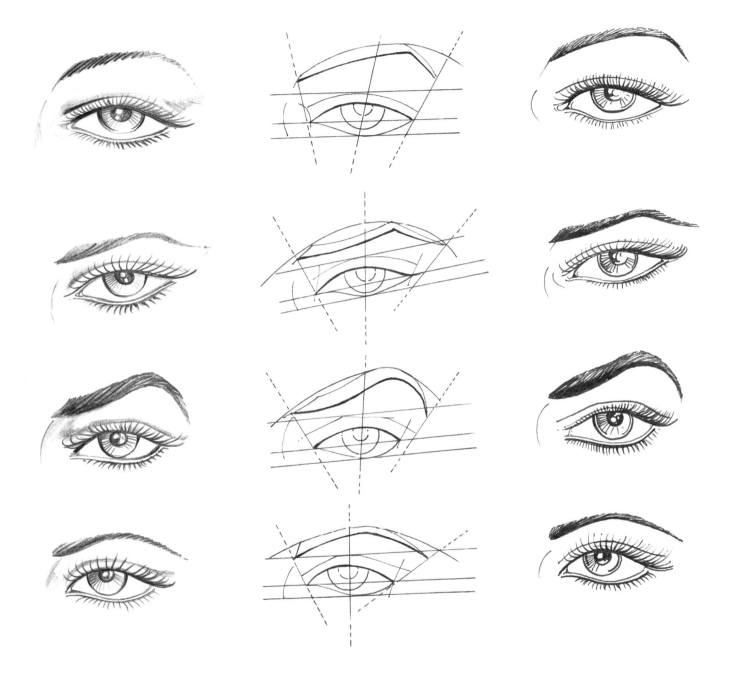

The drawings underline the transition from the eye drawn from life, via its geometrical analysis to the subsequent stylization.
Left: Representation of the real eye with the technique of chiaroscuro.

Middle: Structural analysis of the eye.
Right: Stylized drawing of the eye. The half shadows have been removed, greater emphasis has been placed on the outline and on the inside of the upper eyelid.

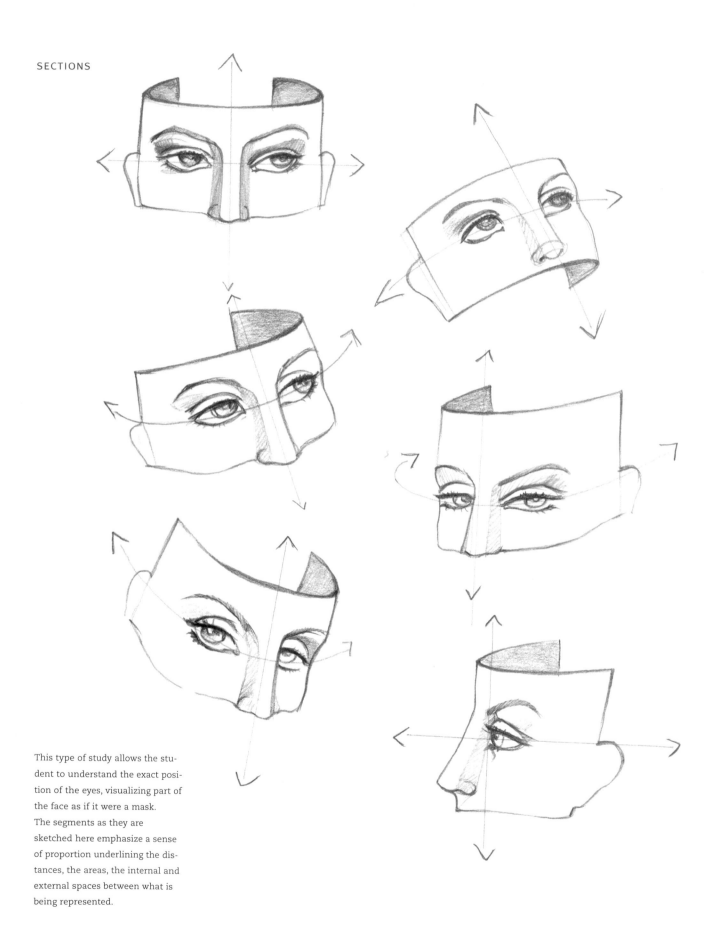

This type of study allows the student to understand the exact position of the eyes, visualizing part of the face as if it were a mask. The segments as they are sketched here emphasize a sense of proportion underlining the distances, the areas, the internal and external spaces between what is being represented.

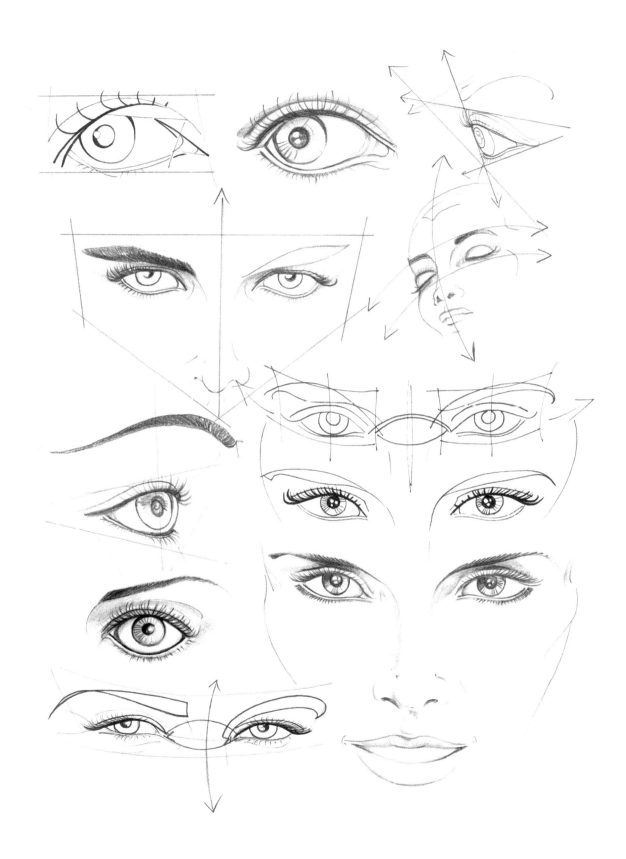

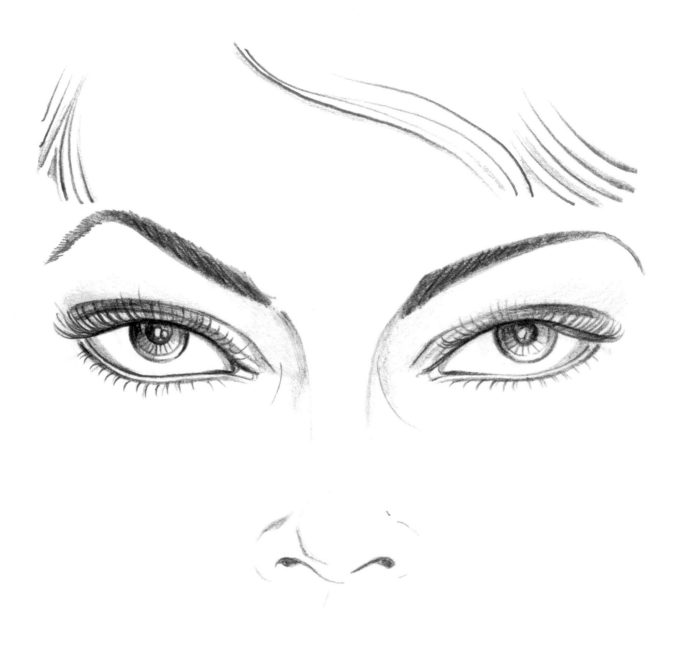

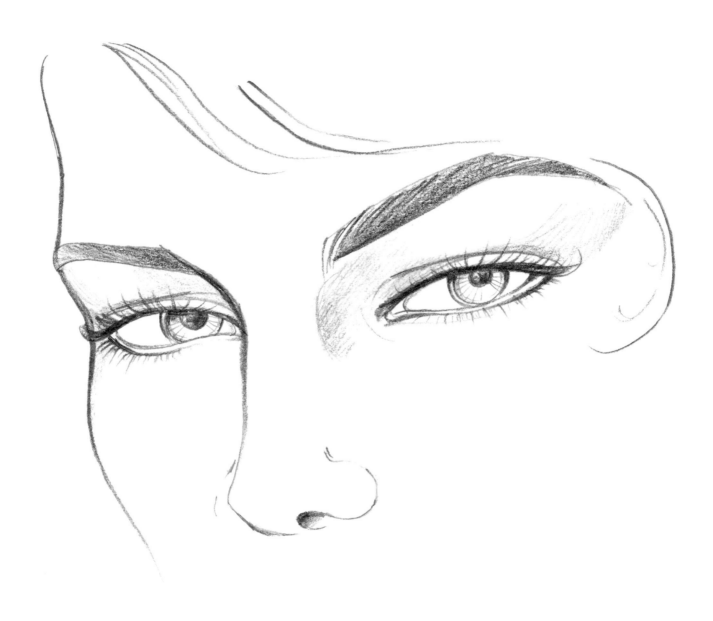

As far as the head is concerned, the nose is the most prominent anatomical feature. Every face has a different nose which sometimes gives it a decisive appearance.

For this proportional analysis we select a well-proportioned nose, even if it is generic in form.

For an accurate frontal portrayal we enclose the nose in an elongated trapezium at the bottom of which we sketch three circles, the central one being larger and the two side ones being smaller.

The distance between the alae is the equivalent of the width of an eye (AB = A'B'), as the illustration on the page to the right shows.

The nose is divided into the septum, the alae and the nostrils.

It is attached to the mouth by the nasal sulcus, which when seen in profile corresponds to the groove beneath the mouth.

Always in profile, the hollow above the nose is on the same line as the groove below the mouth.

The length of the nose starting from the groove at the top C, is equal to the distance between the point at the bottom of the nose and the chin (CD = DE) and to the height of the ears C'D'.

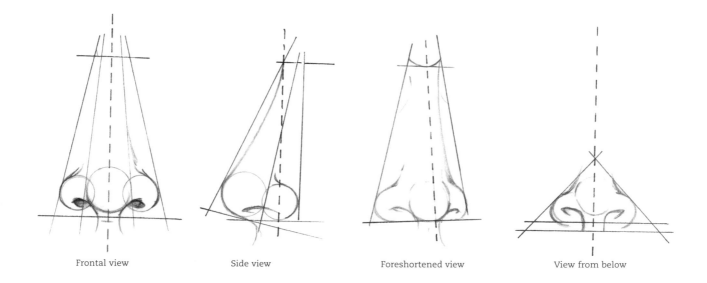

| Frontal view | Side view | Foreshortened view | View from below |

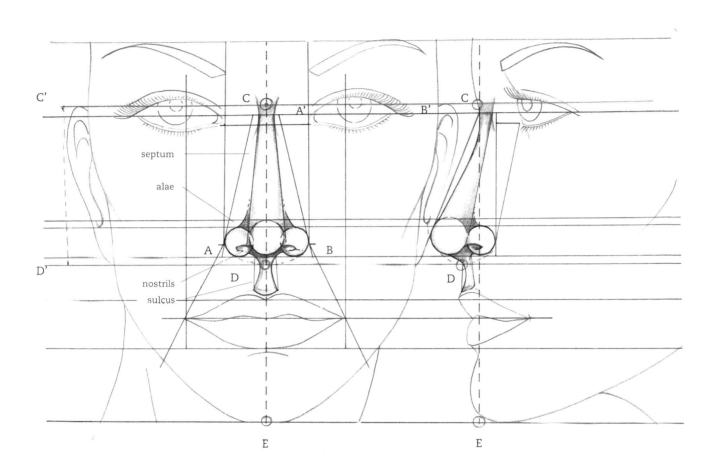

septum

alae

nostrils

sulcus

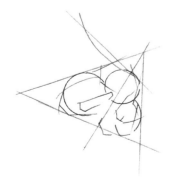

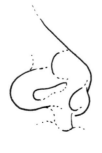

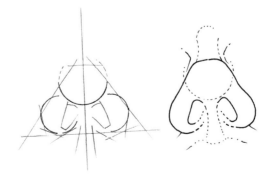

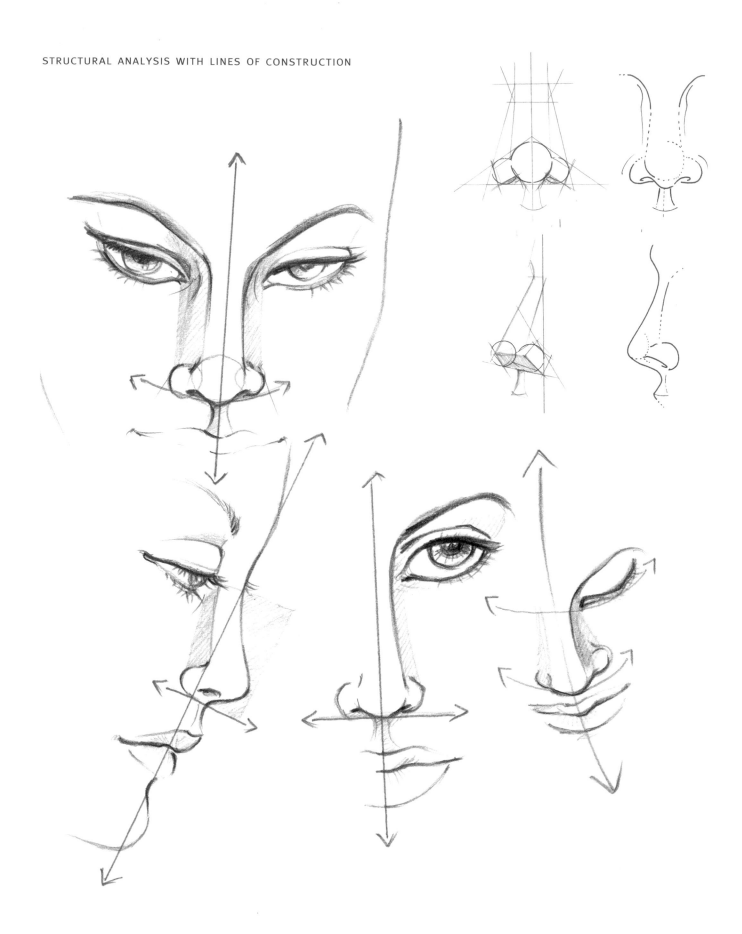

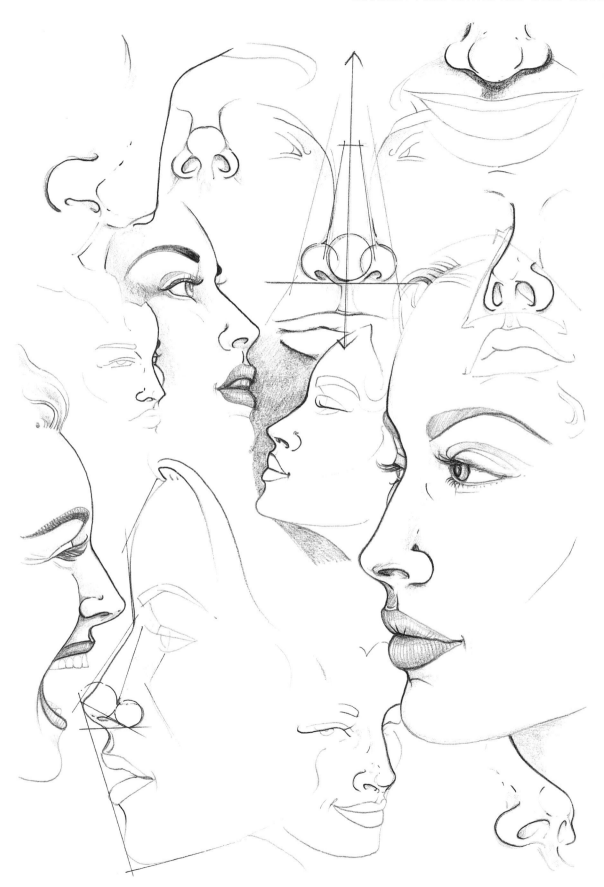

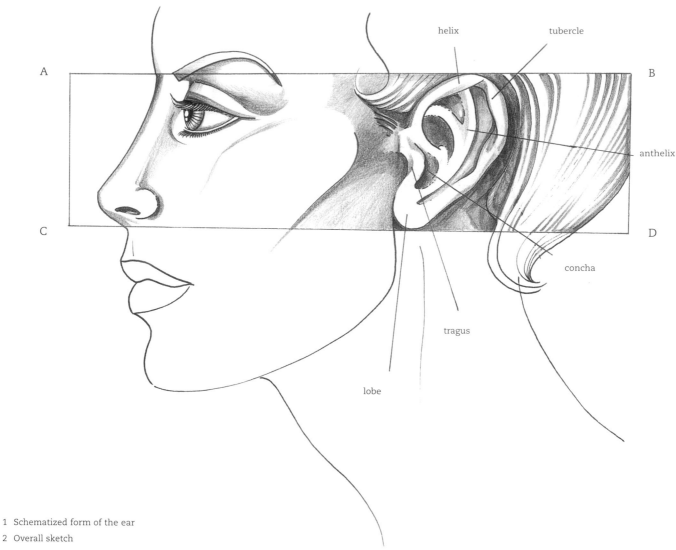

helix tubercle

anthelix

concha

tragus

lobe

A

B

C

D

1 Schematized form of the ear

2 Overall sketch

3 Rear view

4 Three-quarters perspective

5 Left profile

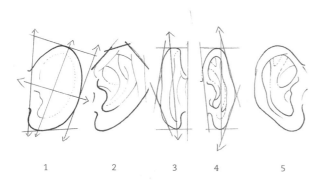

1 2 3 4 5

Externally the ear has the form of a shell or of a large letter C. Structurally it is made up of an external border called a helix, and an internal one called an anthelix, a softer lower feature at the bottom, the lobe, a protrusion which protects the inside of the ear, the tragus, the tubercle, a small swelling on the curve of the helix and finally the concha of the auricle. The height of the ear corresponds to that of the nose.

The upper line of comparison AB aligns the hollow at the top of the nose, the upper eyebrow and the tip of the ear, whilst the lower one CD aligns the bottom of the nose with the bottom of the ear.

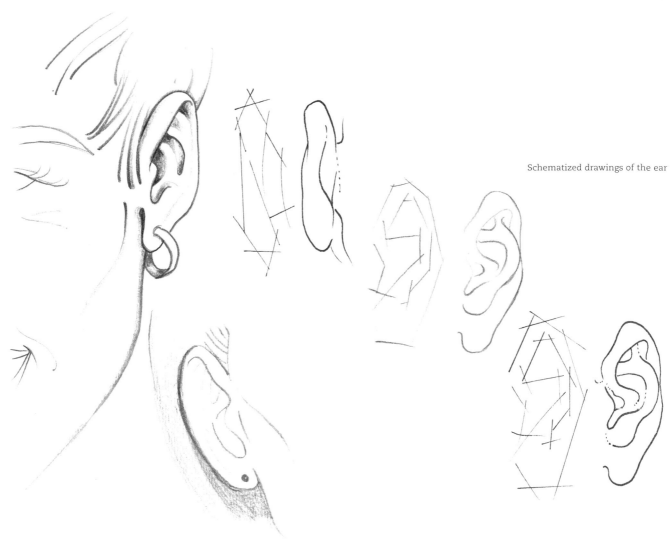

Schematized drawings of the ear

Series of drawings from the sketch
to the definitive representation.

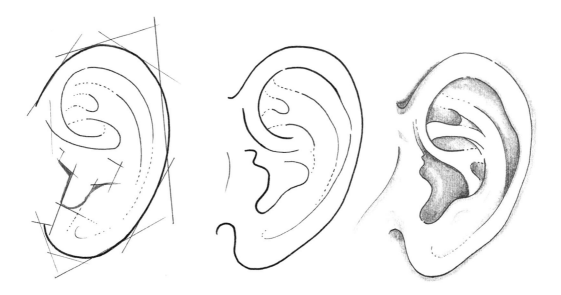

33

THE MOUTH ANALYSIS AND STRUCTURE

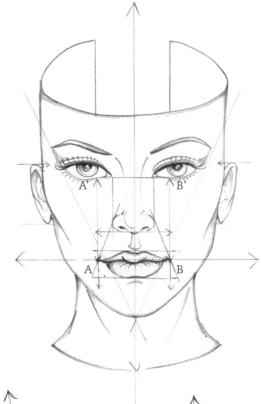

The mouth is made up of two moving parts, the smaller and broader upper lip and the larger and fleshier lower lip. Where the lips join corresponds to a point one-third across each eye (AA' BB').

The trapezoidal sulcus is found between the nose and the mouth, its central axis dividing the mouth exactly into two equal parts.

Frontal view Side view Three-quarters view

Sketches of mouths from different perspectives.

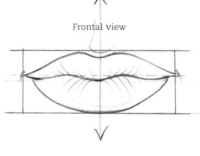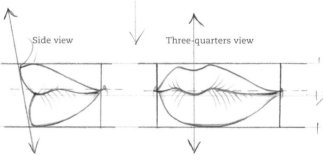

Seen in profile the upper lip is more exposed than the lower.

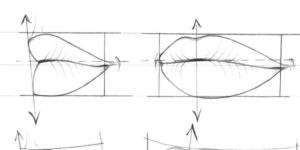

All of the visualizations are drawn with the help of lines of construction.

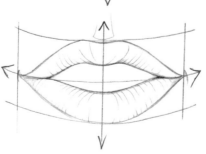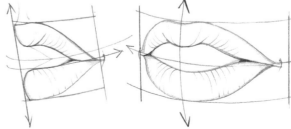

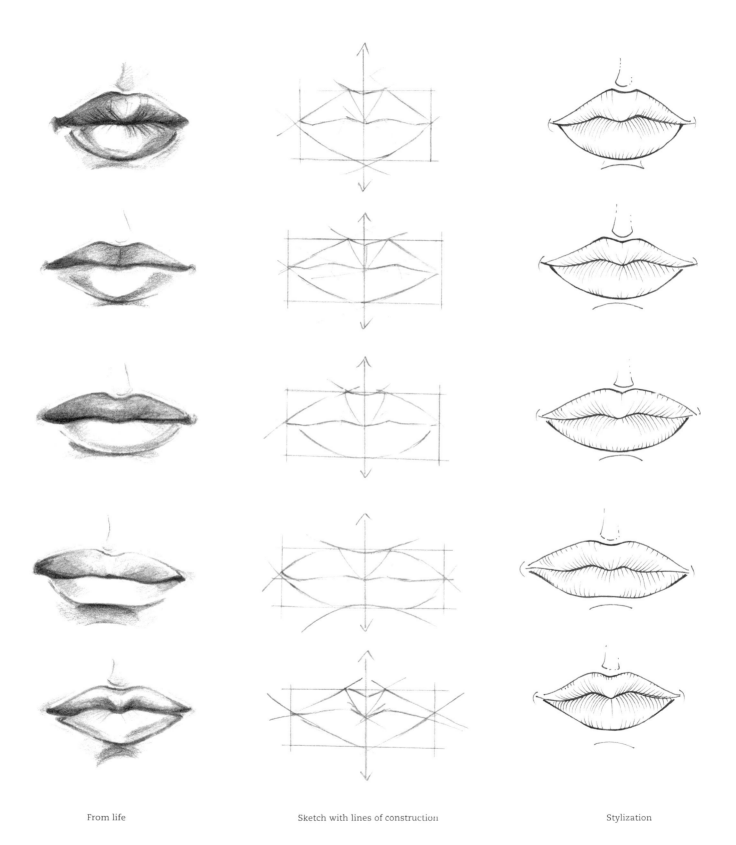

| From life | Sketch with lines of construction | Stylization |

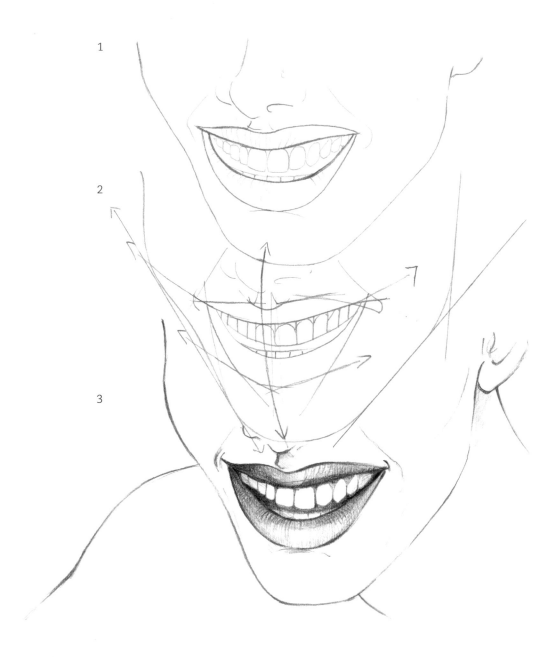

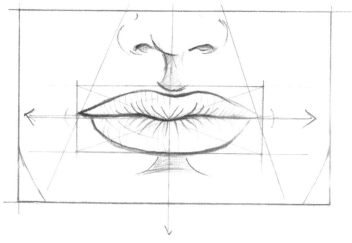

Sequence of drawings

1 Outline sketch

2 Structural analysis with lines of construction

3 Drawing with the mouth executed using chiaroscuro

4 Visual relationships between spaces and anatomical features underlined
 as in previous drawings by lines of construction.

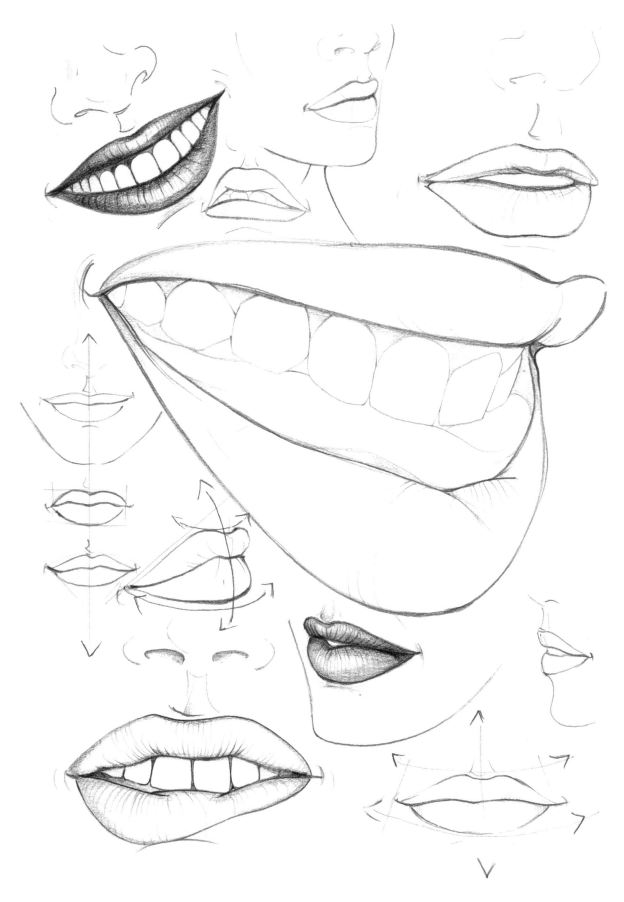

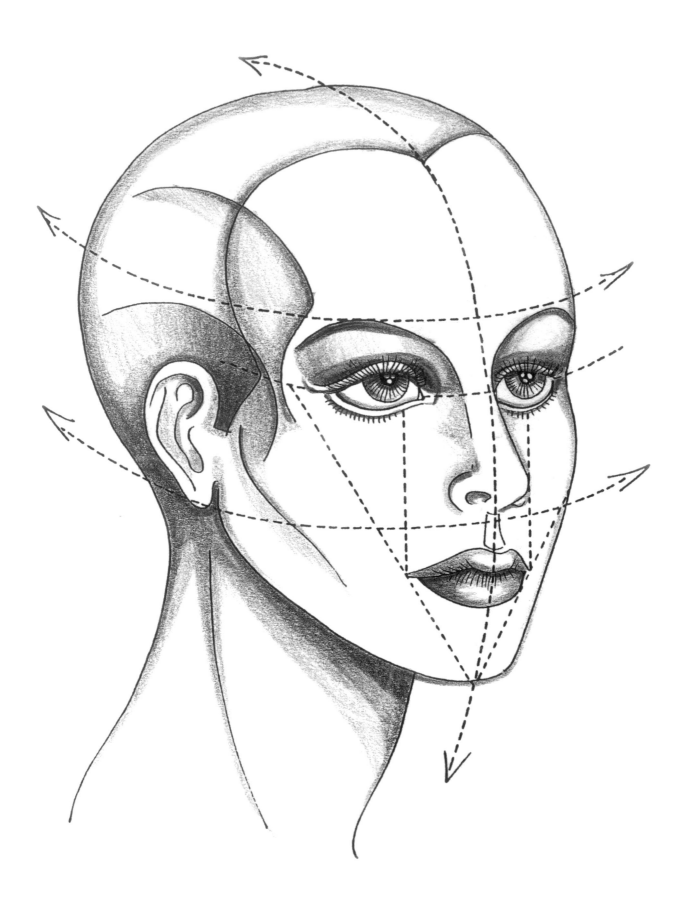

For a student who is training for the profession of fashion design, the representation of the head is probably the most complex artistic subject-matter.

The body has no other anatomical part as diversified in its form, size, proportions and expression.

Therefore an in-depth analytical study is necessary, accompanied by systematic exercises to acquire the necessary ability to reproduce the head by rote.

The overall structure of the head is similar to an egg, whose upper part consists of the cranium and whose lower part consists of the face and the jaws.

The drawings below show three highly simplified representations of the head and each has been divided into four sections by drawing in the horizontal axis AB and the vertical axis CD.

The horizontal axis AB divides the upper part, which we shall call the cranial area (CA), from the lower part, which we shall call the facial area (FA).

Cranial area

Facial area

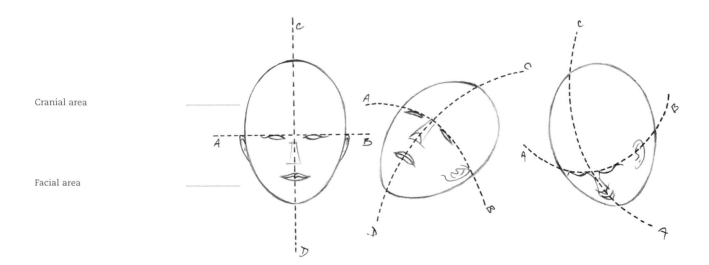

Fig. 1

Fig. 3

Precisely because of its complex and variable morphology, the head has been an element of study from antiquity and there are many artists who with their observations and reflections have contributed to stabilizing the rules of proportion.

The rule used is one of three divisions from the hairline to the tip of the chin, because it has been shown to be the simplest from the point of view of drawing it.

It was Leonardo da Vinci who established that the perfect oval must be divisible into three equal sections measured from the hairline to the upper eyelid, from there to the bottom of the nose, and finally from the bottom of the nose to the tip of the chin.

The student should use this rule to draw a female face correctly.

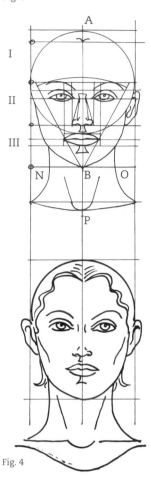

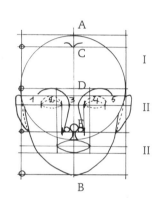

Fig. 2

Fig. 4

Analysis of the Rules of Proportion

1) Draw the vertical line AB and the hairline C.

2) Divide the perpendicular line into three equal parts between the hairline C and the bottom of the diagram B, locating points D-E.

3) Plot a circle with the radius D-A, allowing for the fact that its lowest point corresponds to the top of the upper lip and that the segment E-B divided in half forms the bottom of the lower lip. The horizontal diameter F-G determines the location of the eyebrows.

4) Construct an oval that has as its principal axis AB, making sure that it is confined to a rectangle which is subdivided into two equal parts by the line H-I. In this way we will establish the cranial area CA and the facial area FA.

5) Divide the straight line H-I which corresponds to the distance between the temples into five equal sections, thus establishing the spaces which lie between the temples and the extremities of the eyes (1-5), the position and the width of the eyes (2-4) and the distance between them (3).

The highlighted part of the central section of the straight line L-M describes the width of the base of the nose. Let us now proceed to sketch the almond-shaped eyes and the trapezoidal shape of the nose (Fig. 2).

Remember that in drawing the eyelids, the upper one is larger and broader than the lower one. Then let us retouch the oval, adding to the face more feminine features.

Then let us project a distance of one-third of the eyes as far as the line of the mouth, thus finding the extremities of the lips.

Let us finish these sketches of the face by drawing the ears, whose height is equal to the line which links the upper eyelid to the base of the nose.

Finally let us draw the eyebrows in a curved fashion touching at their highest point the bottom of section I.

Let us finish the sketches of the face with more realistic features (Fig. 3).

To find where the neck joins the head, let us extend the horizontal line that extends from the base of the lower lip until it touches the oval at the points N-O. From the base of the chin B let us draw a straight line BP, the height of one section of the rectangle, establishing the hollow, the height and the width of the neck.

As a last exercise trace the resulting outline giving clarity to the features of the face, the neck and the hair (Fig. 4).

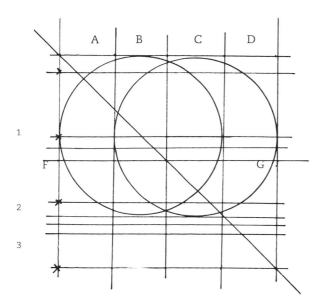

Fig. 5

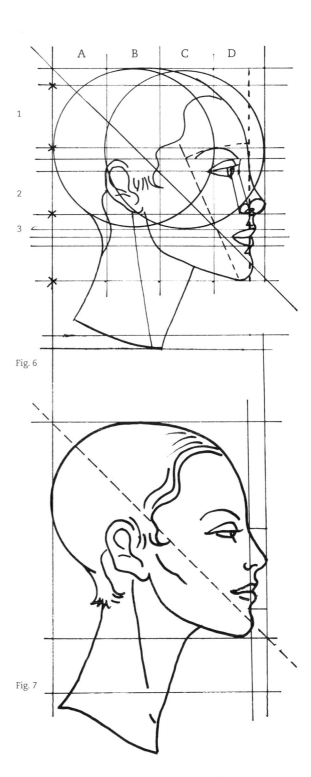

Fig. 6

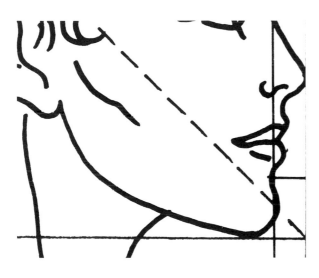

Fig. 8

Fig. 7

In order to construct a head in profile, sketch a circle the same size as the one used for the cranial area, extend the diameter by one-third beyond the circle, construct another circle of the same size bisecting the first (Fig. 5).

Draw a square whose upper side touches the circles and whose width encloses both of them and divide it into four equal sections A-B-C-D. Draw all the horizontal axes as they are portrayed at the number 3, establishing all of the points of correspondence and proportion (Fig. 5).

The female head is smaller than the male one, and because of this to sketch the face in profile it is necessary to start again in the first section establishing the forehead, the nose, the mouth and the chin (Fig. 6).

In profile, the bridge of the nose is aligned with the indentation below the mouth (Figs. 7-8). The ear inserted into section B is to be located behind the jaw in a slanting position. Repeat the resulting outline giving clarity to the features of the face, of the neck and of the hair (Fig. 7).

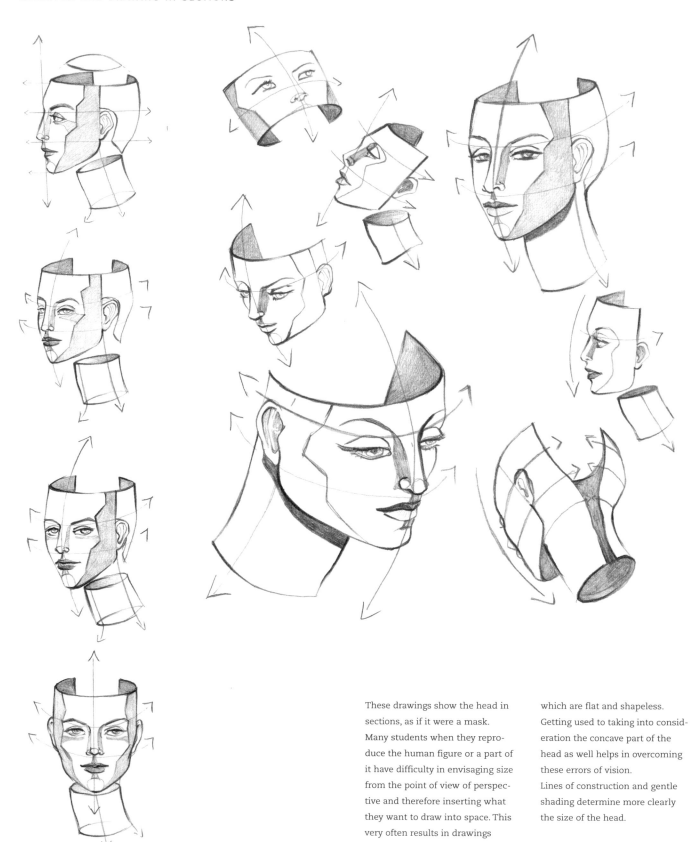

These drawings show the head in sections, as if it were a mask. Many students when they reproduce the human figure or a part of it have difficulty in envisaging size from the point of view of perspective and therefore inserting what they want to draw into space. This very often results in drawings which are flat and shapeless. Getting used to taking into consideration the concave part of the head as well helps in overcoming these errors of vision.

Lines of construction and gentle shading determine more clearly the size of the head.

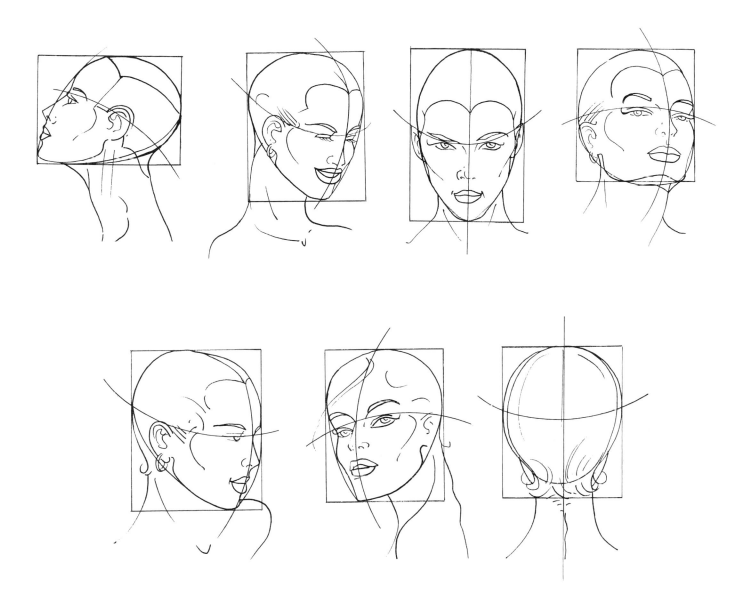

Foreshortening is a way of representing a figure or part of it in perspective.

Every movement of the head results in a new redefinition of the figure and its visual aspects.

In these pages we see visualized some faces portrayed from a variety of angles. The structure of the oval is emphasized by a neutral background the better to emphasize in each rotation the resulting proportions.

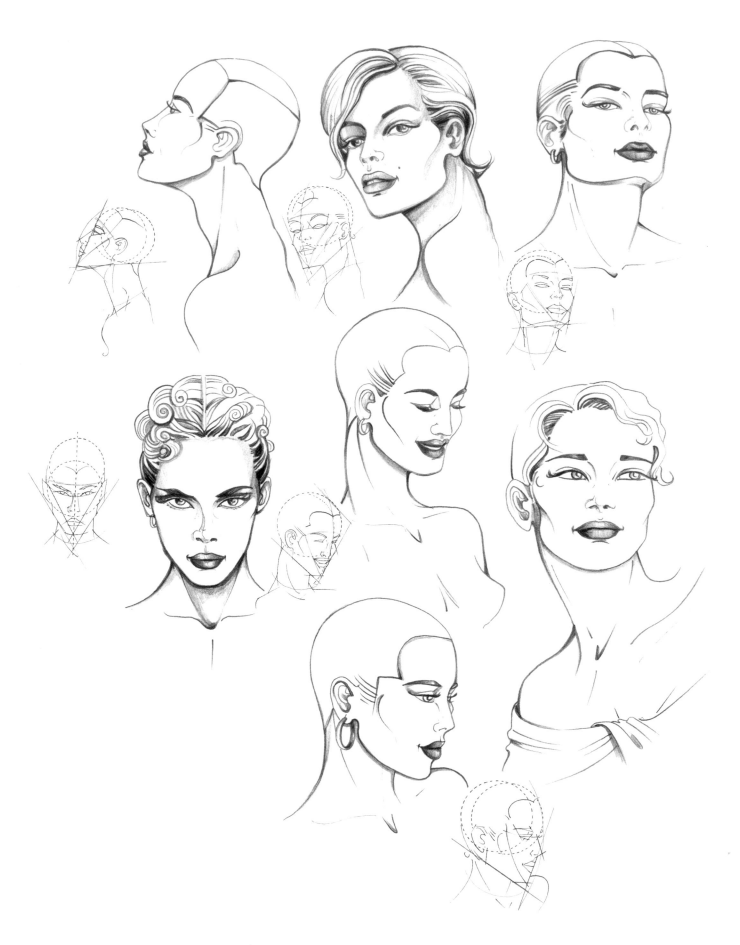

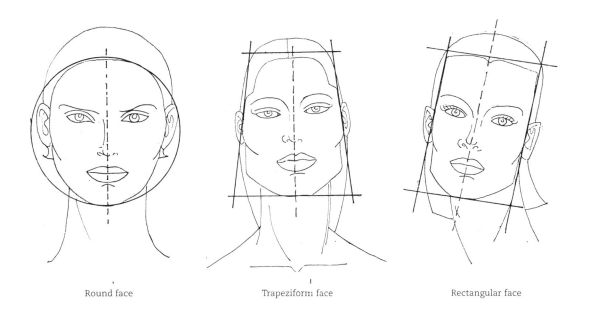

Round face Trapeziform face Rectangular face

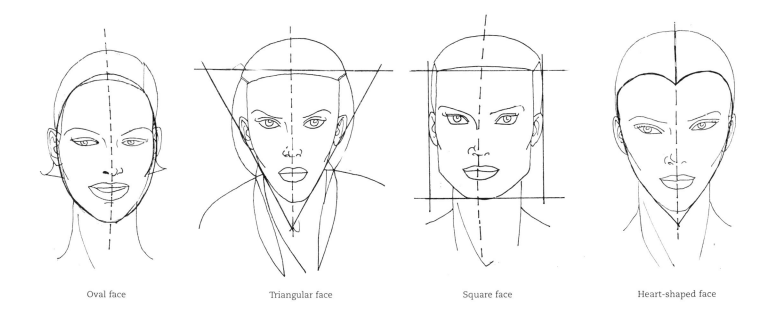

Oval face Triangular face Square face Heart-shaped face

It is possible to group faces into different fundamental outlines, highlighted by symbolic geometrical forms.

These drawings show the most common facial characteristics among women.

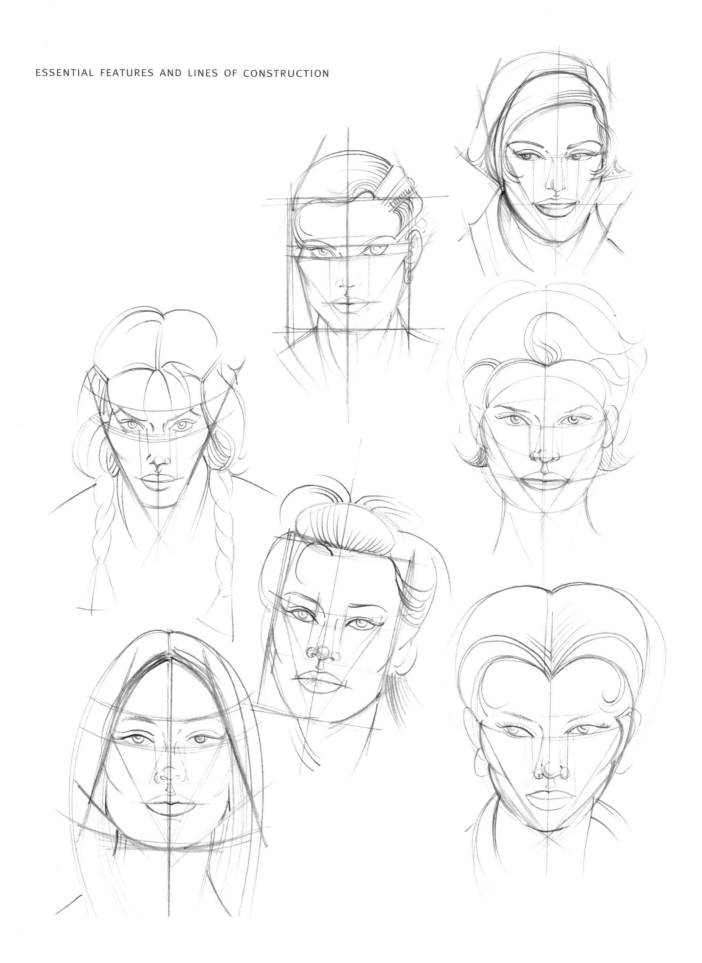

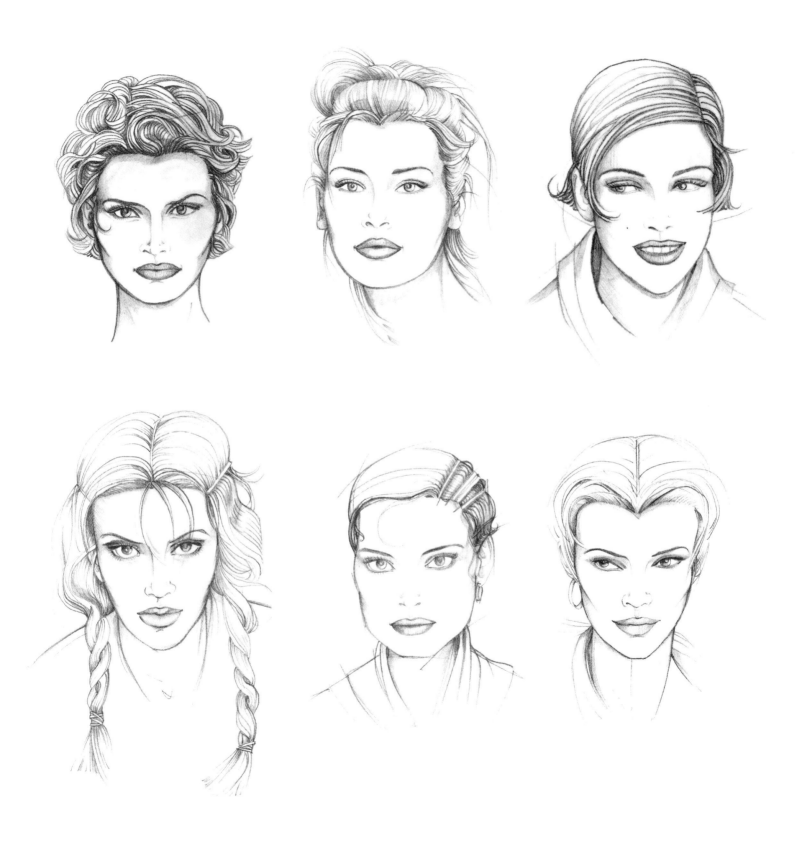

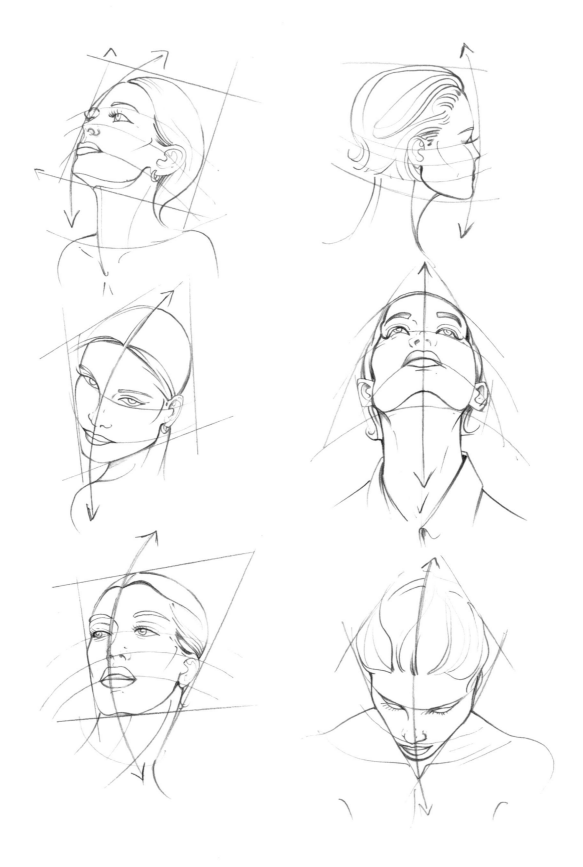

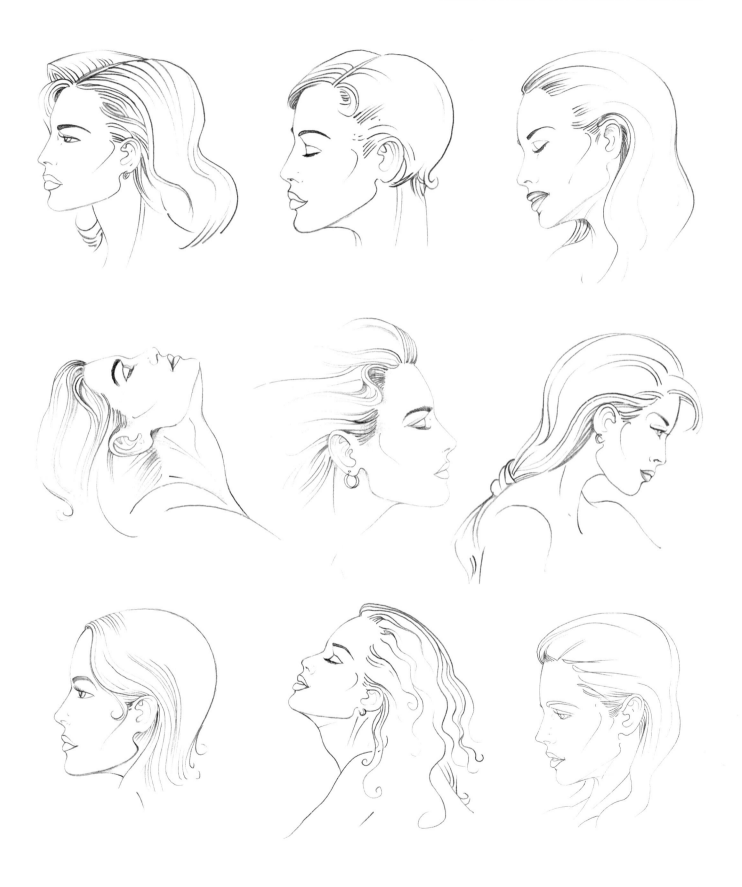

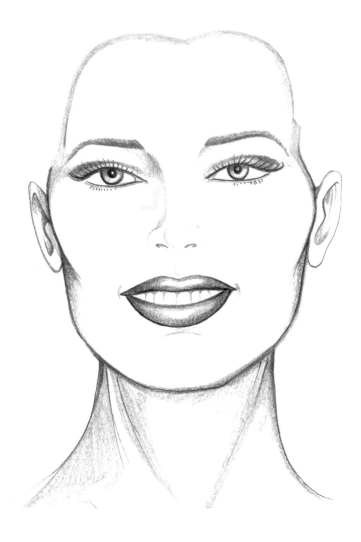

On these pages, the same face is represented with twelve different hairstyles.
As you will see, although every image has the same face it looks totally different.
This means that sometimes it is unnecessary to change the face of a model, it is enough to modify the hair to obtain the type of woman suitable for the interpretation of a style, a trend, a fashion. Also by modifying the make-up it is possible to accentuate the difference all the more.

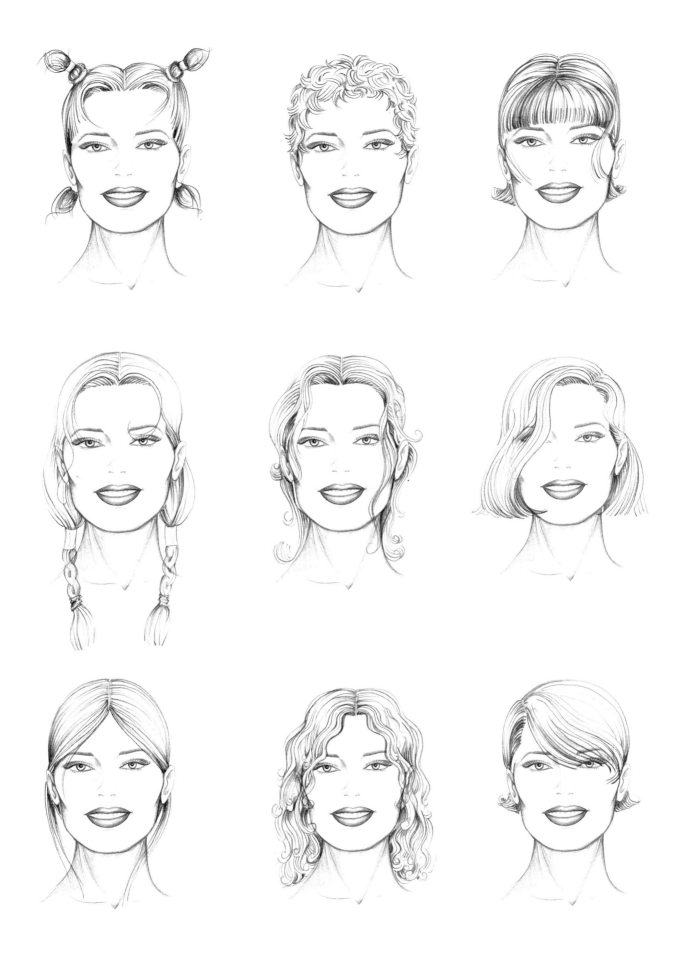

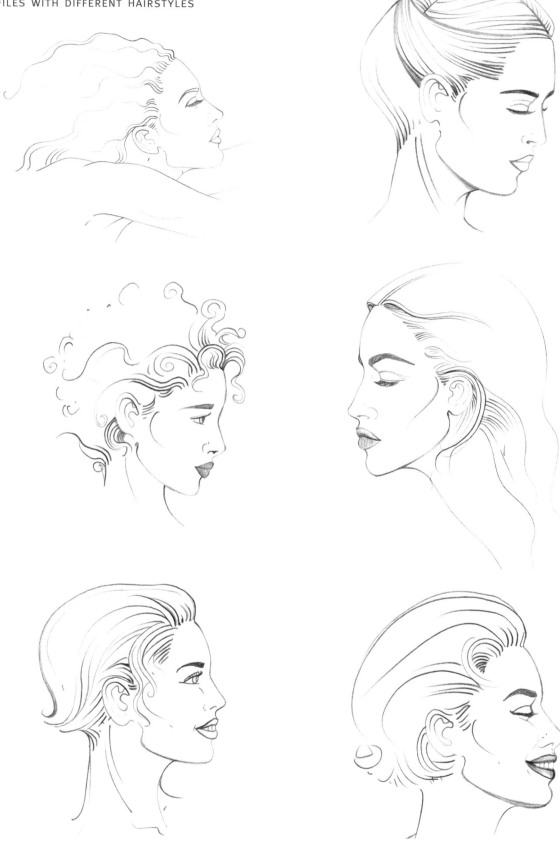

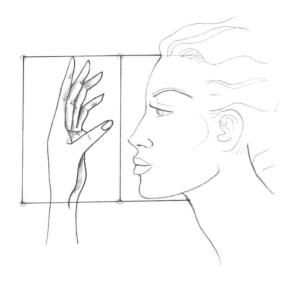

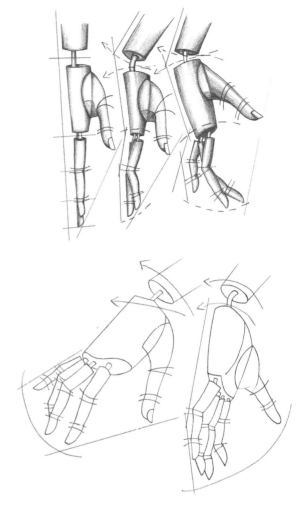

Along with the head, the hand constitutes one of the most important and difficult parts of the human body when it comes to drawing.

Its variety of movements and joints obliges the student to undertake an infinite series of studies whether from life or from memory, with the aim of reproducing it accurately in harmonious proportions and from various angles.

A well-drawn hand confers more grace and femininity on the fashion plate, a badly designed hand compromises its overall harmony.

Analysis of Structure

Proportionately speaking, the hand is as long as the face. The principal parts of the hand are: back, palm and fingers.

The latter consist of the thumb, thicker and shorter than the other fingers and made up of two phalanxes, the index finger, the middle finger, the longest, the ring finger and the little finger which is almost as short as the thumb.

The last four fingers are made up of three phalanxes known as follows: the proximal phalanx, which joins the hand, the middle phalanx, which forms the middle of the finger and the distal phalanx, which is at the extremity of the limb.

Every finger is of a different length, the various points of articulation and movement allow a hand to be the prehensile instrument of the body and in its particular morphology and expressivity the hand sometimes reveals the character and the degree of sensibility of the person.

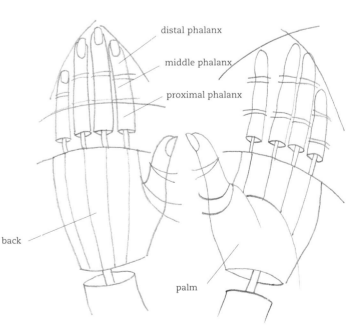

distal phalanx

middle phalanx

proximal phalanx

back

palm

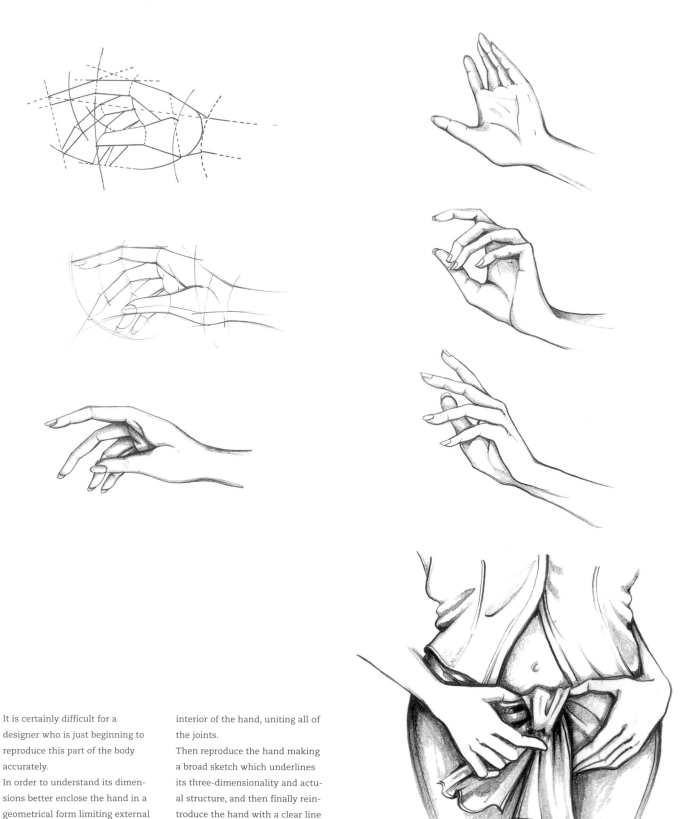

It is certainly difficult for a designer who is just beginning to reproduce this part of the body accurately.

In order to understand its dimensions better enclose the hand in a geometrical form limiting external space, and do the same with the interior of the hand, uniting all of the joints.

Then reproduce the hand making a broad sketch which underlines its three-dimensionality and actual structure, and then finally reintroduce the hand with a clear line and light chiaroscuro.

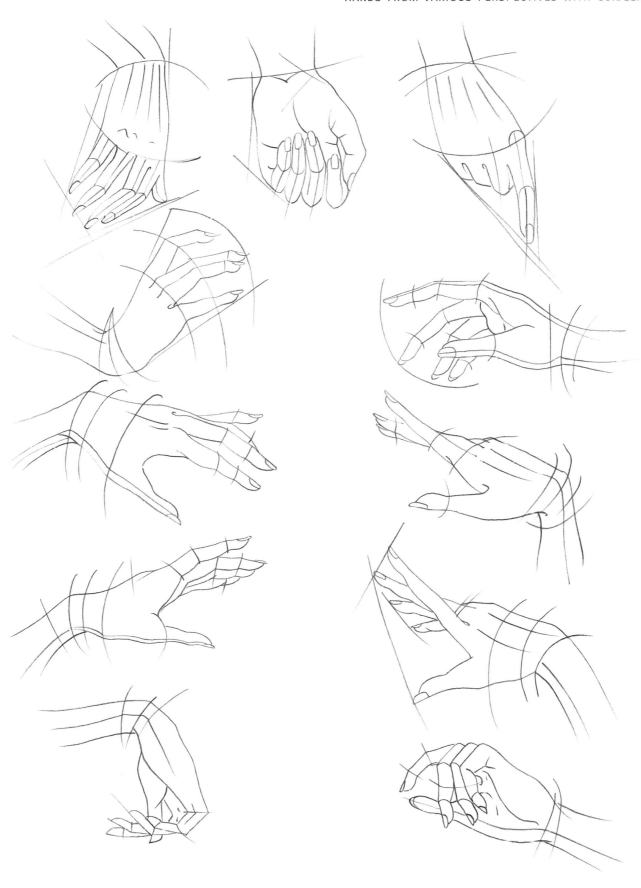

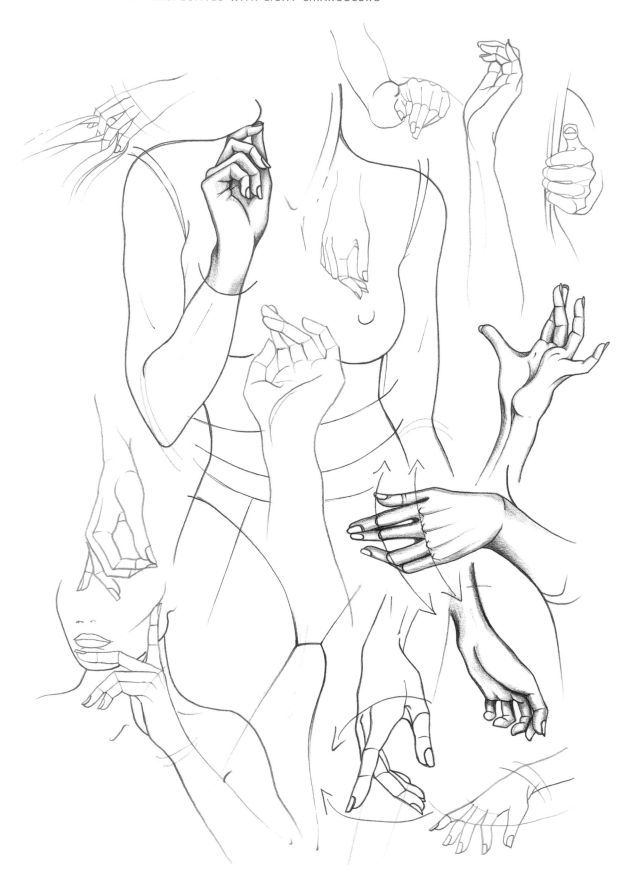

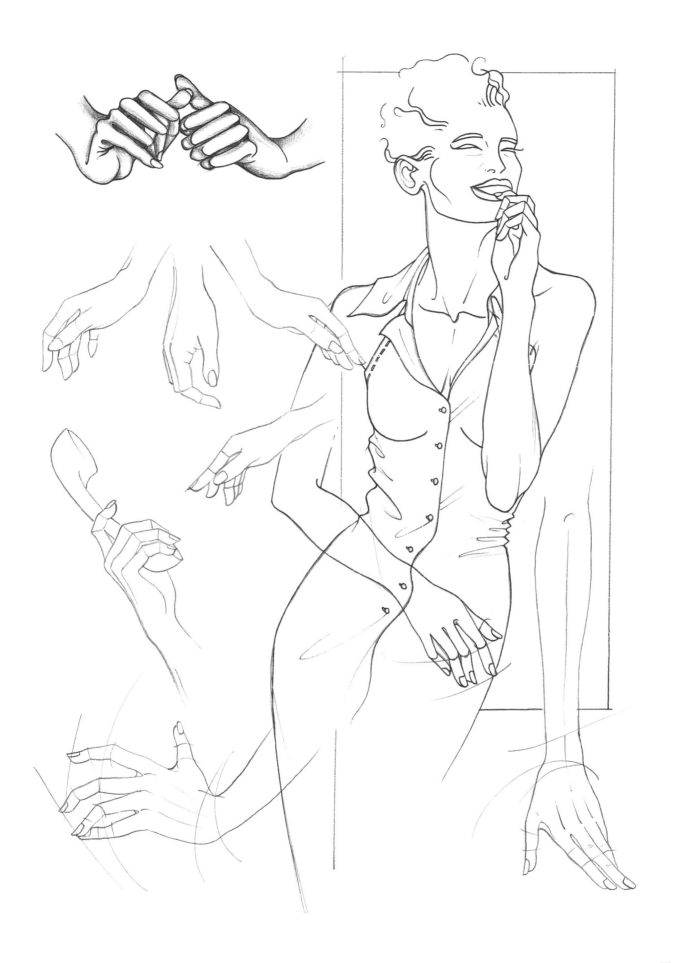

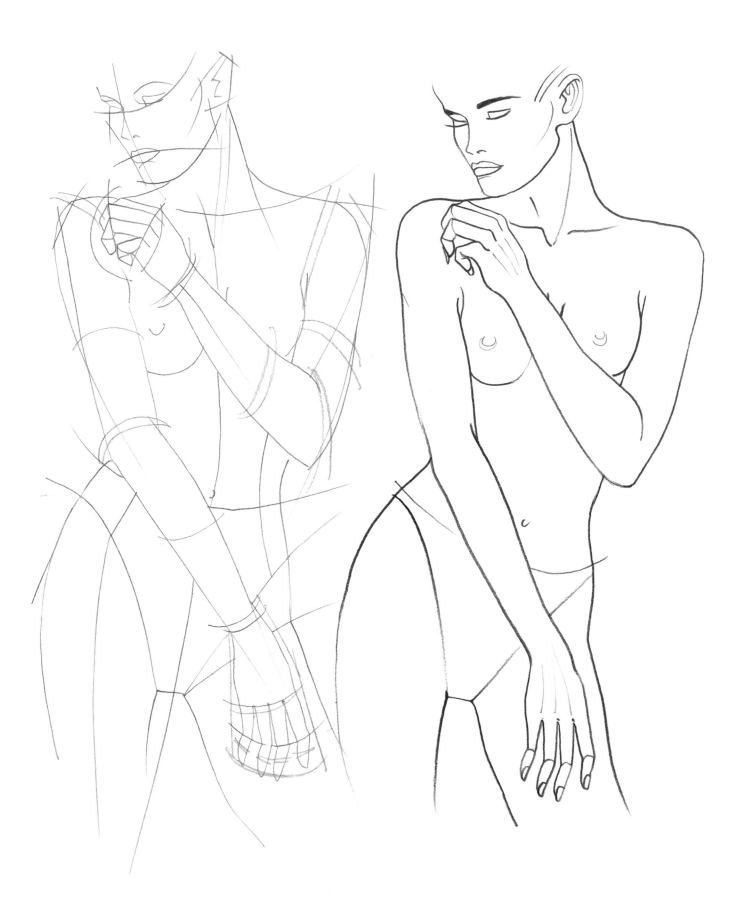

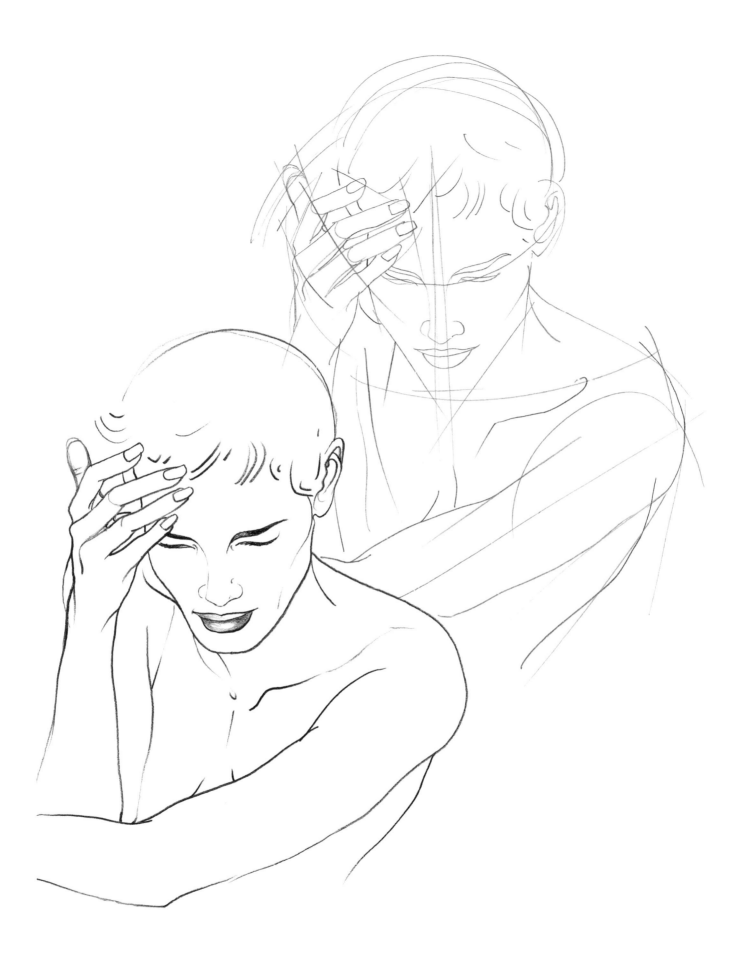

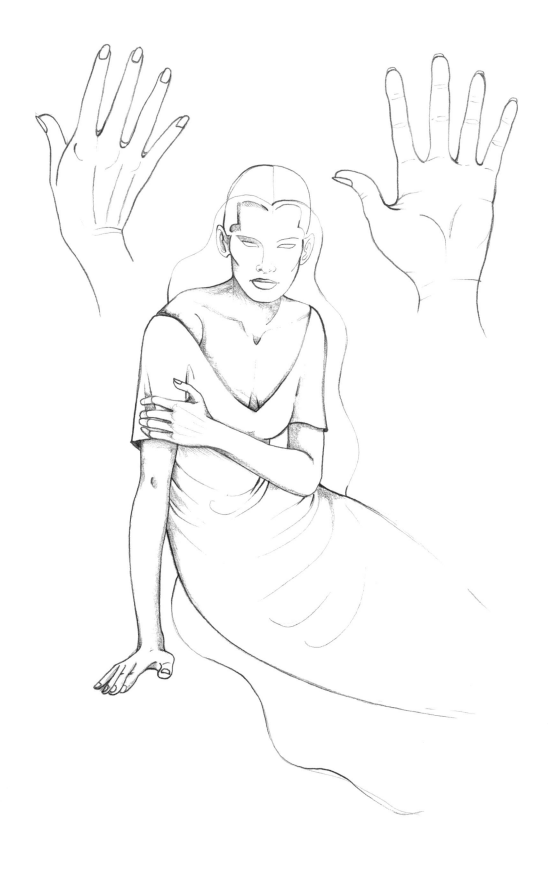

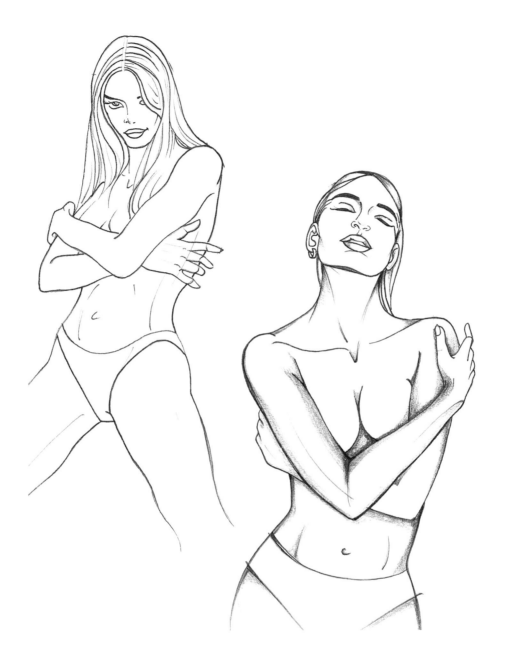

The arm is the upper limb of the body and is made up of four moving parts: shoulder, upper arm, forearm and hand.

Each part has a corresponding joint, which allows extreme flexibility, mobility and rotation.

The broad outline of the limb can be represented by two cylinders which narrow at the base, the upper part of the forearm is similar to a truncated cone and the hand with fingers extended but not separated is similar to an elongated rhombus.

Three spheres of different sizes indicate the respective joints of the shoulder, the elbow and the wrist.

The arm extends from the shoulder to the waist, the forearm from the waist to the groin, whilst the hand extends approximately halfway down the thigh.

For a better understanding of the proportions and the joints of the arm, as for the rest of the body, we recommend studying from life or using manikins.

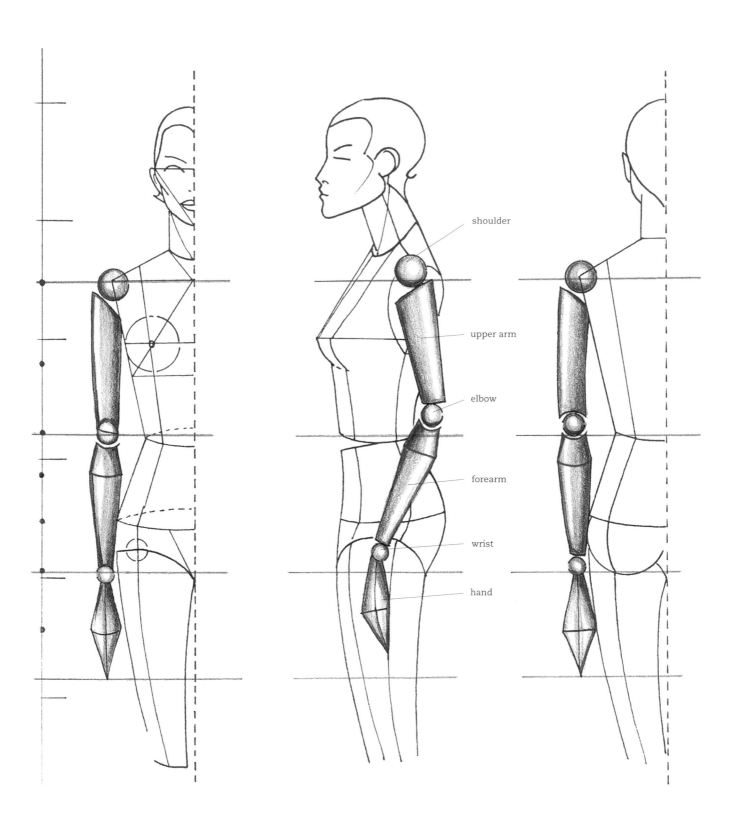

shoulder

upper arm

elbow

forearm

wrist

hand

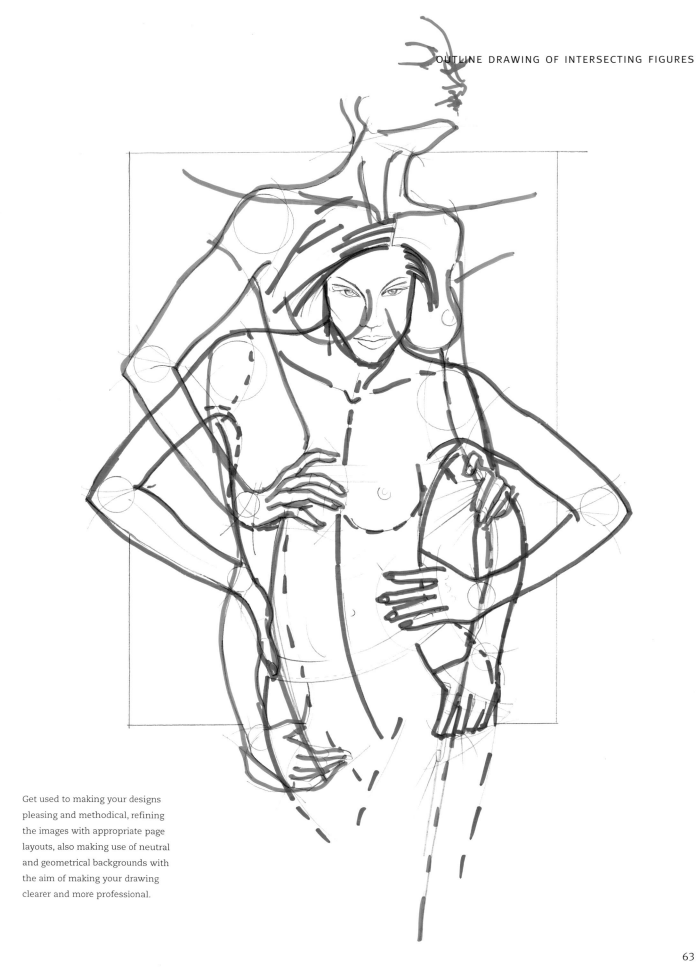

Get used to making your designs
pleasing and methodical, refining
the images with appropriate page
layouts, also making use of neutral
and geometrical backgrounds with
the aim of making your drawing
clearer and more professional.

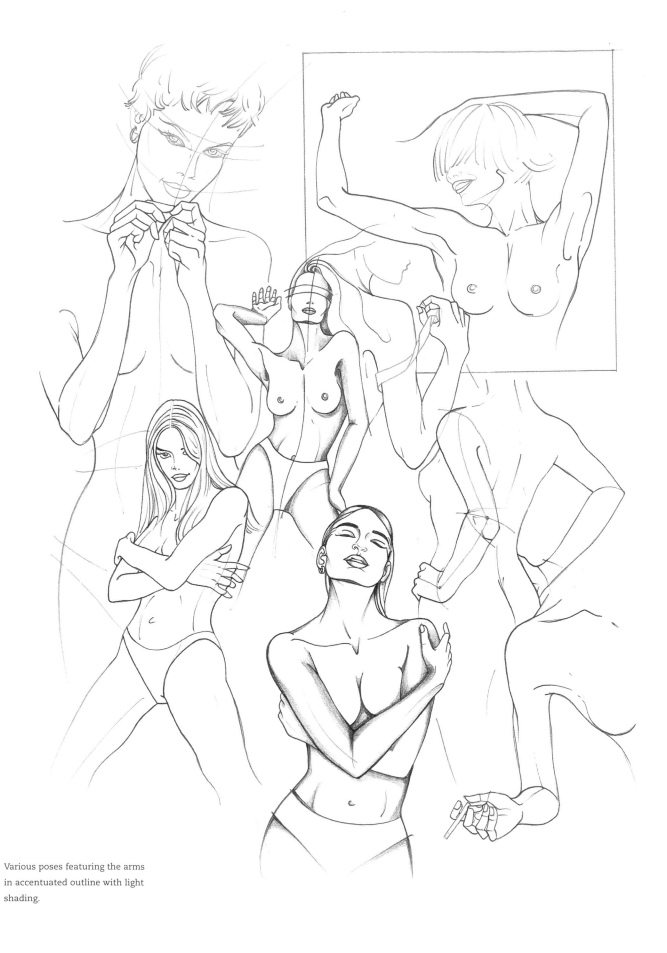

Various poses featuring the arms
in accentuated outline with light
shading.

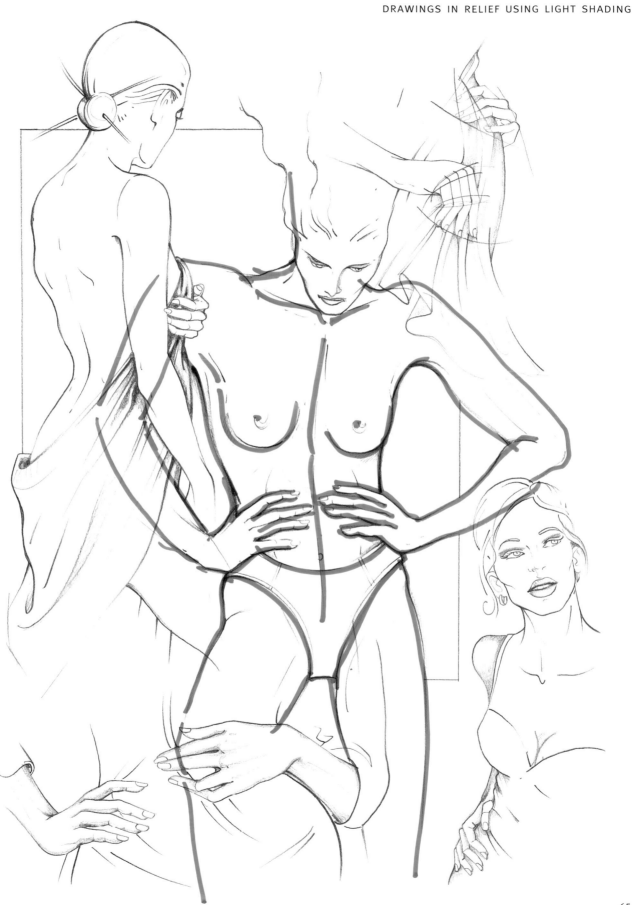

THE FOOT ANALYSIS AND STRUCTURE

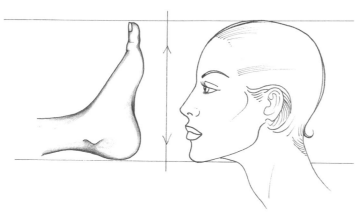

The length of the foot corresponds to one-eighth of the height of the body, therefore to the height of the head.
Unlike the hand, the foot is more closed and compact and its wedge-like shape and broad sole ensure that the foot functions as a support for the body.
Structurally it consists of five main parts: the heel, the two malleoli, the bridge of the foot and the five toes.
The hallux, or big toe, is the largest. Finally, the sole of the foot has the function of supporting the body.

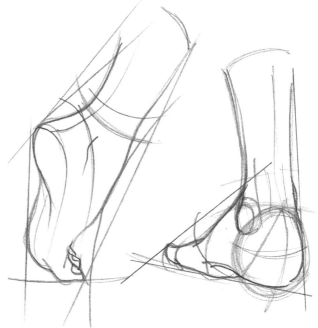

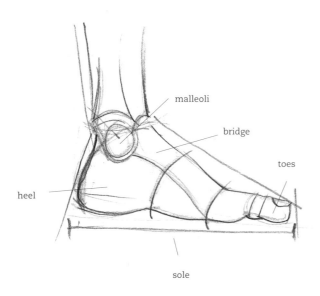

malleoli

bridge

toes

heel

sole

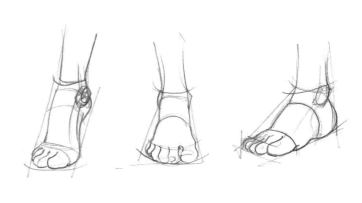

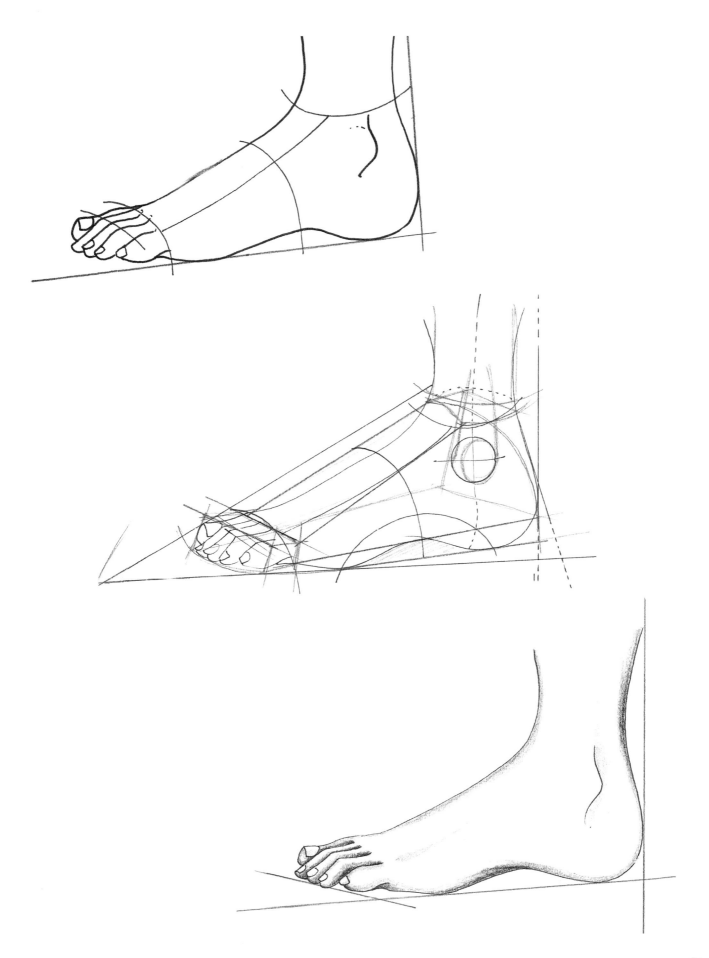

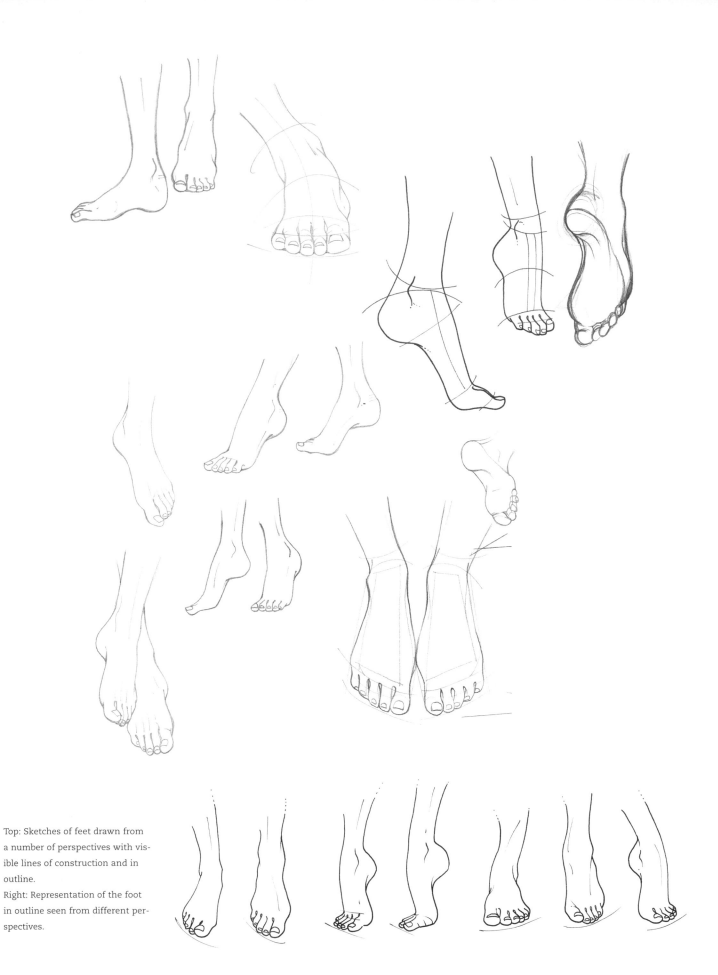

Top: Sketches of feet drawn from a number of perspectives with visible lines of construction and in outline.

Right: Representation of the foot in outline seen from different perspectives.

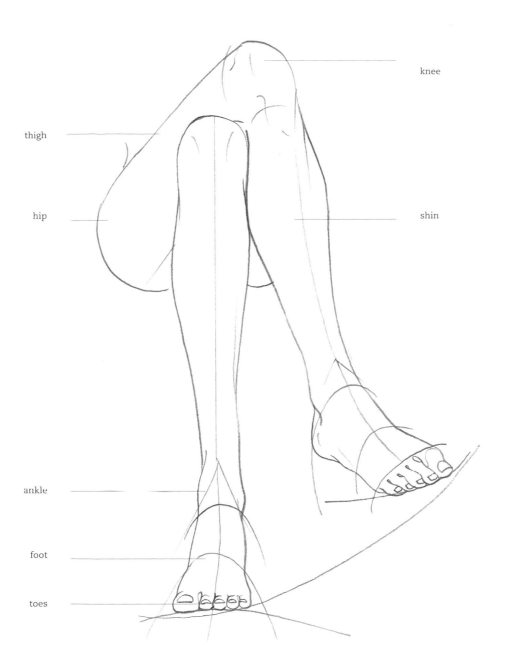

knee

thigh

hip

shin

ankle

foot

toes

The leg is the lower limb of the body.
Proportionately the leg, including the foot, has a height of approximately four units of measure of the overall figure. Structurally the limb is made up of three moving parts: the thigh, the leg and the foot, which are connected by the joints of the hip, the knee and the ankle.
The various anatomical parts of the entire leg bend and rotate by means of a moving and rounded bony structure,

which allows extreme mobility, exactly as we have seen with the arm.
The broad outline of the lower limb can be represented as with the upper limb by two cylinders, which narrow at the bottom, by a truncated cone, which holds the calf geometrically and by a wedge-shaped form already mentioned in the previous chapter for the foot. Three spheres of various sizes indicate the location of the joints.

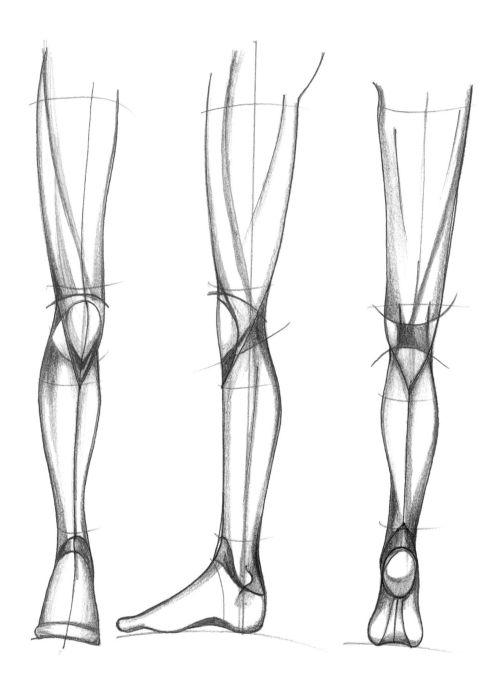

The length of the thigh is equal to that of the shin. The first difference that we notice in these three drawings is the variation in rhythmic structures. In the first and third drawings, the rhythmic structure assumes a curved aspect which starts from the hip joint going as far as the centre of the knee, whereafter it descends vertically to the inside of the foot.

In the leg shown in profile the rhythmic structure assumes the form of an elongated letter S by contrast.
In profile the lower half of the leg underlines the difference in height which exists in the bending of the knee, namely lower at the front and higher at the back.
The frontal view of all three legs demonstrates the points of con-

tact with the body's musculature, on the inside upper part of the thighs, the knee, the calf and the ankles. By contrast we note those areas where there is no contact with the musculature on the inside of the thighs, between them and the pubic region, between the knee and the calf, on the leg below the knee and between the ankles and the foot.

Right: Legs portrayed from a variety of perspectives, drawn with rhythmic structure, points of articulation and bending.
Sizes and proportions change according to the type of perspective.

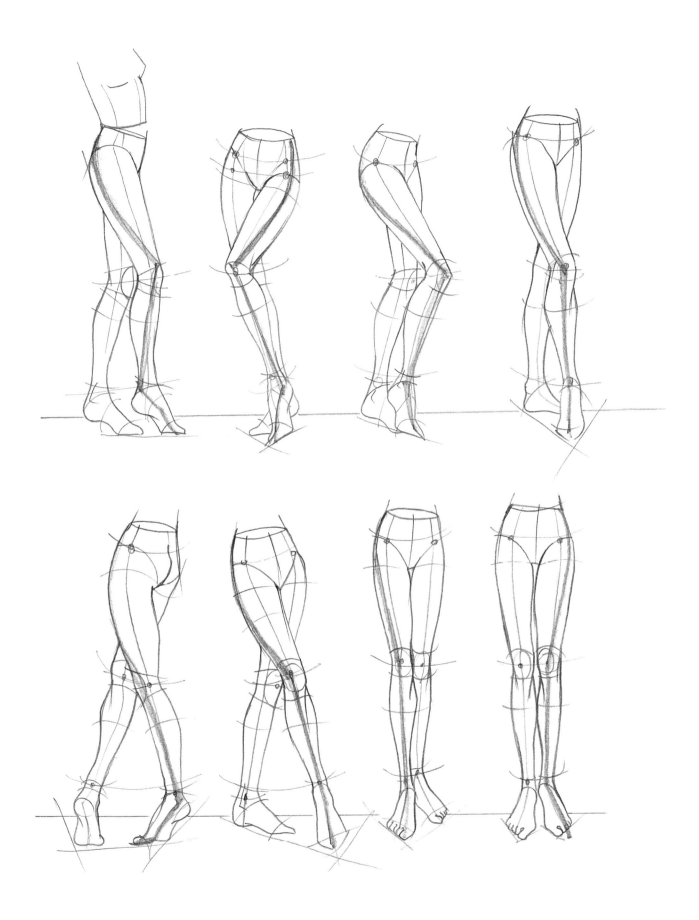

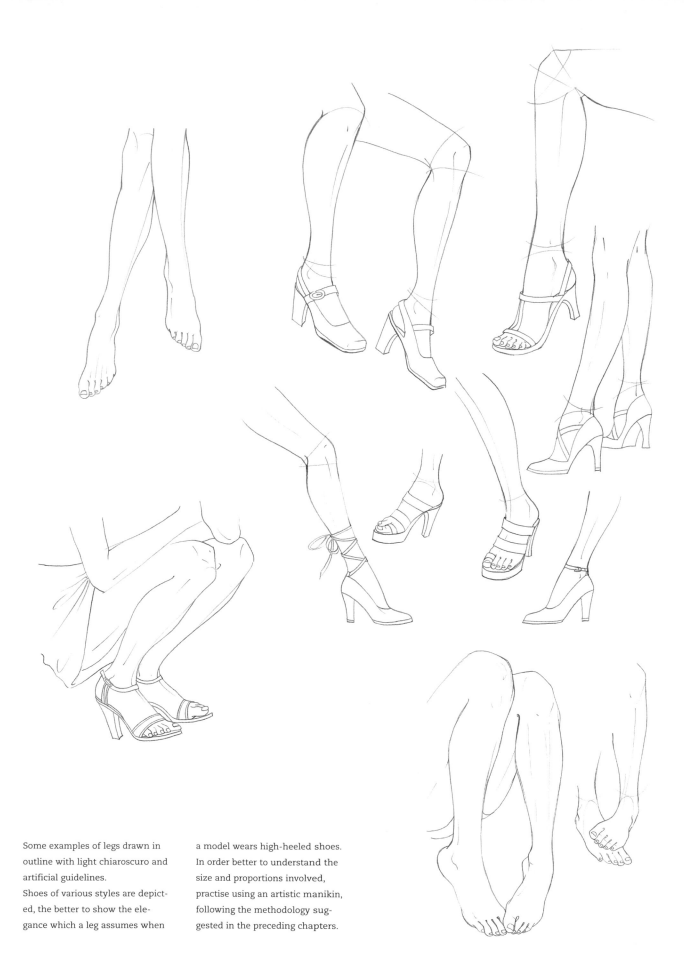

Some examples of legs drawn in outline with light chiaroscuro and artificial guidelines.
Shoes of various styles are depicted, the better to show the elegance which a leg assumes when a model wears high-heeled shoes. In order better to understand the size and proportions involved, practise using an artistic manikin, following the methodology suggested in the preceding chapters.

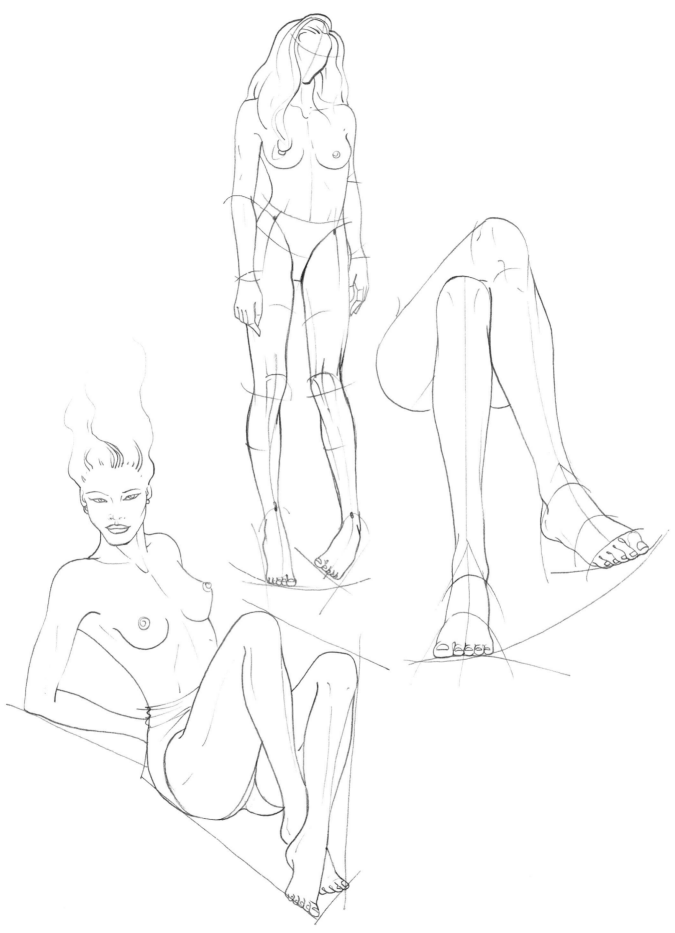

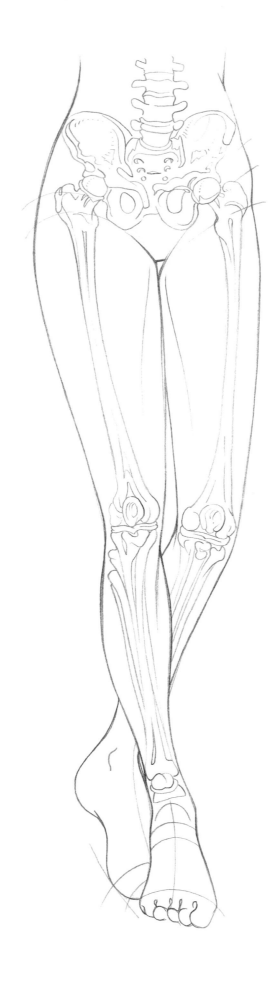

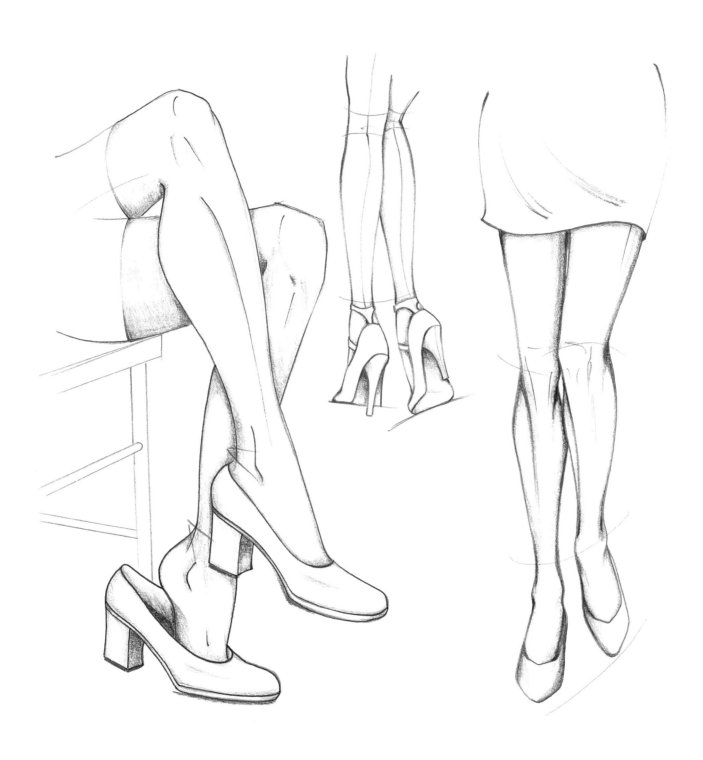

THE UPPER BODY

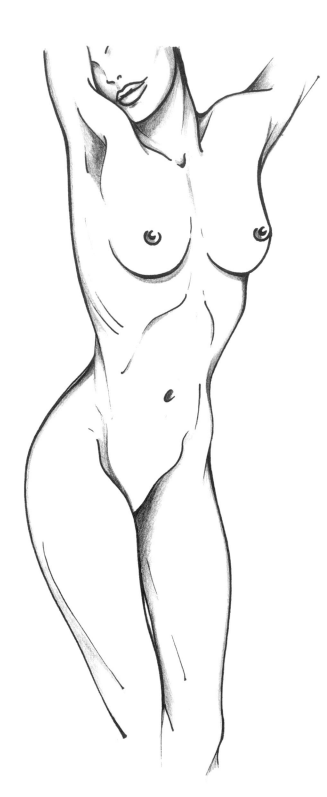

The upper body, or torso, is certainly the most important anatomical part of the female figure; its extreme plasticity and shape make it an important protagonist in so many ways.

Stylists like to place it in evening dress with a surprising décolletage or to emphasize its curvaceousness in highly feminine suits.

The upper body is the key to the fashion plate and knowing how to reproduce it perfectly from every angle and in its every movement is a sign of great artistic ability.

By contrast, an upper body in which the proportions are badly rendered or which is drawn too rigidly undermines the entire figure and throws its wearability off balance, rendering the fashion plate listless and impractical.

In order to move so expressively, models practise at length the art of walking with an air of dignity, and to understand realistically every slightest rotation, every tension and every muscular coordination, much attention must be lavished even on the smallest movement.

Carrying out numerous exercises is therefore indispensable to achieve the necessary harmony for each pose.

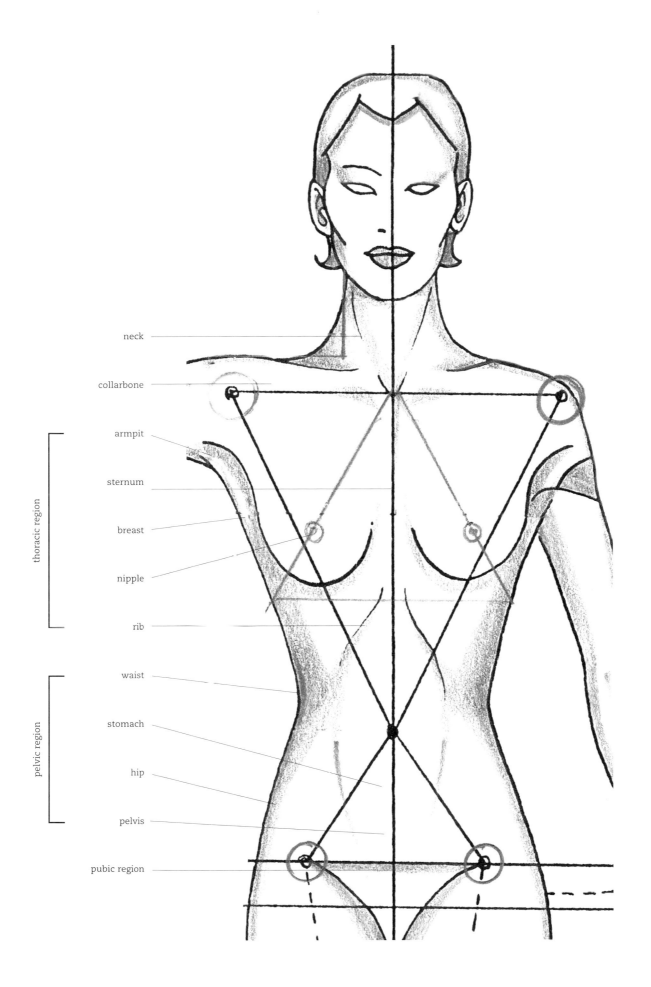

neck

collarbone

armpit

sternum

breast

nipple

rib

thoracic region

waist

stomach

hip

pelvis

pelvic region

pubic region

77

Perspective:

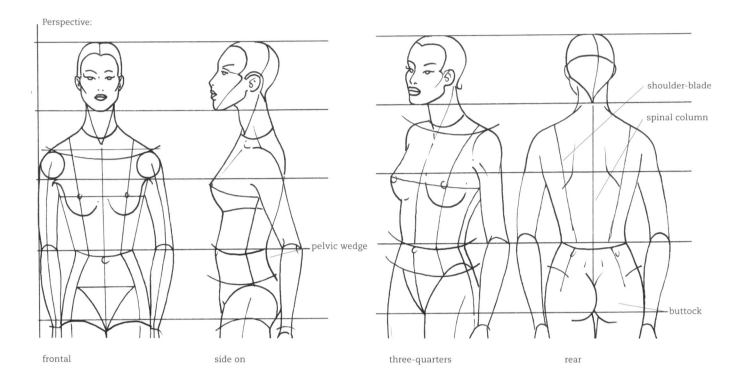

shoulder-blade

spinal column

pelvic wedge

buttock

frontal side on three-quarters rear

Proportionately speaking, the upper body extends over two and a half units of measure of the overall female figure. Structurally it is made up of two moving parts of different sizes, the thoracic region and the pelvic region.

These anatomical features also constitute the main difference between the female body, which is rounder and more flexible, and the male body which is more imposing and muscular.

A frontal view reveals the following features from top to bottom: the neck, cylindrical in form and nestling in the upper body behind the collarbone, the shoulders which are smaller than those of the male and of the same width as the hips, the collarbones, bones in the shoulders that join up as they dip in the cavity of the neck.

Then we have the thorax, which is the single largest structure in the body, formed by the ribs, the sternum, the protruding breasts and the armpits.

To find the exact position of the nipples it is useful to draw two lines at 45° from the hollow of the neck through the ribcage.

It will be noted by so doing that the nipples are orientated towards the outside.

The shape of the breasts in an adolescent girl resembles an upside-down goblet and the dimensions can vary according to the type of build.

The upper body joins the hips at the waist, which is much smaller and slightly elevated in contrast to a man's.

The pelvic region is formed by the stomach with the navel, by the hips and the pubic region.

The main features of the back are the shoulder-blades, which follow the movement of the arms, and the spinal column, which elevates the upper body and allows by means of its particular anatomical structure an infinite number of positions and movements.

The lower part of the upper body is formed by the pelvic wedge, which extends backwards to the sacrum and the buttocks, whose medium-sized and large muscles have the shape of a butterfly.

In profile we can see at the front the shape of the thoracic region and at the rear the shape of the pelvic region.

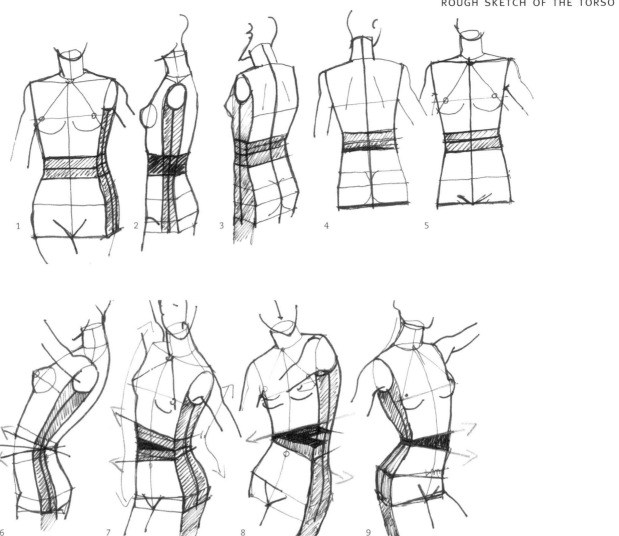

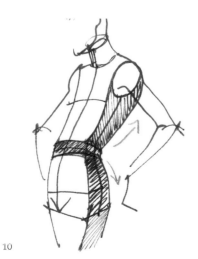

The basic form of the torso is made up of two moving structures, the thoracic region and the pelvic region.

The thoracic region can be represented from the front and from behind by a trapezium (1-4-5) whilst from the side and when foreshortened it assumes a more rounded aspect, almost like a barrel (2-3).

The pelvic region is represented from the front and from behind by a more flattened trapezium, whose base is as wide as the shoulders (1-4-5).

From the side and when foreshortened it assumes the schematic appearance of a cuneiform box to contain the buttocks (2-3).

Pay careful attention to protrusions and indentations in the thoracic region and the pelvic region and to their proportions. In order better to emphasize the dynamic of both parts or of one only, we have drawn the area of the hip and the waist with chiaroscuro.

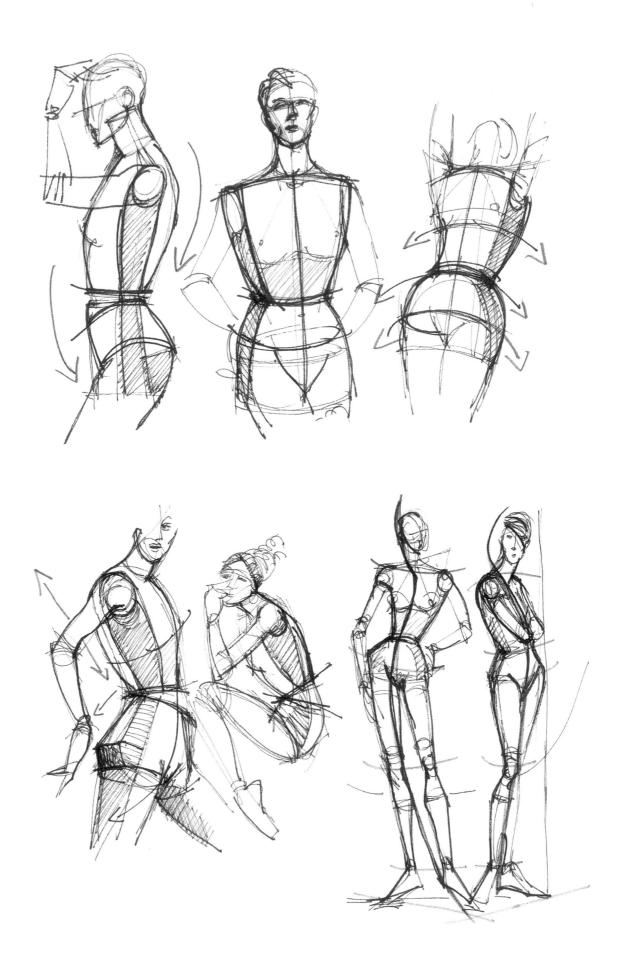

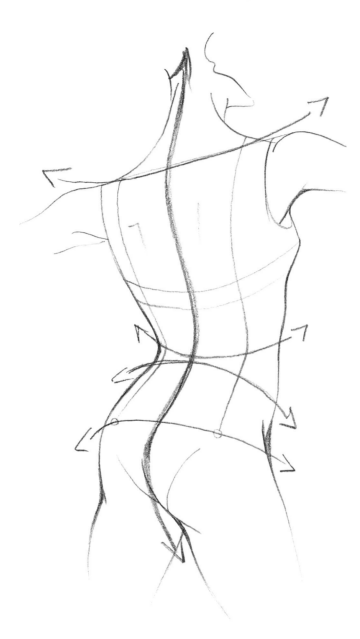

The diagrams on pages 81 - 5 show the rotations most frequently made by models.

From an infinite variety of movements we have carefully chosen selected poses to present the most common positions adopted by models when they are modelling or sitting.

In this instance it is also advisable to acquire the necessary ability to portray any movement of which the upper body is capable, even if subsequently only those poses most suitable to the needs of the fashion designer are used.

For an exact reproduction either of the parts of the body portrayed or of the rotations and counter-rotations of which the body is capable, it is highly important to establish the rhythmic structure straight away, along with the broad outline of the upper body and the pelvis.

We shall emphasize one line in order to stress the internal rhythm and use finer lines to envisage the rotations and counter-rotations.

We have marked the upper body here with curved lines, as far as the breast, waist, hips and groin are concerned.

The lines drawn from top to bottom divide the body in half, be it from the front, side or rear.

Every sideways bend corresponds to an extension on the other side of the body.

Every movement of the shoulders corresponds to a movement in the pelvis.

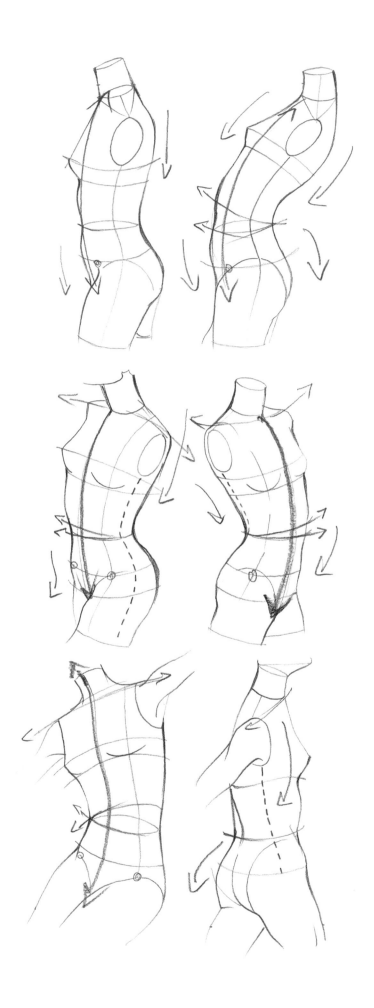

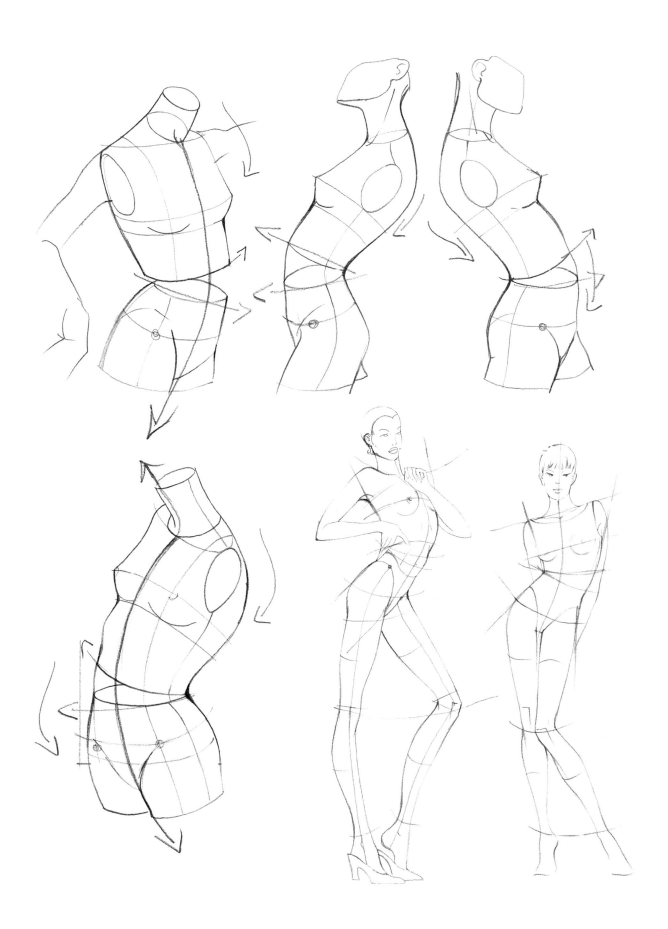

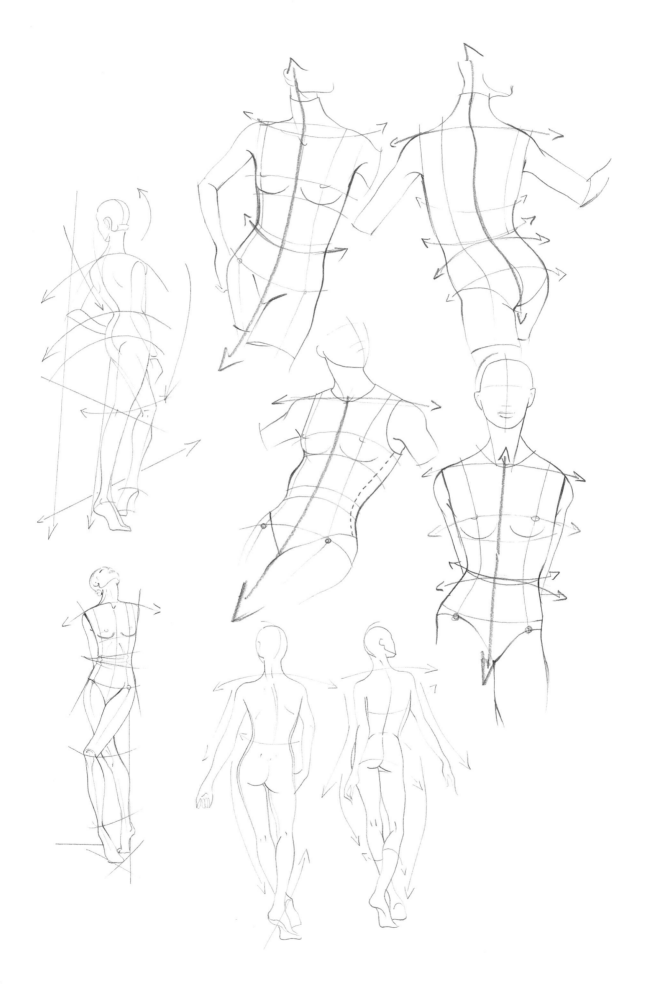

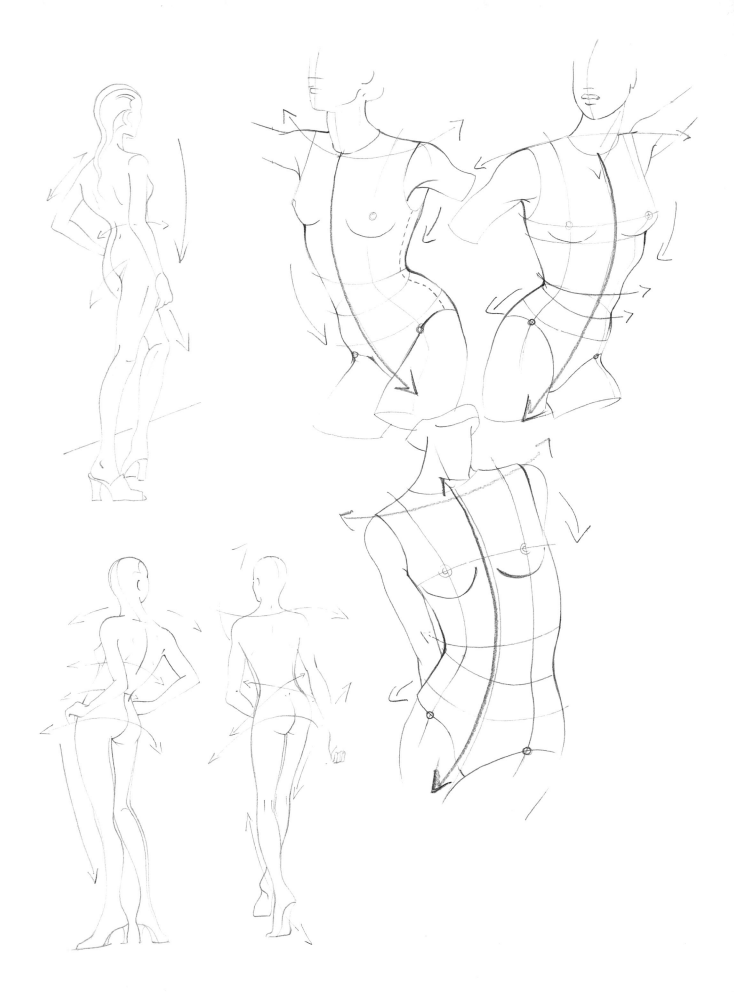

85

THE FASHION PLATE

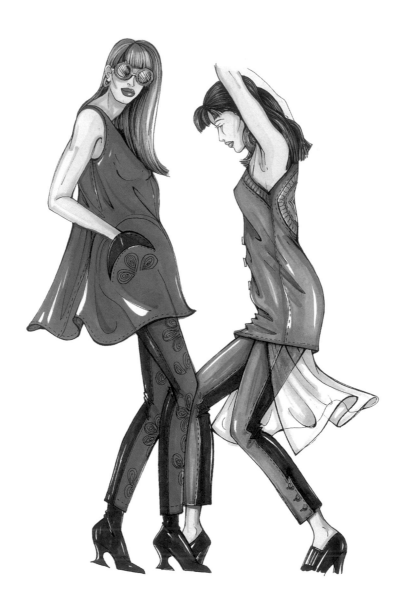

When you portray a human body it is necessary to remember that you are depicting something that is alive, and in the specific case of fashion design, it is fundamental to observe closely the typical movements which characterize the poses adopted by the models.

They are movements which are supple, trim and nimble. The fashion model walks in a way that is absolutely unique, turns and swings her hips in a wonderful way, stops and poses in ways which defy gravity.

The reaction to the gait of a professional fashion model is one of amazement and captivation in the face of so much charm and elegance.

Let us seek to understand together how to capture with a few lines in a drawing these exceptionally flexible and dynamic movements.

In each instance rotation and counter-rotation of the upper body will be analysed, identifying the rhythmic structure and proportions of every pose.

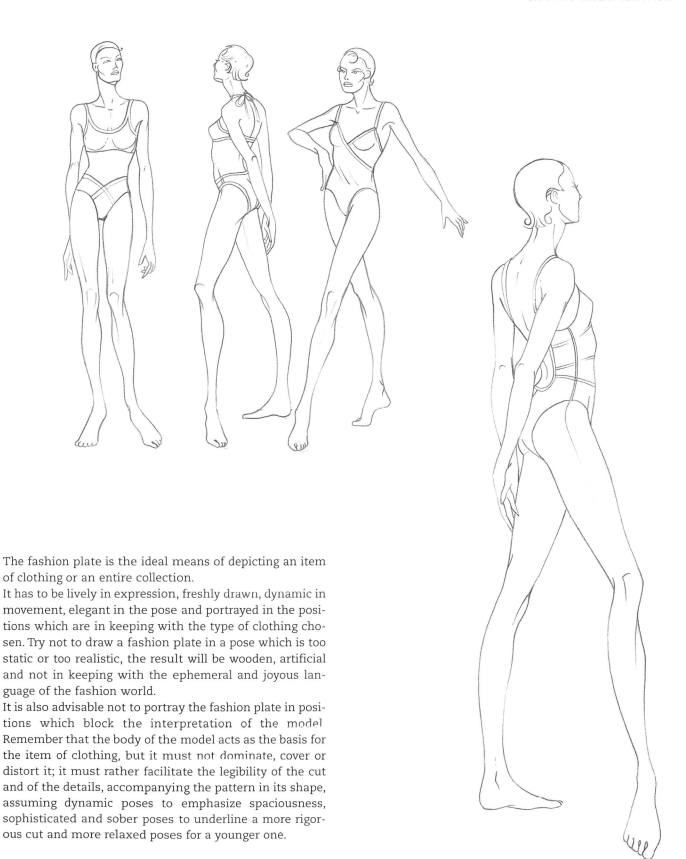

The fashion plate is the ideal means of depicting an item of clothing or an entire collection.

It has to be lively in expression, freshly drawn, dynamic in movement, elegant in the pose and portrayed in the positions which are in keeping with the type of clothing chosen. Try not to draw a fashion plate in a pose which is too static or too realistic, the result will be wooden, artificial and not in keeping with the ephemeral and joyous language of the fashion world.

It is also advisable not to portray the fashion plate in positions which block the interpretation of the model Remember that the body of the model acts as the basis for the item of clothing, but it must not dominate, cover or distort it; it must rather facilitate the legibility of the cut and of the details, accompanying the pattern in its shape, assuming dynamic poses to emphasize spaciousness, sophisticated and sober poses to underline a more rigorous cut and more relaxed poses for a younger one.

To make a figure come alive, it is not enough to have a perfect knowledge of anatomy, a copy which is too faithful can harm the image, making it cold and impersonal.

It is important, by contrast, to be able to catch the correct position with a few strokes and to distribute bodily weight, signalling inside and outside of the body planes of incidence, lines of comparison, angles and perpendicular lines so that it is possible to reproduce the pose of the model in the most faithful way possible.

First of all it is necessary to locate the key line, or put another way the rhythmic structure, which is inherent in every pose. This line can vary enormously, as every figure has its own fundamental rhythm.

First and foremost you should sketch a line in the upper body, passing through the hollow of the neck, the sternum, the navel and the pubic region, which then descends to the ground following the leg, which functions as a support for the body.

In a static figure viewed from the front, the rhythmic structure corresponds to the line which describes the height of the figure.

Method of Execution

To understand how the weight of the various parts of the body is distributed, sketch the rhythmic structure, reduce the body to a skeleton and visualize schematically the principal structures, namely the line of the shoulders, waist, hips and finally the segments which indicate the position and length of the limbs, marking the joints with small circles.

We shall thereby have obtained the outline or the essential structure of the female body.

Then, as the second phase of this procedure, draw on top of the structural skeleton the broad sketch of the figure determining the areas of the body, outlines and the dimensions of the hair.

The result will be a geometrical figure similar to a robot, with all of the joints clearly indicated.

Proceed then to a more detailed analysis of the various anatomical features with a view to reproducing faithfully or almost faithfully the subject under scrutiny.

It is important to draw lightly insofar as there will be a number of pencil strokes superimposed.

Only intensify those that are right for the visualization of the outline, eliminating the others that do not form an integral part of your study. Finally, on a sheet of tracing paper, draw the figure only in outline, removing all the pencil strokes, lines and segments that you have drawn to characterize perfectly every aspect of the body.

The outline that you obtain will be your first fashion plate.

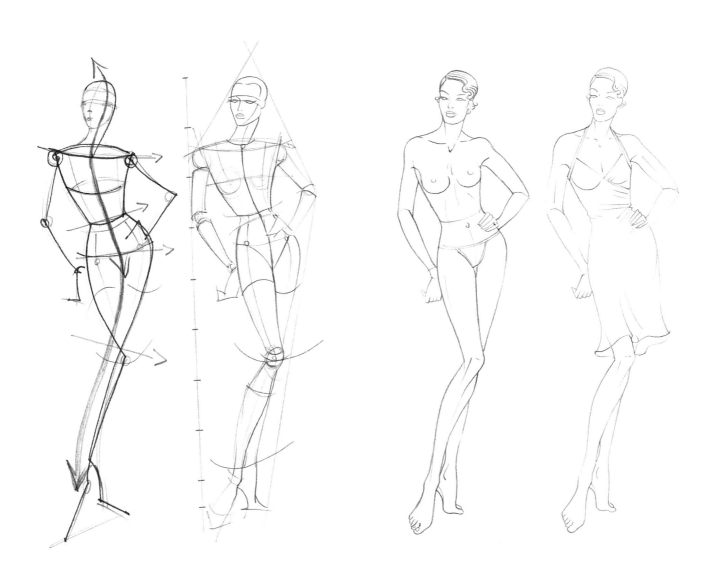

Left to right: outline and arrange-
ment of parts of the body with
rhythmic structure.
Figure in outline and fashion
plate.

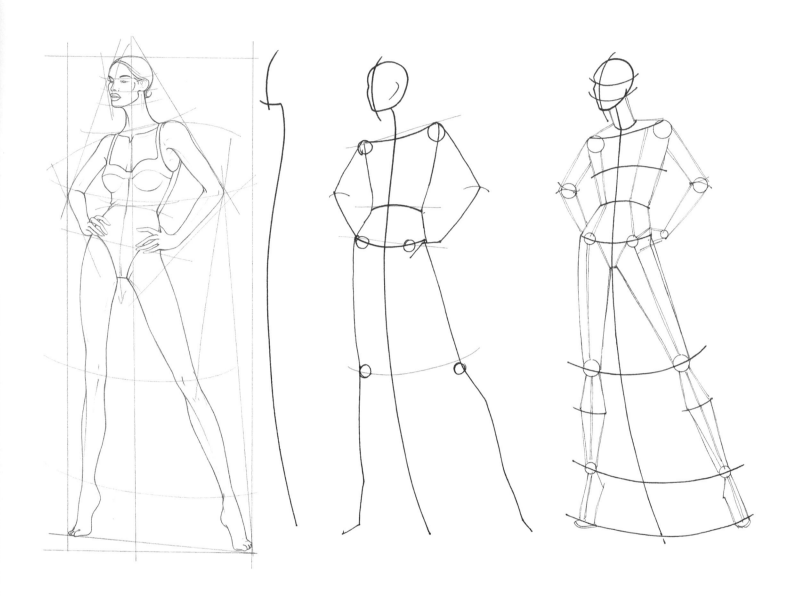

Basic fashion plate to be reproduced.

From left to right:

Location of the key line or rhythm.

Construction of the skeletal structure in outline, sketching the line of the shoulders, of the waist and of the hips.

Schematic representation of the parts of the body.

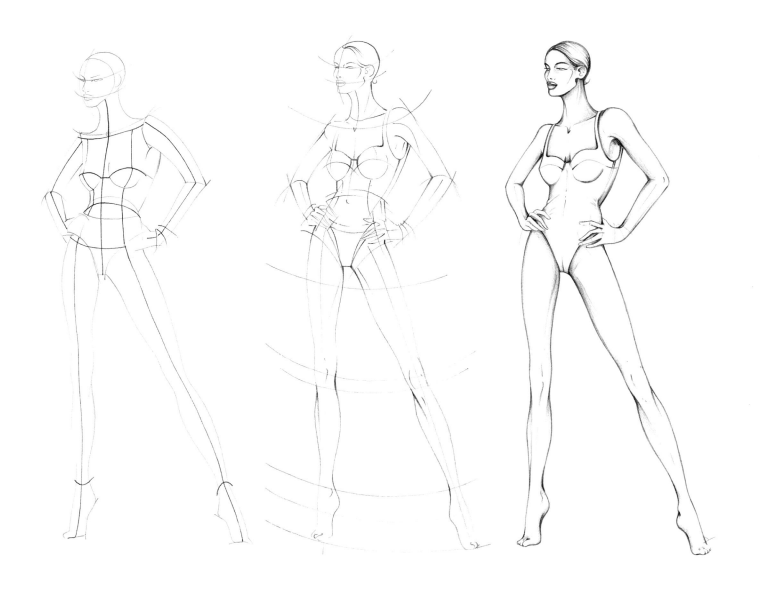

From left to right:
Broad sketch of the whole figure.
Detailed analysis of the various
anatomical parts.
Copy of the figure obtained in
outline.

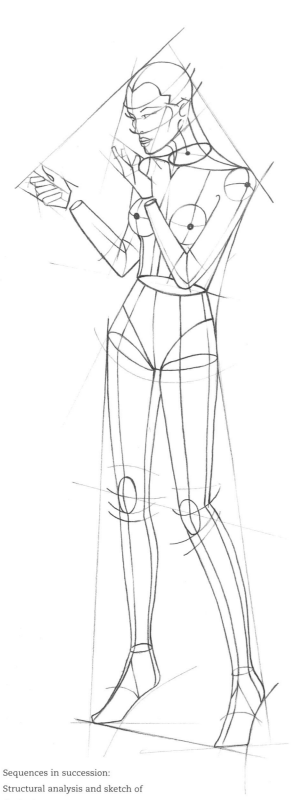

Sequences in succession:
Structural analysis and sketch of
the body.

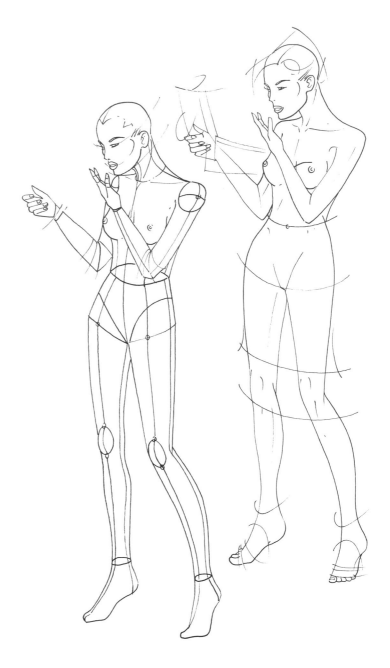

As in all disciplines, there are also rules that should be followed in drawing to reproduce any subject or composition correctly. One of these rules, probably the most important, is the notion of positive and negative space.

The space surrounding the figure is negative, whilst the space that the body occupies in a given area is positive.

In every respect it is essential to consider a negative area as positive to achieve the correct reproduction of the given subject.

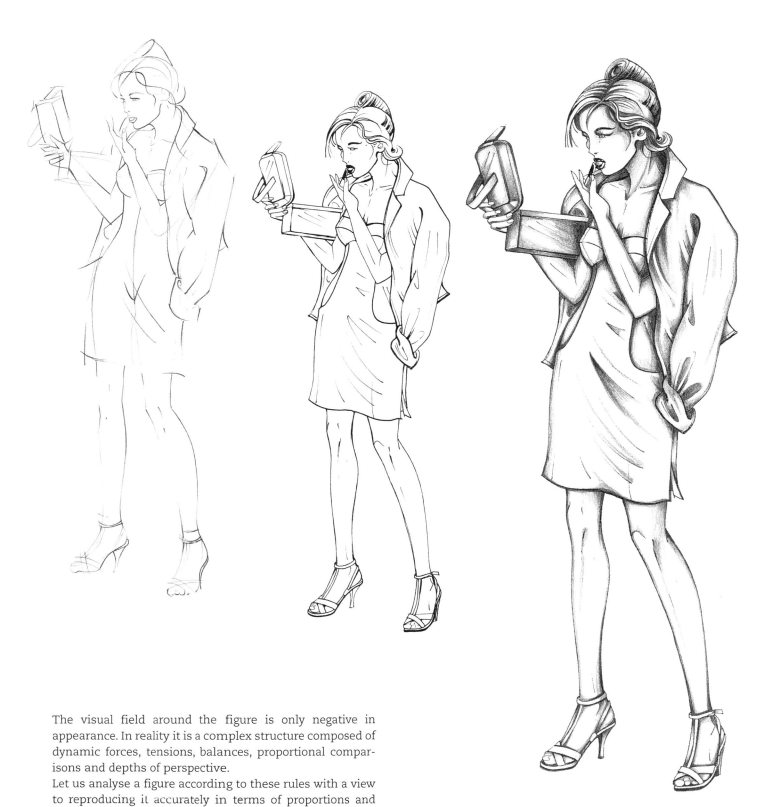

The visual field around the figure is only negative in appearance. In reality it is a complex structure composed of dynamic forces, tensions, balances, proportional comparisons and depths of perspective.

Let us analyse a figure according to these rules with a view to reproducing it accurately in terms of proportions and position. The use of tracing paper is advised to visualize all of the lines of construction directly over the subject, in order then to proceed to drawing freehand.

Model ever more clearly defined. The fashion plate finished in outline and light chiaroscuro.

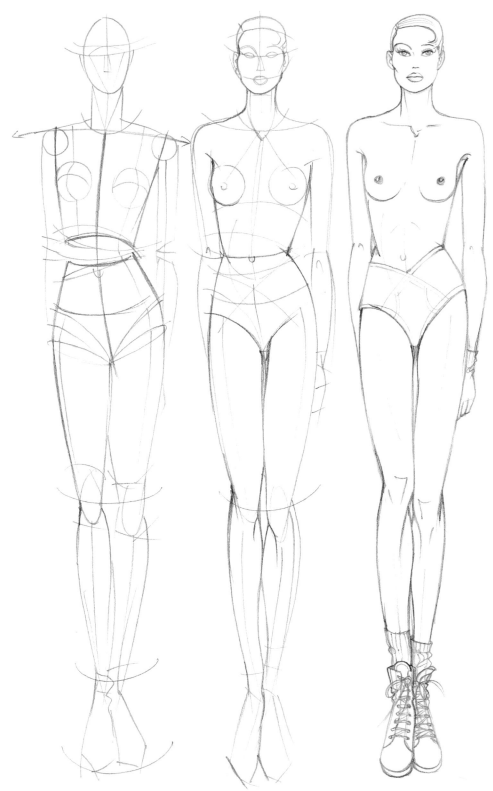

From left to right:
Structural and outline analysis.
Fashion plate drawn in outline.

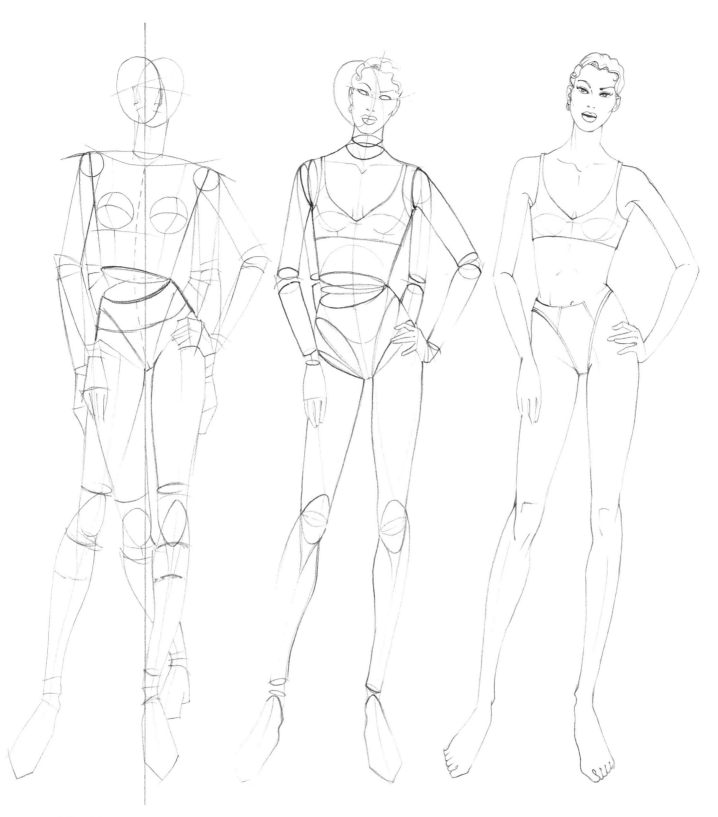

From left to right:
Structural diagram with robot-like
figure. The upper and lower limbs
assume various positions.
Fashion plate drawn in outline.

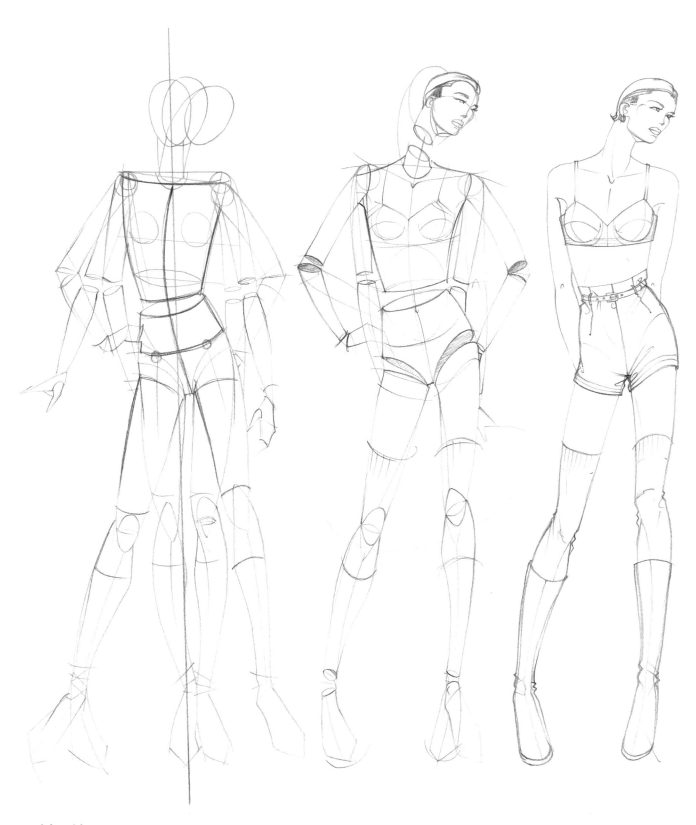

From left to right:
Structural analysis.
Robot.
Fashion plate partially clothed,
drawn in outline.

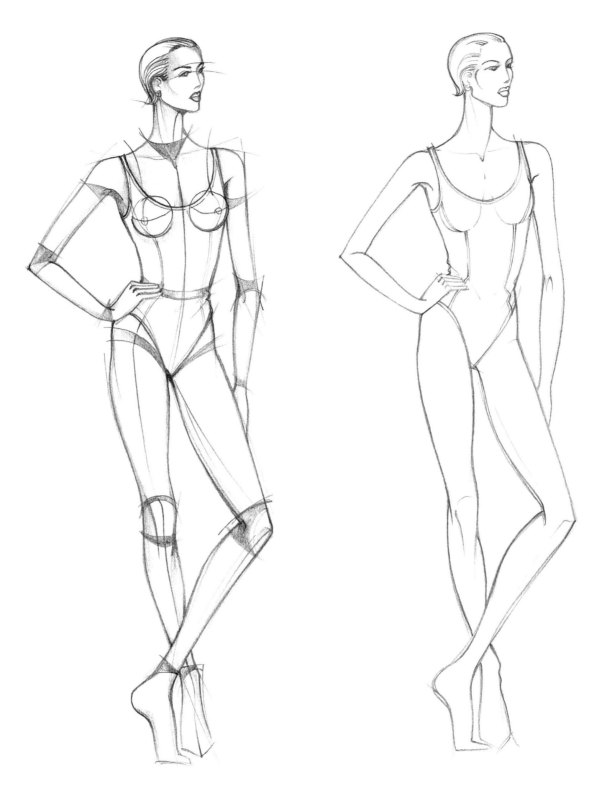

From left to right:

Structural analysis with lines of construction.

Fashion plate in outline.

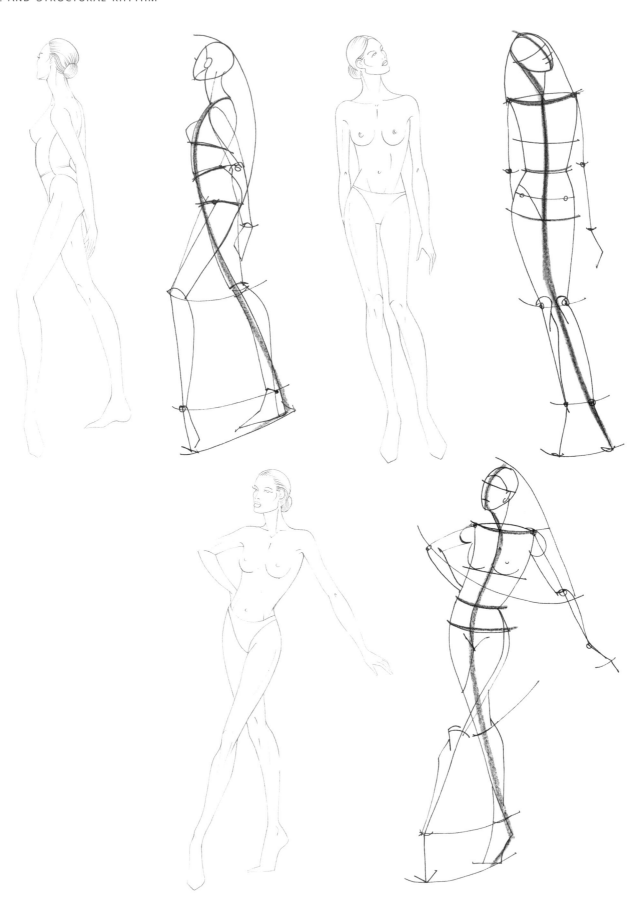

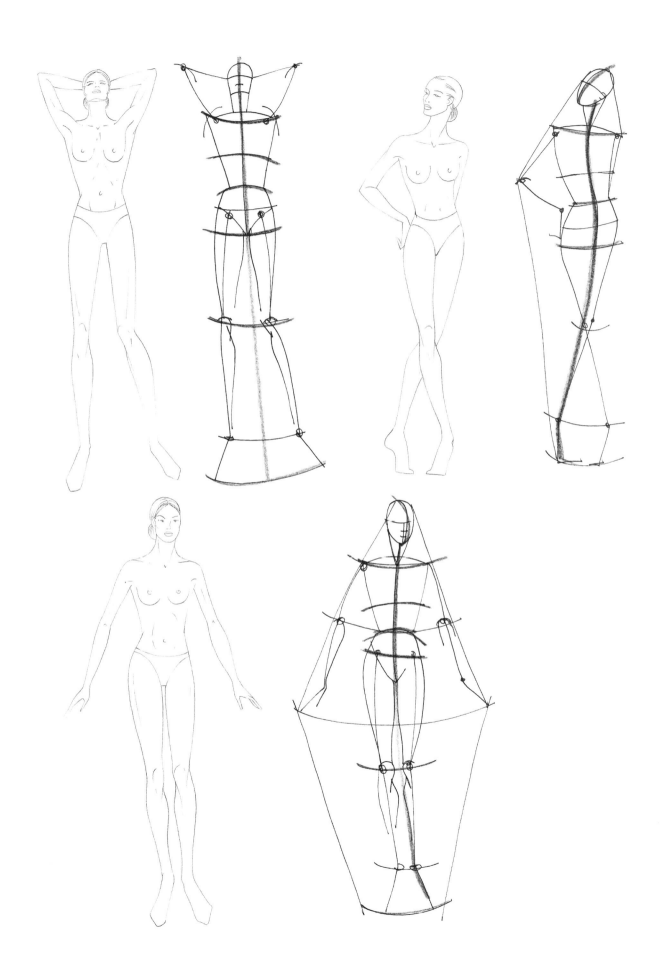

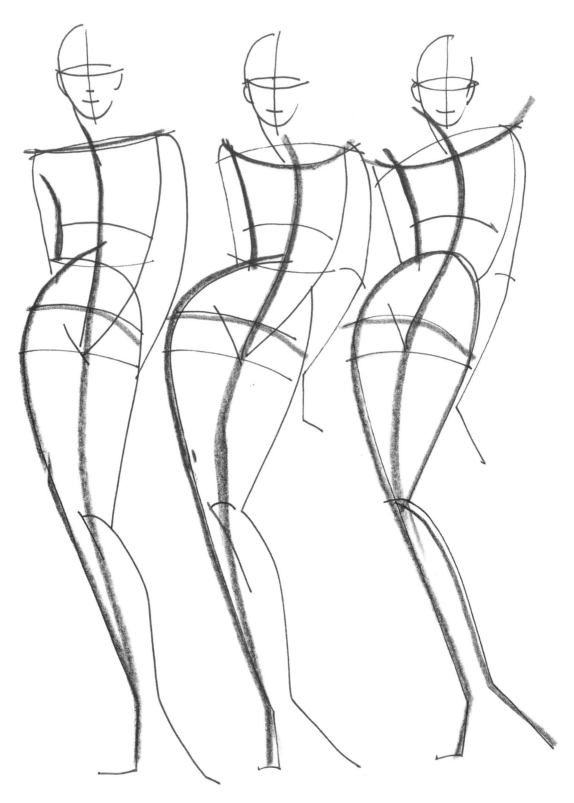

Movements in dynamic succession.
As the shoulders and the pelvis
move, the rhythmic structure of
the entire figure changes.

100

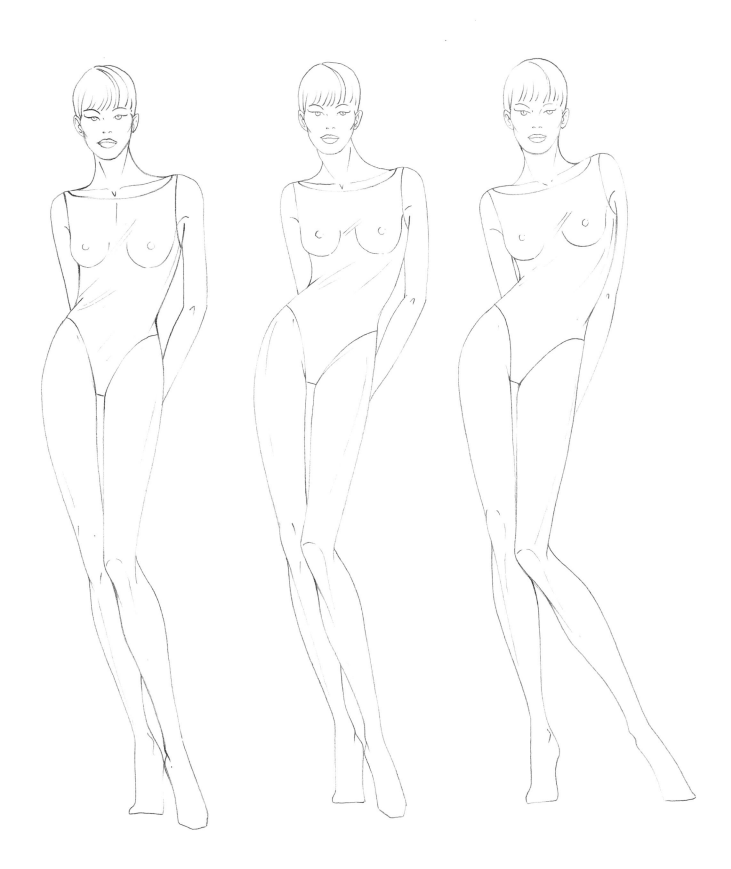

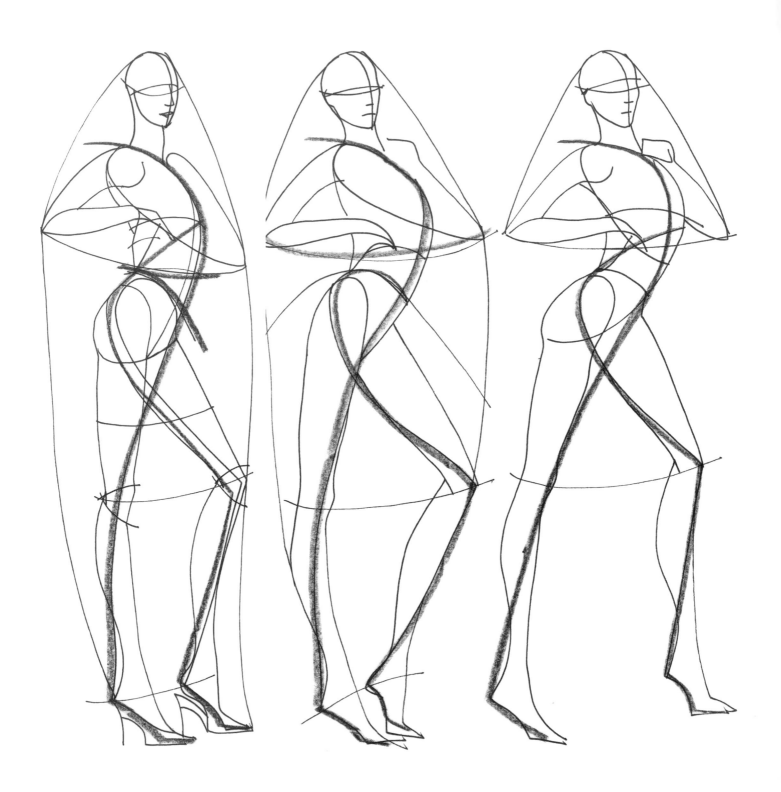

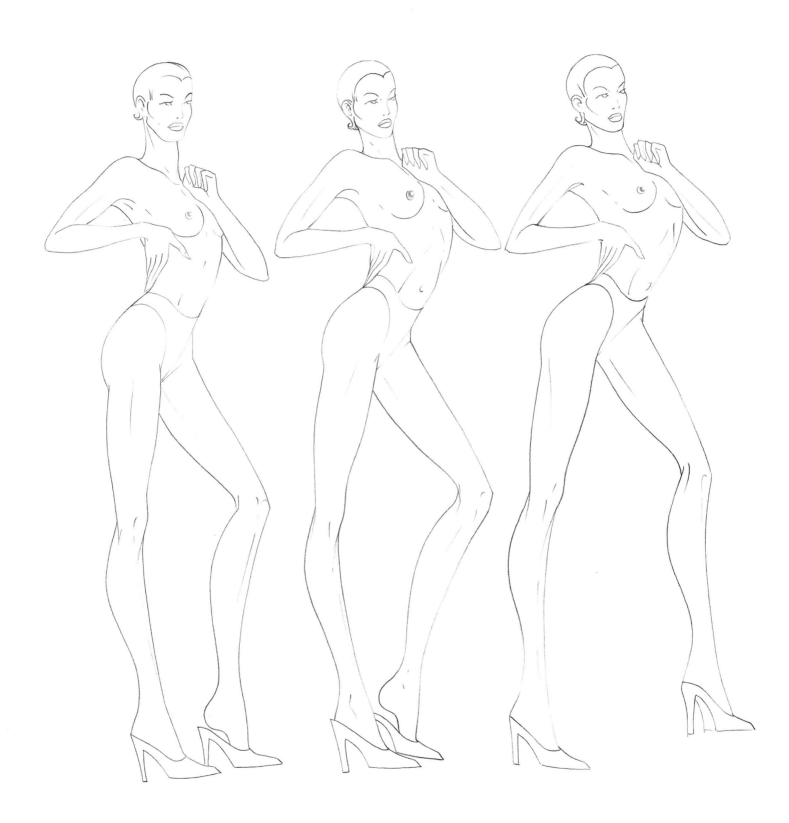

STYLIZATION

By the term stylization is understood the exaggeration of the structure of the body, reducing it to a few essential features.

There are various ways of stylizing a figure, and one of them is to elongate the height of the model by one or two units of measure.

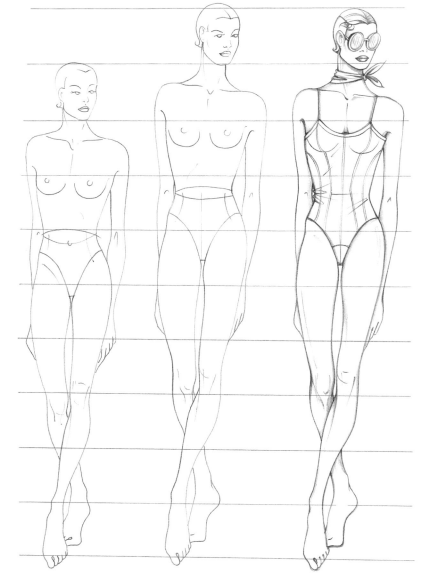

First method

As you will see in the two diagrams, the proportions have remained unchanged in every instance, that is to say that the anatomy of the figure has remained the same while the length of the limbs and principal parts of the body has been modified.

The diagram above has been elongated by one and a half units of measure and the one on the page opposite has been raised by two.

The head has more or less the same dimensions, the shoulders are slightly broader in relation to the pelvis, the neck has been slightly elongated. The chest has also been broadened while the pelvic region has been shortened, thereby raising the pubic region.

The waist has been reduced in size, the limbs have been elongated, maintaining proportions with the upper body.

The feet obviously follow the extension of the body in length.

104

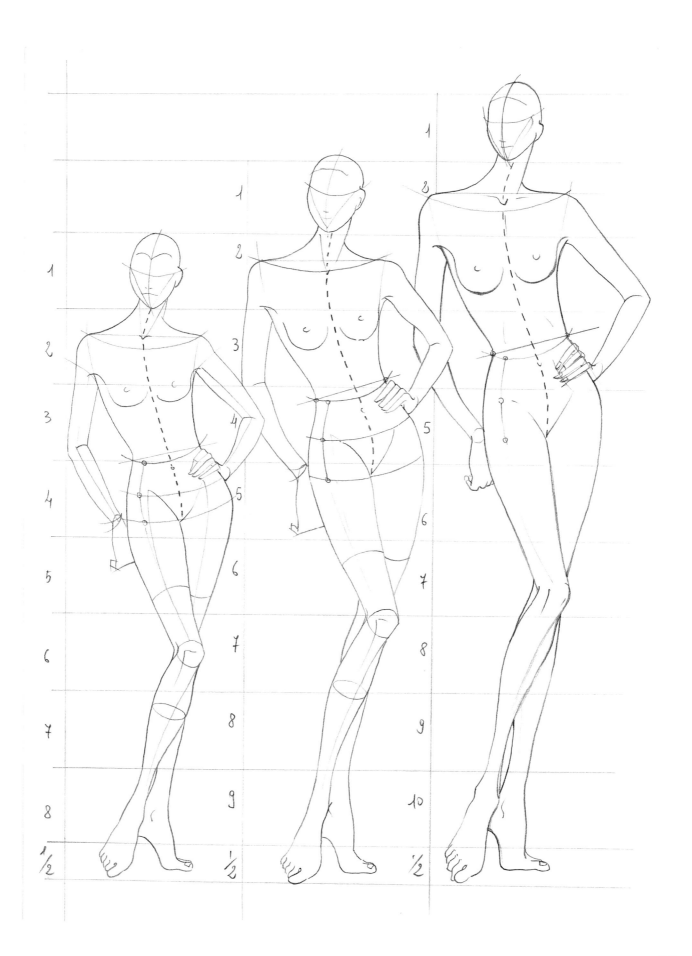

Second method

Here below, the pose has been
rendered even more abstract,
reducing the figure to a few essen-
tial lines which exaggerate the
structure.

The resulting drawing is very sim-
ilar to the outline but presents
more energy and vitality.

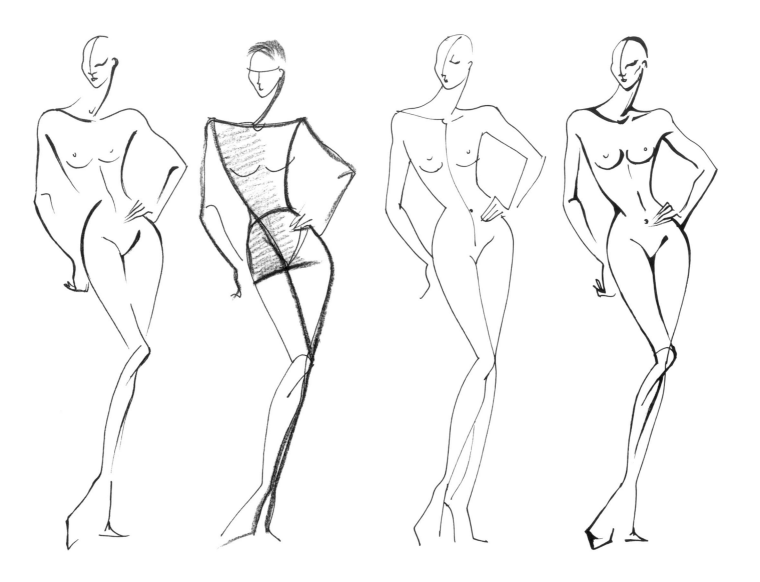

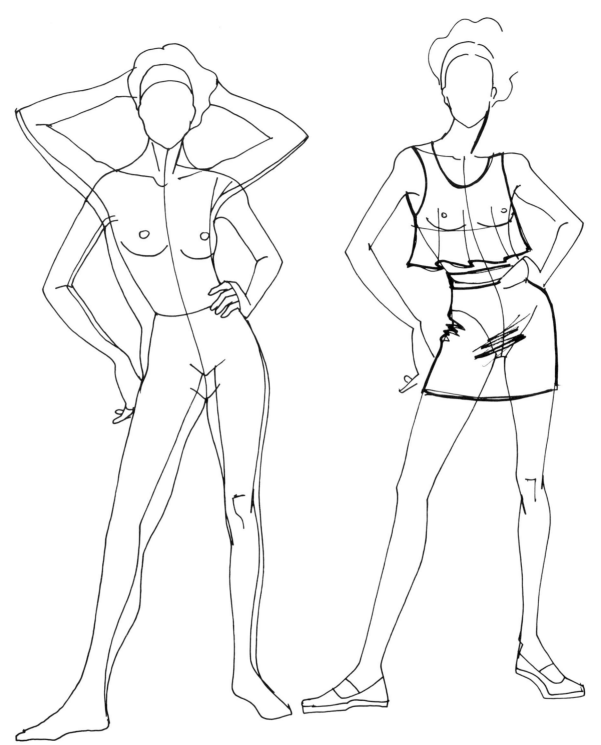

Third method

Another system for obtaining a convincing fashion plate is that of reducing a real figure without making it any taller, leaving almost unaltered its basic proportions.

The diagram clearly shows the variations that we have introduced. We have made the waist thinner as well as the flank, the pubic region has been raised, the legs and arms are equally long but have been made thinner, the neck is slimmer, while the head and the feet remain unchanged from their original size.

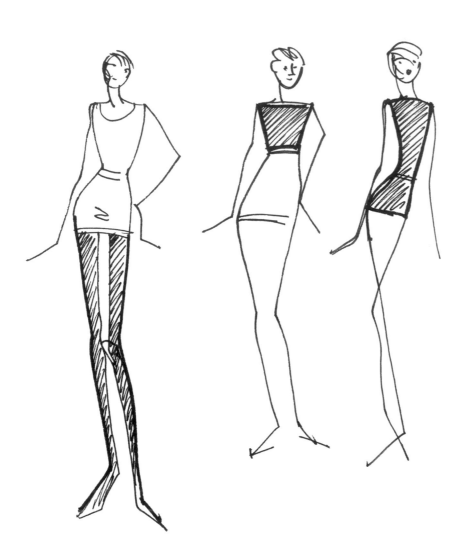

Now that we have established the correct basis for designing a fashion plate, let us analyse in detail the errors that can be made when it comes to personal interpretation.

It is opportune in this respect to keep a file of poses used by professional fashion designers; this will be extremely useful for copy practice and for examples of interpretation.

When the legs are too long in comparison with the rest of the body it is difficult to make out exactly the height of the head. An upper body that is short or narrow impedes the clarity of the line.

When the neck is too long and the head is too small in comparison with the rest of the body, a giraffe-like effect results.

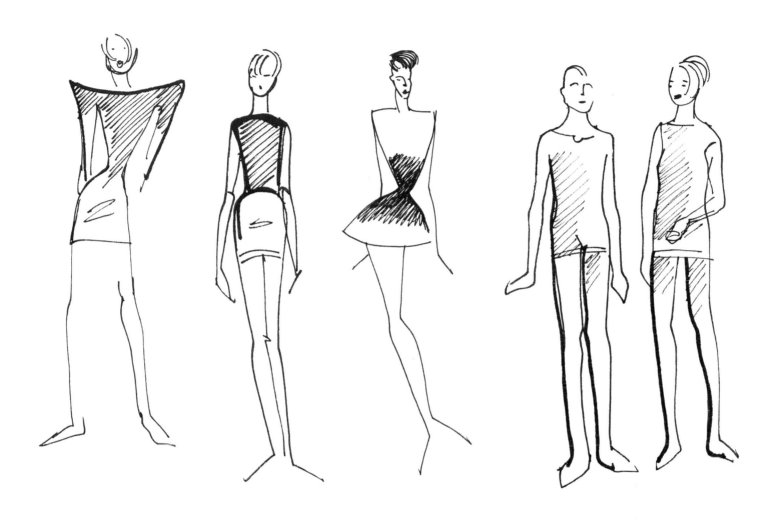

Large and clumsy feet burden a figure, but if you still want to draw them, confine them to the casual style only.

Shoulders that are too broad or too narrow interfere with wearability.

A waist that is too narrow impedes the clarity of the waistline.

Poses that are too static, relaxed or generic make the fashion plate wooden and dull.

Artistic techniques that are too illustrative are of no use in the planning stage, even if they are pleasing in the execution.

Remember that you are fashion designers and not illustrators, therefore your task is to conceive of the collection in considerable detail and as quickly as possible.

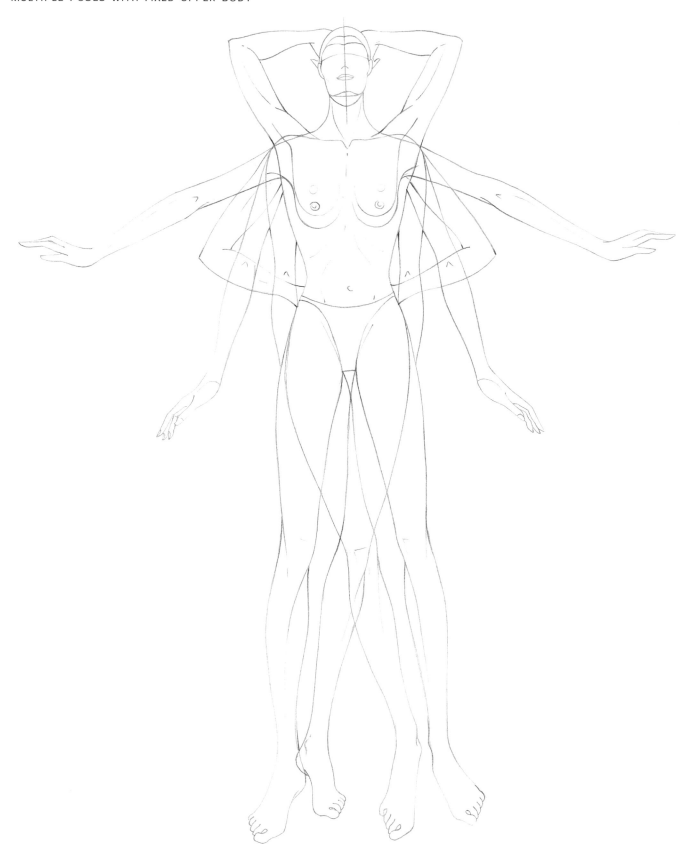

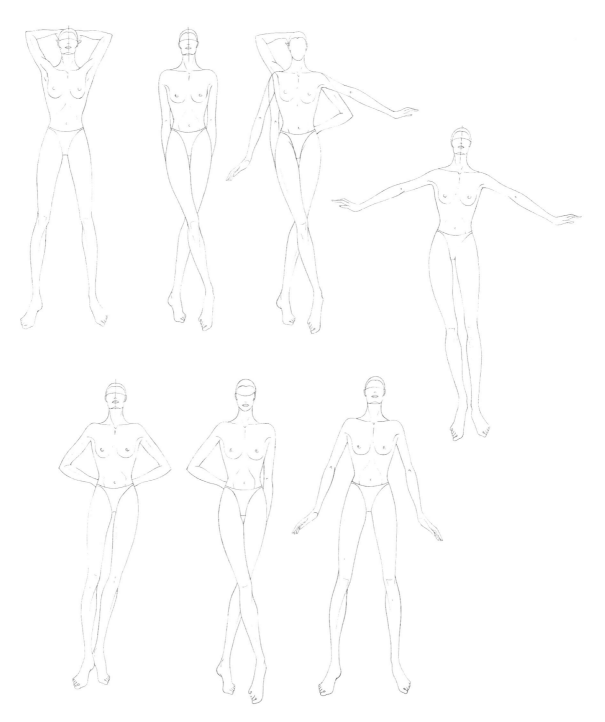

Often a fashion designer when he is setting out thinks that he has to commit to memory so many positions that he can use for his projects, and this creates in some people a real crisis of memory.
To simplify the initial work we suggest that you use only a few key poses and that you transform them as we show you in this chapter's illustrations.
Take a simple and striking fashion pose, such as the one in the diagram.

Keeping the upper body fixed, move only the arms and legs of the model. If you want to you can move the head: you will obtain from a single position various fashion plates portrayed in different positions.

Using this technique of multiple poses with a fixed upper body, you will obtain various fashion plates from a few basic original positions.

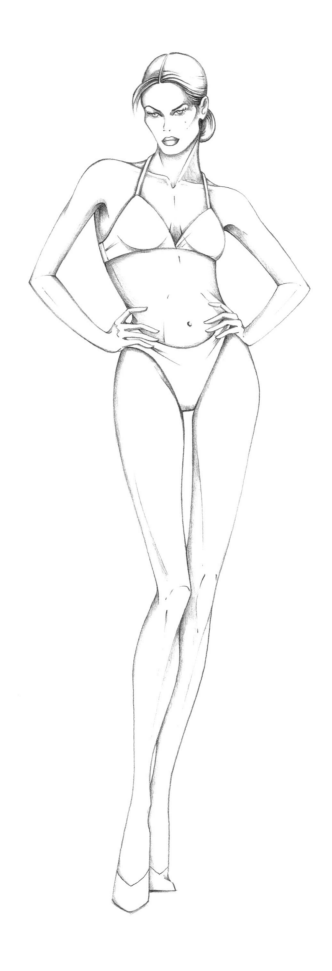

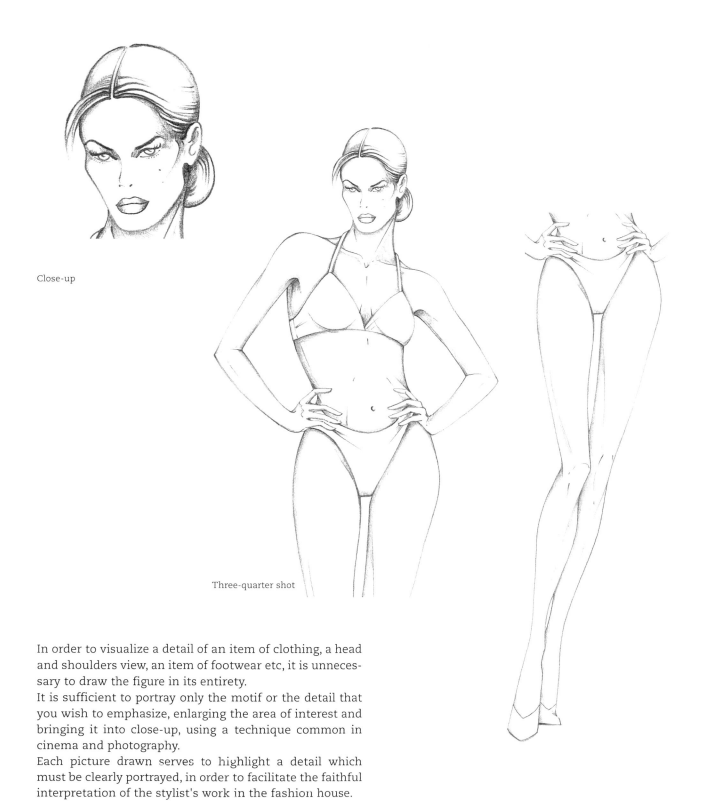

Close-up

Three-quarter shot

In order to visualize a detail of an item of clothing, a head and shoulders view, an item of footwear etc, it is unnecessary to draw the figure in its entirety.

It is sufficient to portray only the motif or the detail that you wish to emphasize, enlarging the area of interest and bringing it into close-up, using a technique common in cinema and photography.

Each picture drawn serves to highlight a detail which must be clearly portrayed, in order to facilitate the faithful interpretation of the stylist's work in the fashion house.

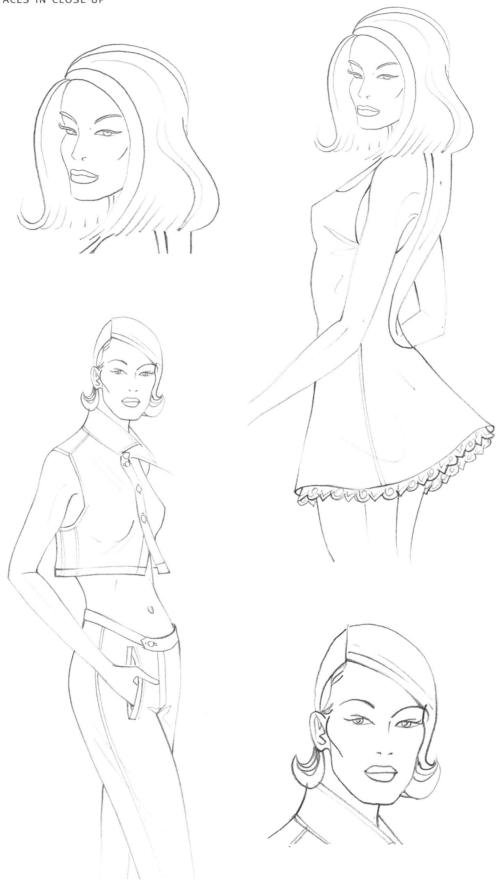

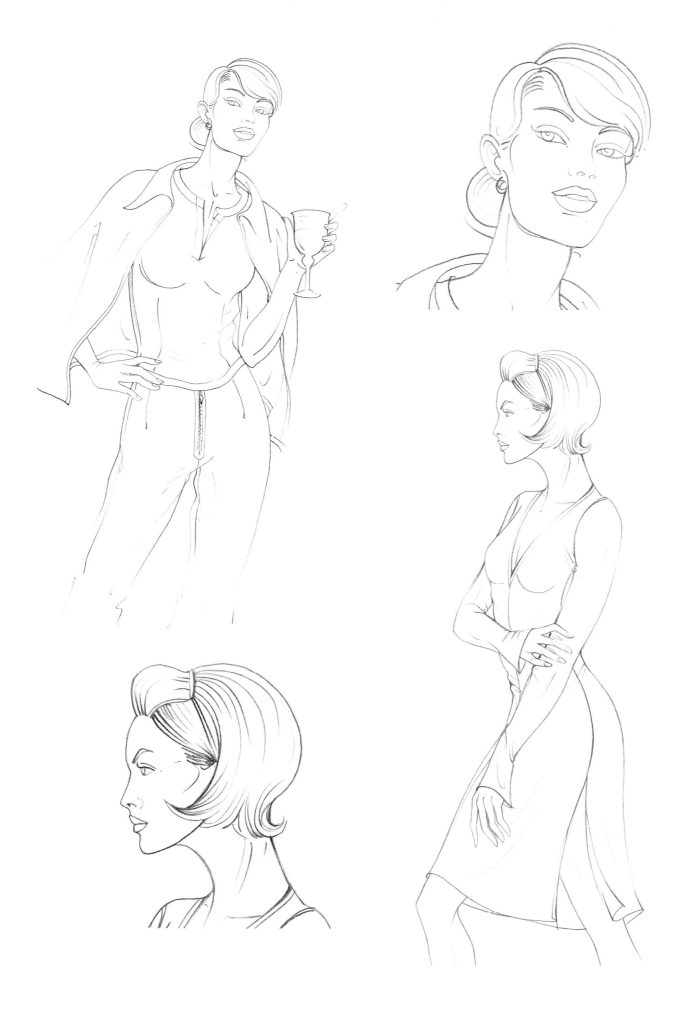

VARIOUS FASHION POSES

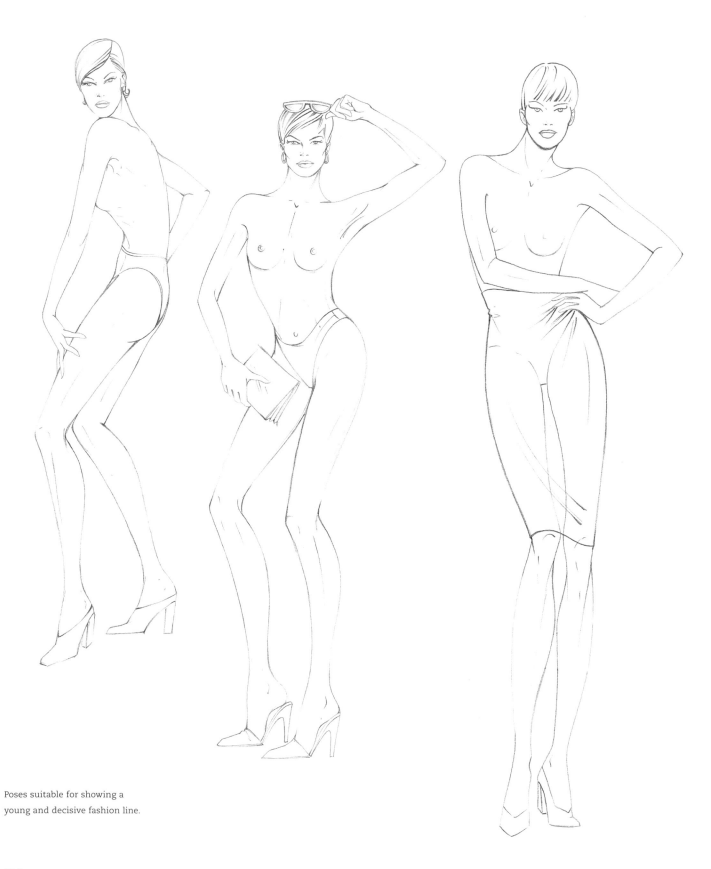

Poses suitable for showing a
young and decisive fashion line.

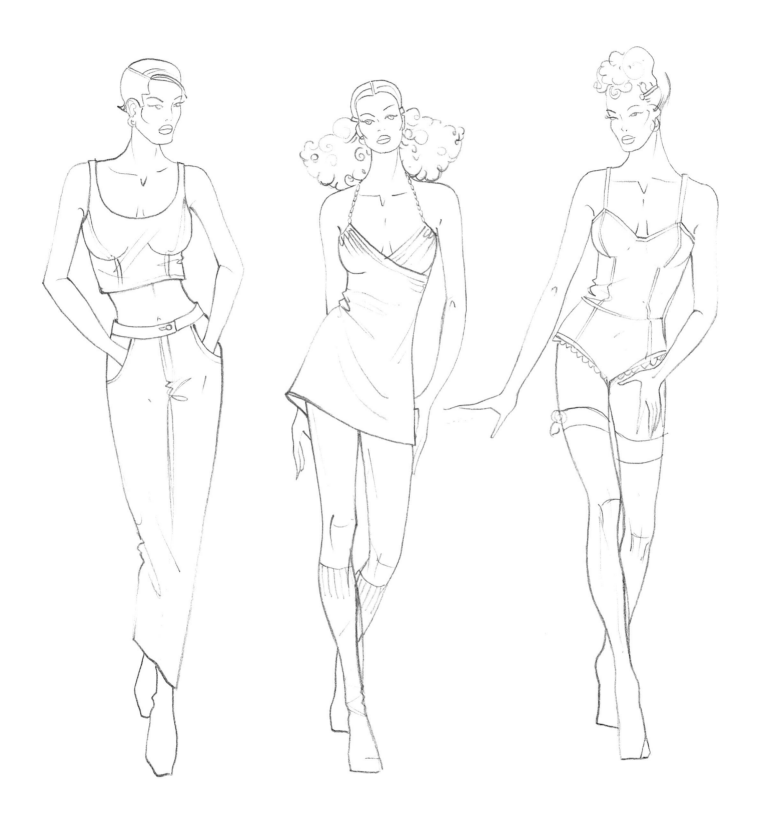

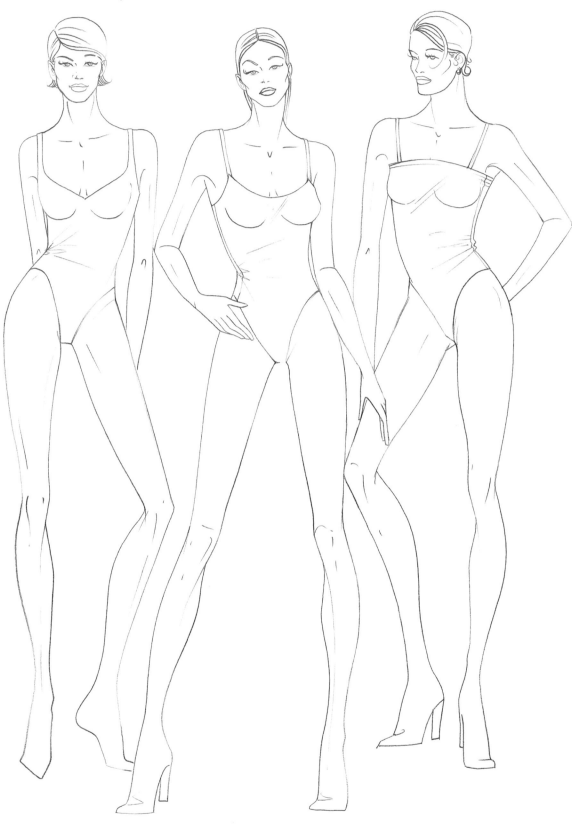

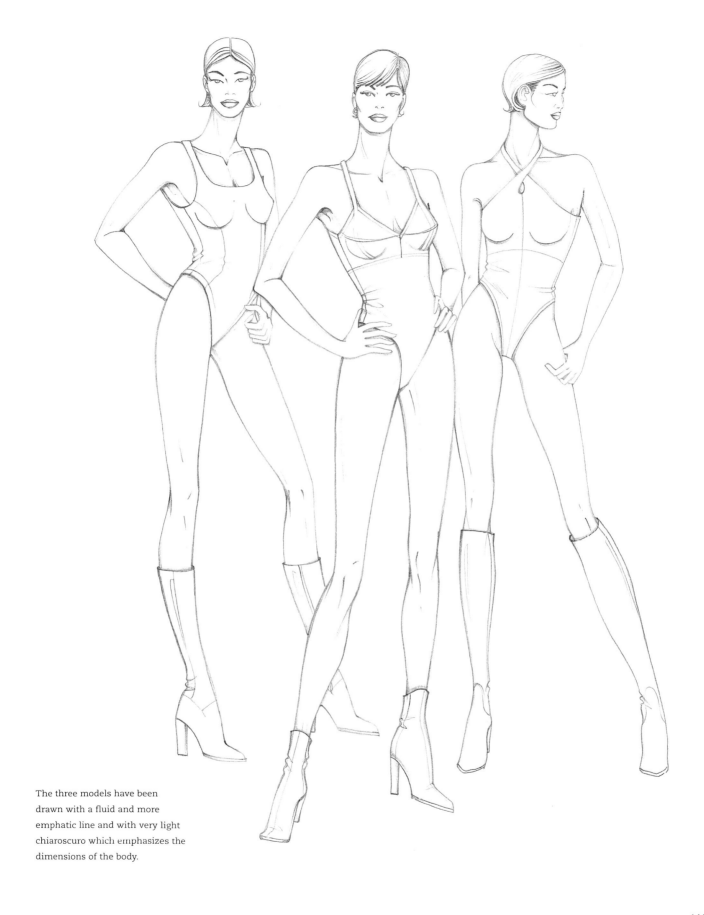

The three models have been
drawn with a fluid and more
emphatic line and with very light
chiaroscuro which emphasizes the
dimensions of the body.

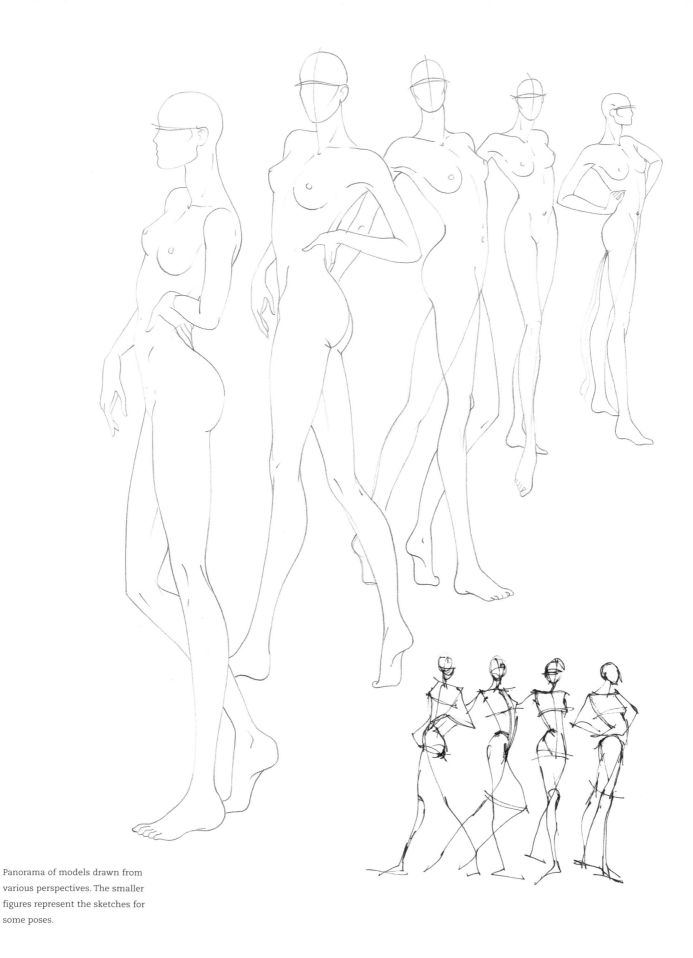

Panorama of models drawn from various perspectives. The smaller figures represent the sketches for some poses.

120

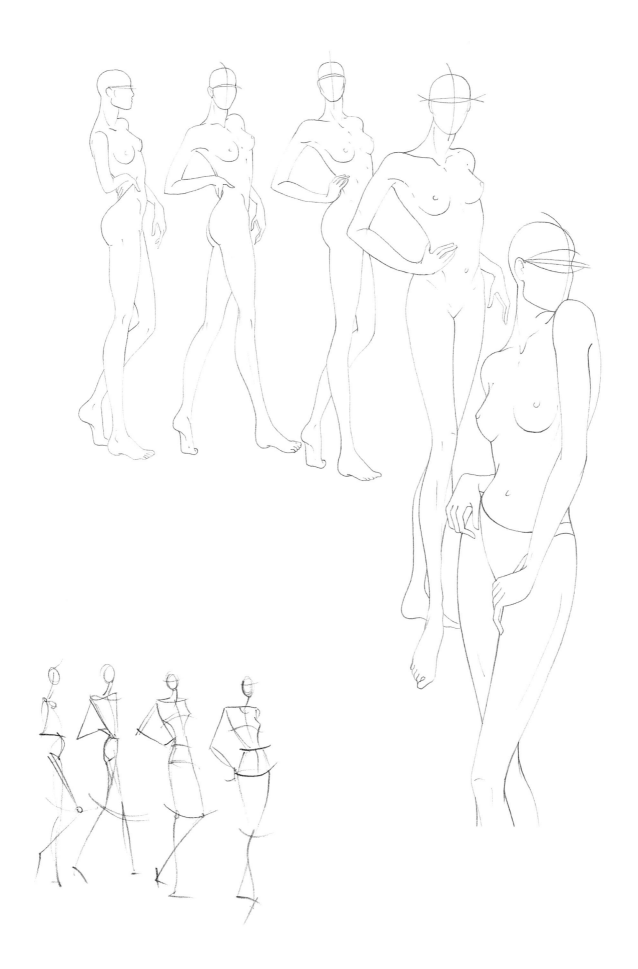

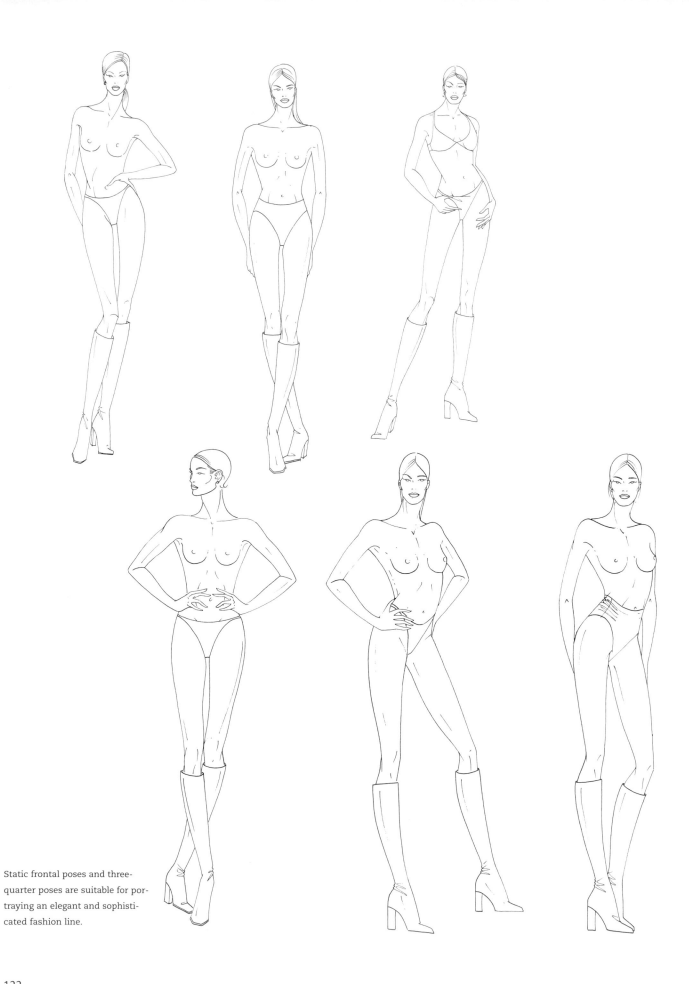

Static frontal poses and three-quarter poses are suitable for portraying an elegant and sophisticated fashion line.

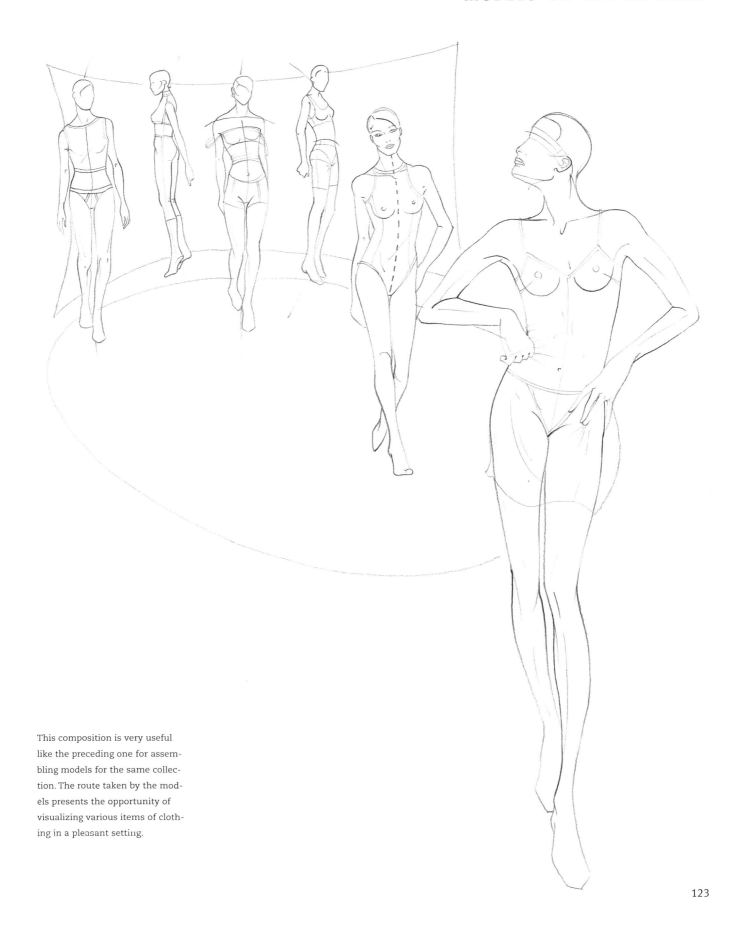

This composition is very useful like the preceding one for assembling models for the same collection. The route taken by the models presents the opportunity of visualizing various items of clothing in a pleasant setting.

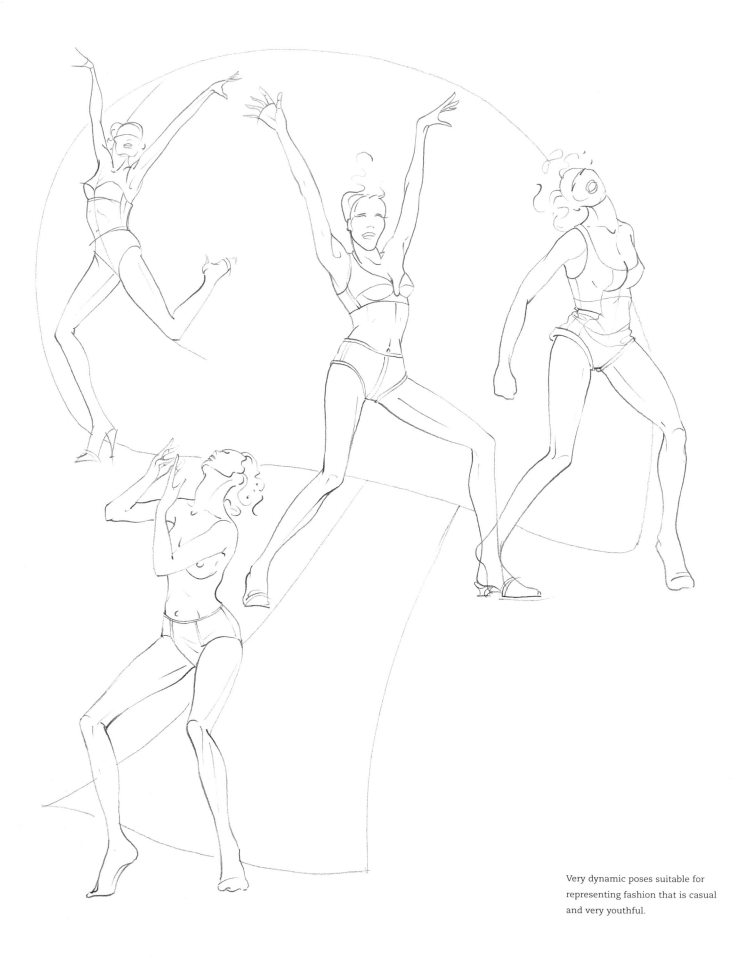

Very dynamic poses suitable for
representing fashion that is casual
and very youthful.

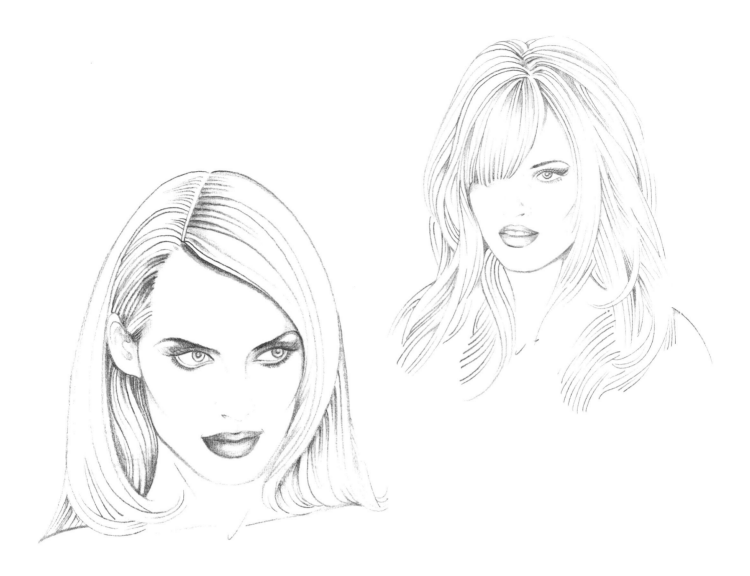

The hairstyles portrayed here in various styles and lengths are a suitable way of personalizing various trends in fashion.

For classical lines you should use hairstyles which are unostentatious and sophisticated. For casual and elegant lines hairstyles which are more natural and fashionable would be more suitable, whereas for a very youthful item of clothing, styles which are more informal and amusing are to be preferred. When putting the finishing touches to a fashion plate it is important to choose an appropriate *coiffure* which underlines the style, because the type of woman for whom the item of clothing or the entire col-

lection are destined will be all the more clear.

Accustom yourself to observing the appearance of the models as they are working, studying the smallest details in relation to the item of clothing that they are wearing, developing the curiosity to discover every message which is hidden from the superficial observer.

Sometimes a hairstyle which is very distinctive and which goes with extravagant accessories is enough to engender fascination, even with a very simple item of clothing.

Designers sometimes love to make their more classical creations seem extreme with hairstyles and bizarre headgear, in order to create an original and spectacular image.

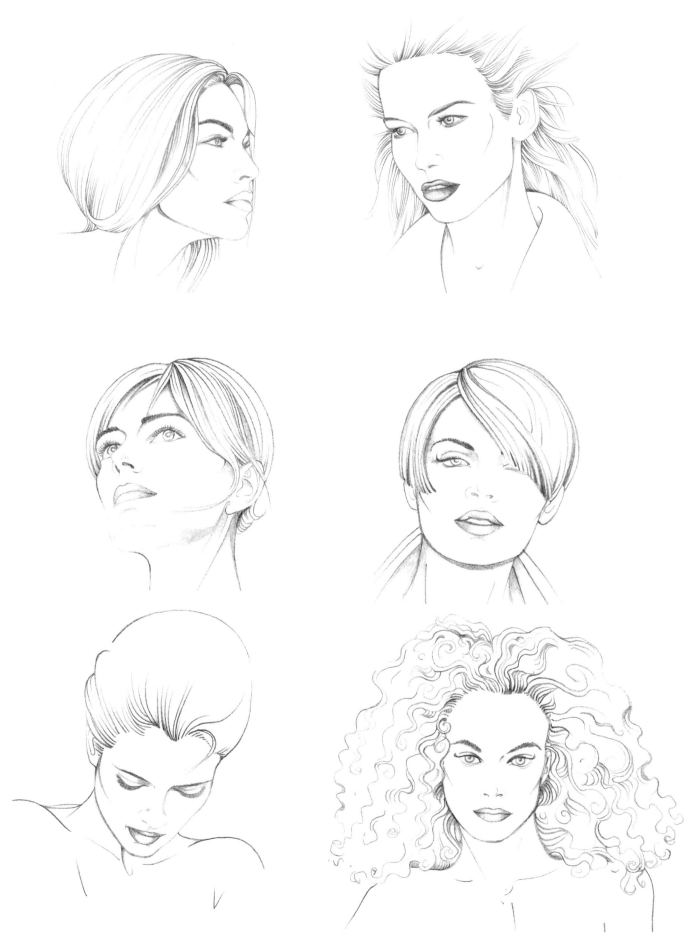

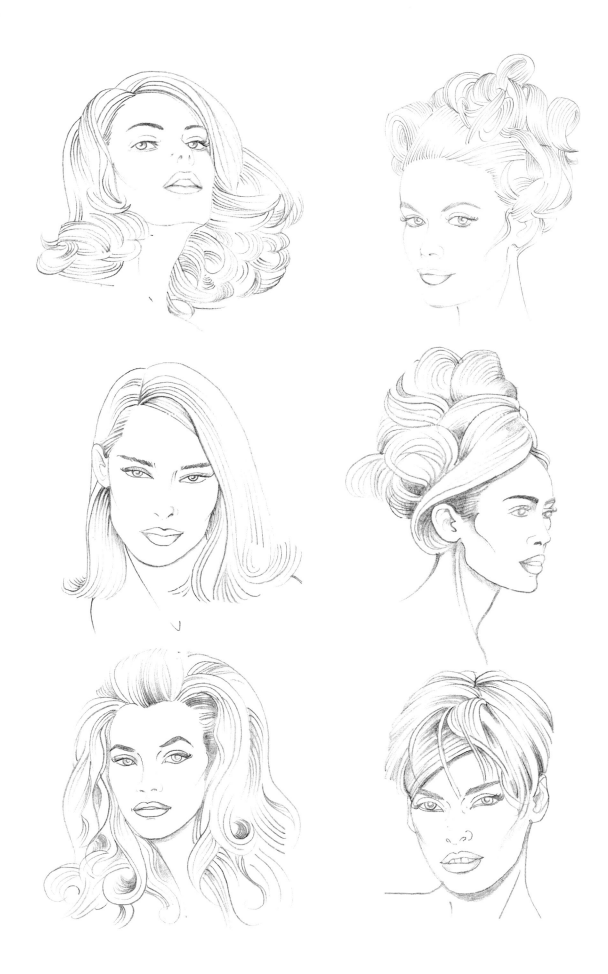

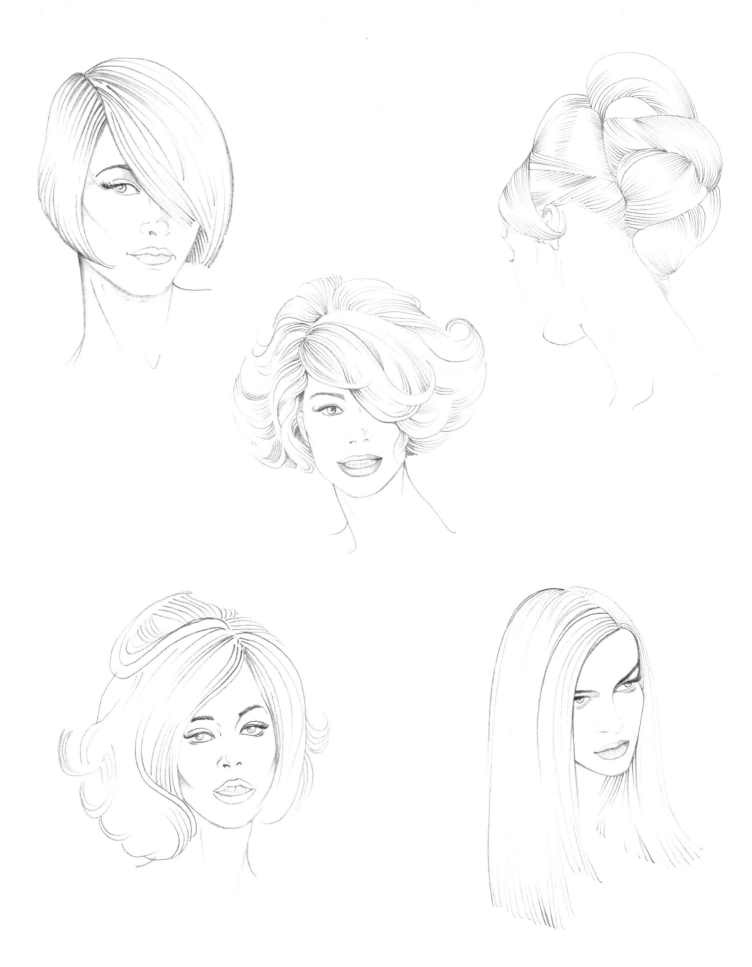

128

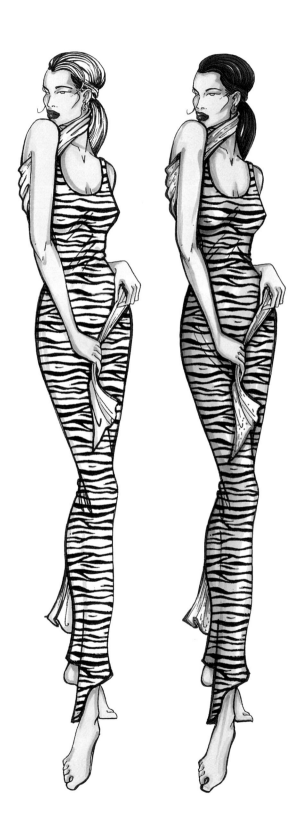

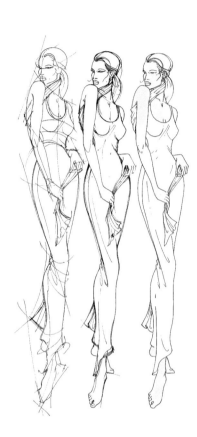

The illustrations on pages 129-61 show sequences which build up to the finished image.

All of the illustrated fashion plates were created with special felt tip pens, using clear and precise strokes (poses on page 121). The technique of felt pens was chosen as it is the one most used by fashion designers for its fresh and impromptu nature.

If you want your design to be neat, it is necessary to trace the primary sketch on a white sheet of paper and to colour it in afterwards.

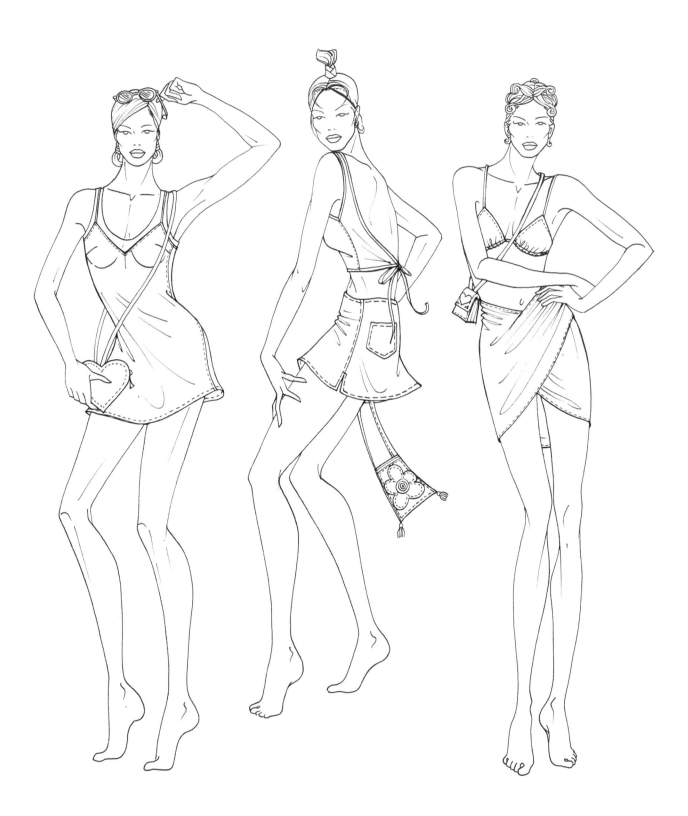

The figures used are to be found on page 116. Dynamic and distinctive poses for this youthful and vital type of fashion.

Take note of the distinctive hairstyles, the fashion accessories and the attention to detail.

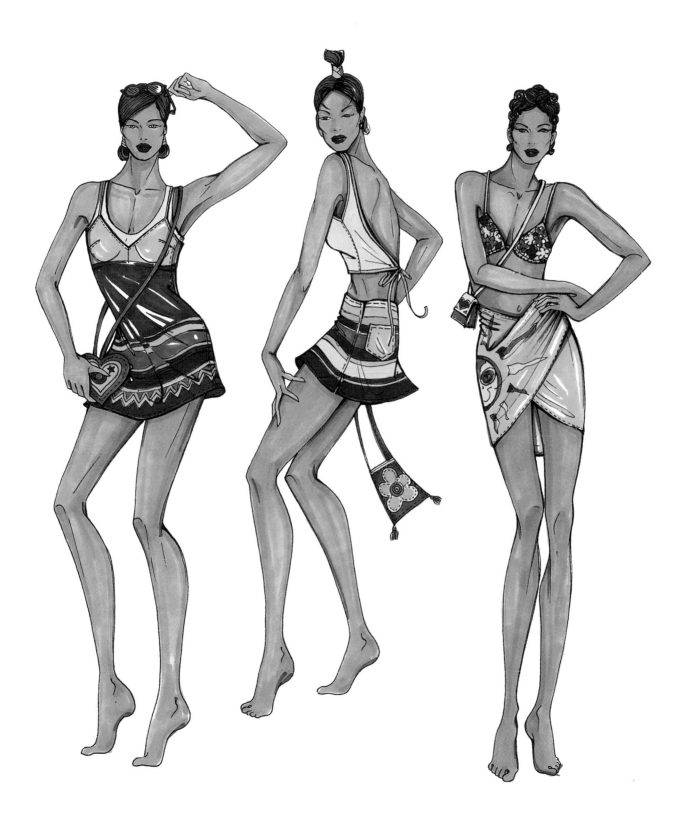

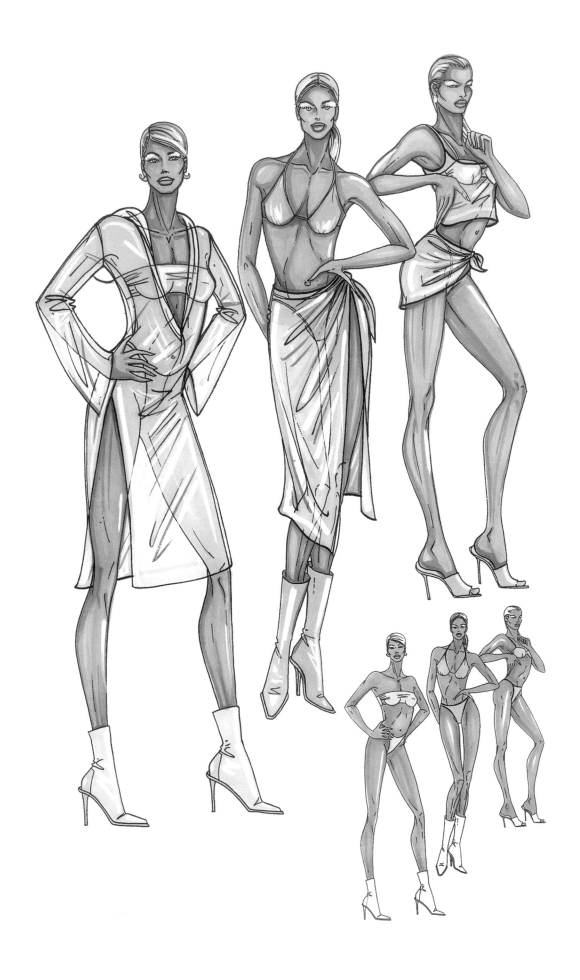

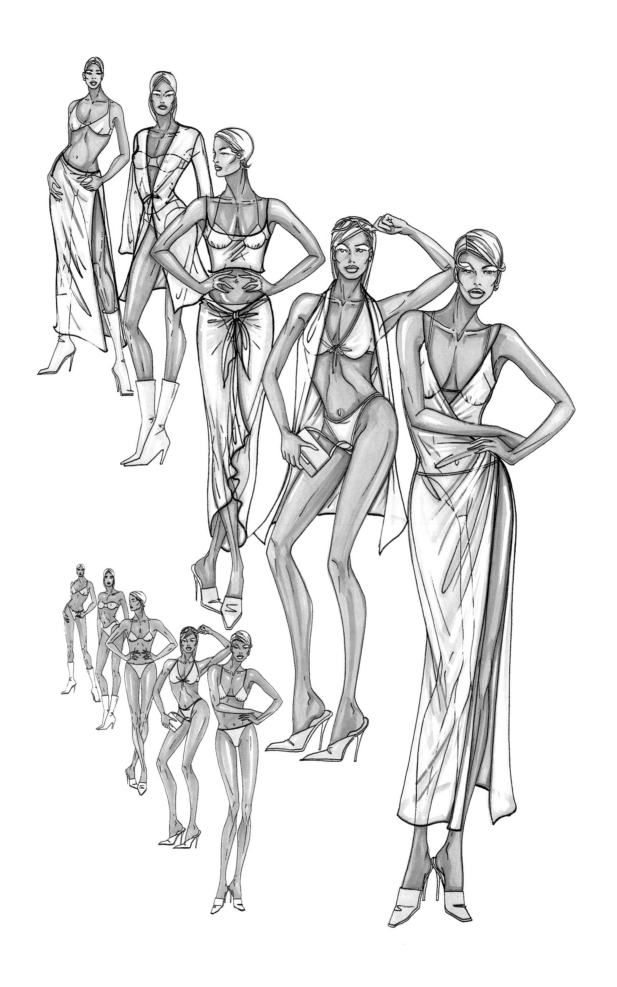

Picture sequences (For poses used, see page 122).
Elegant poses as are required for evening dresses which make use of drapes.

Few lines of movement and economical uses of colour give the figures freshness and spontaneity. The hairstyles and the accessories emphasize the sensual and oriental style of this mini-collection of evening dresses.

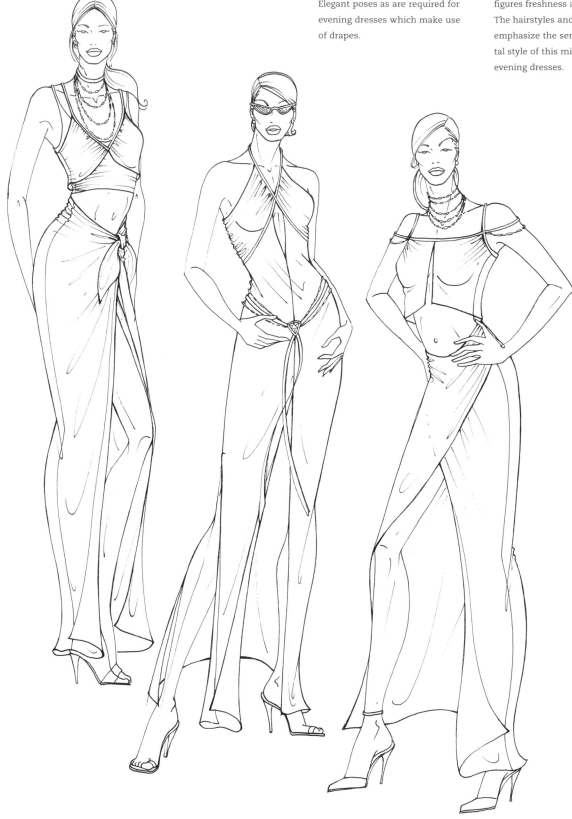

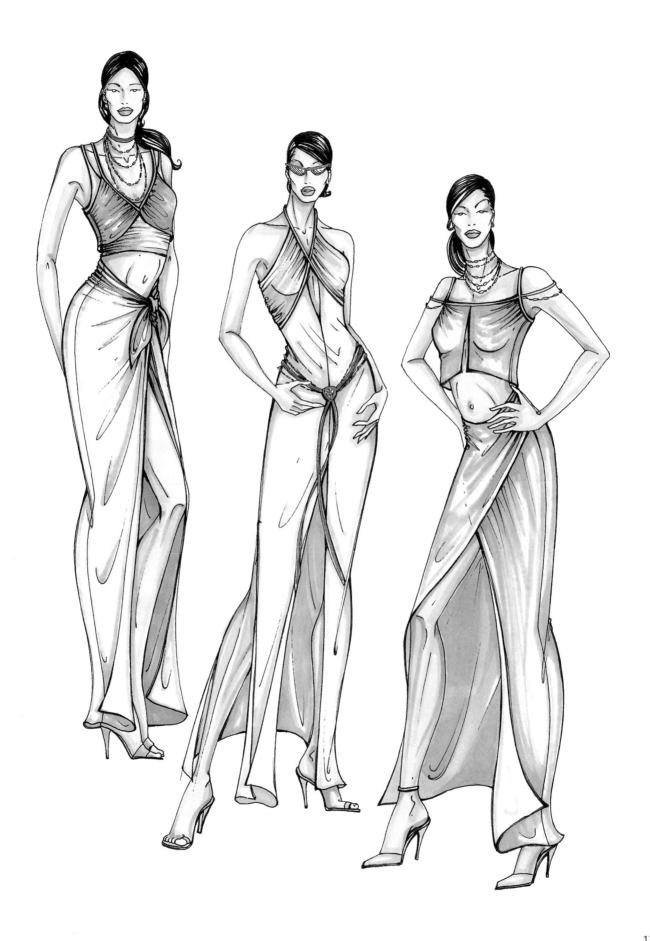

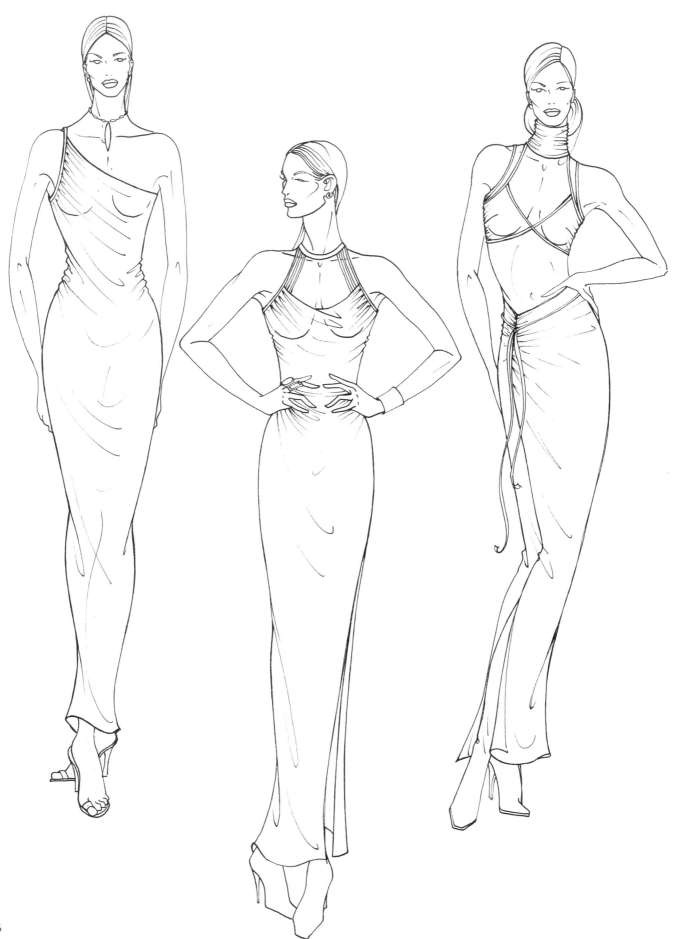

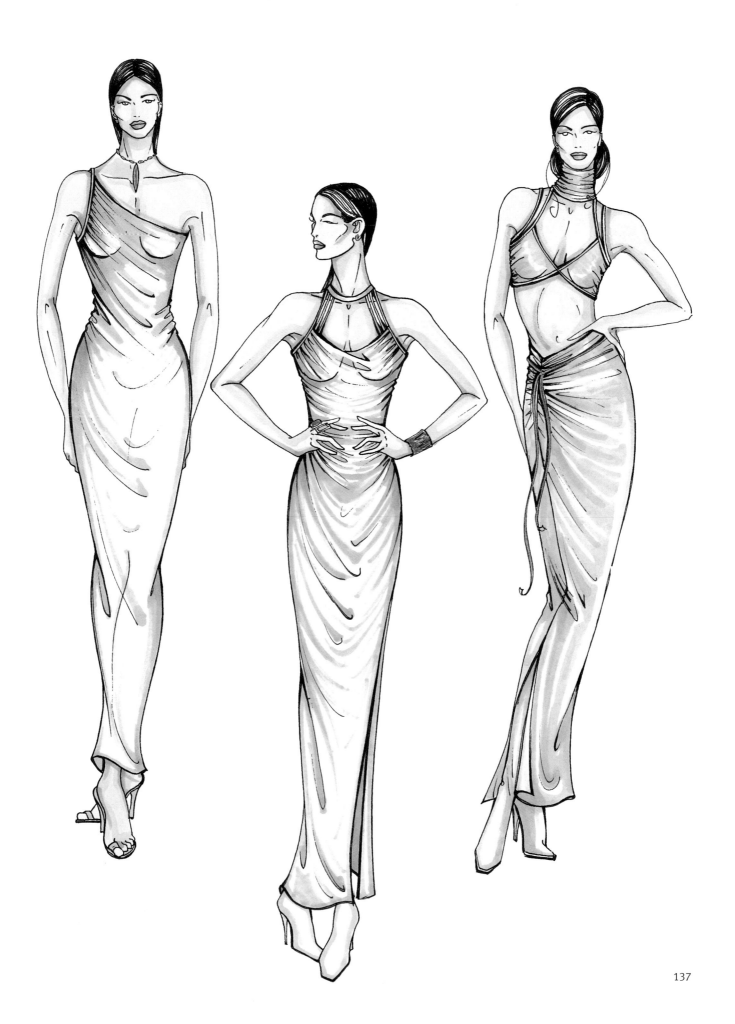

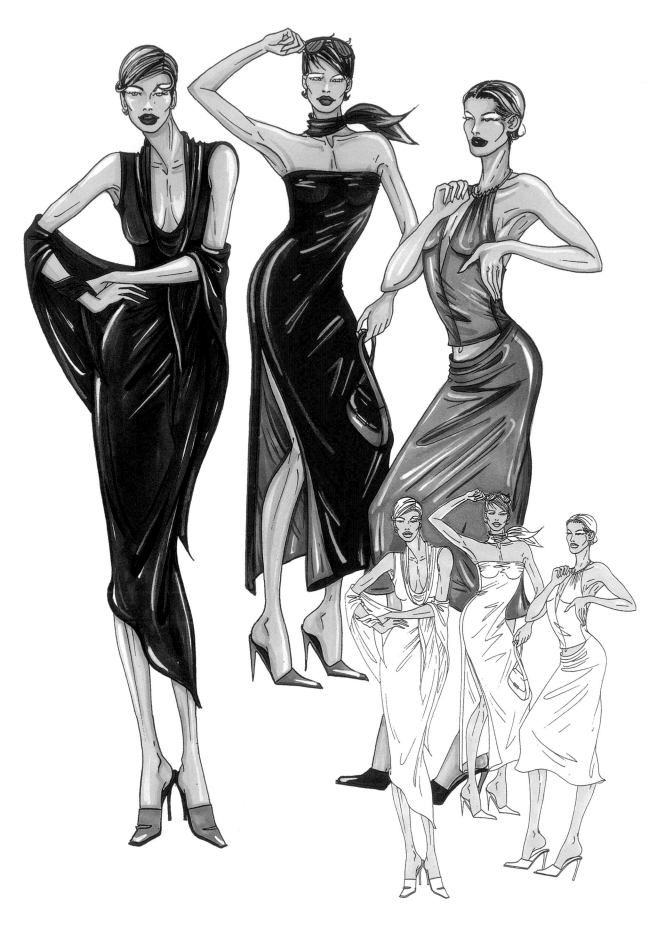

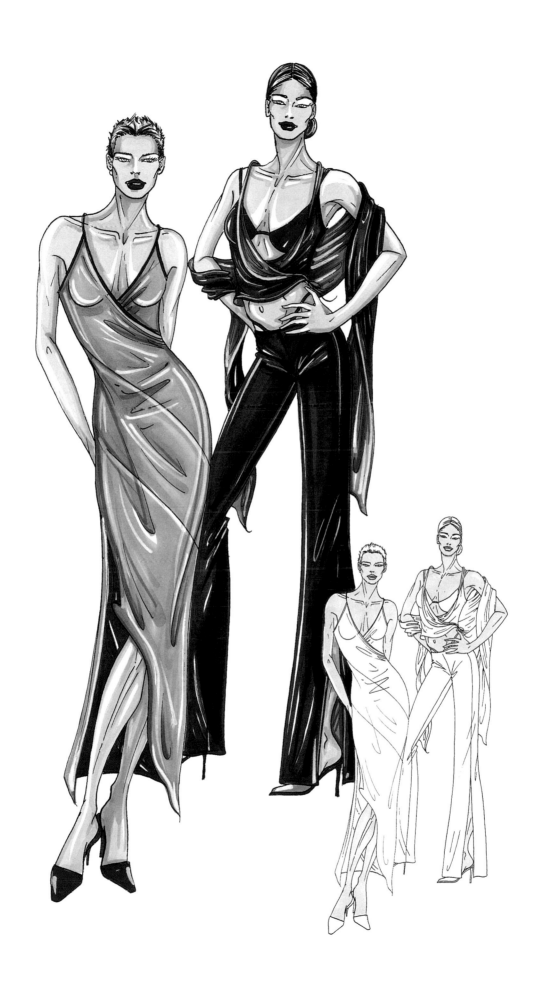

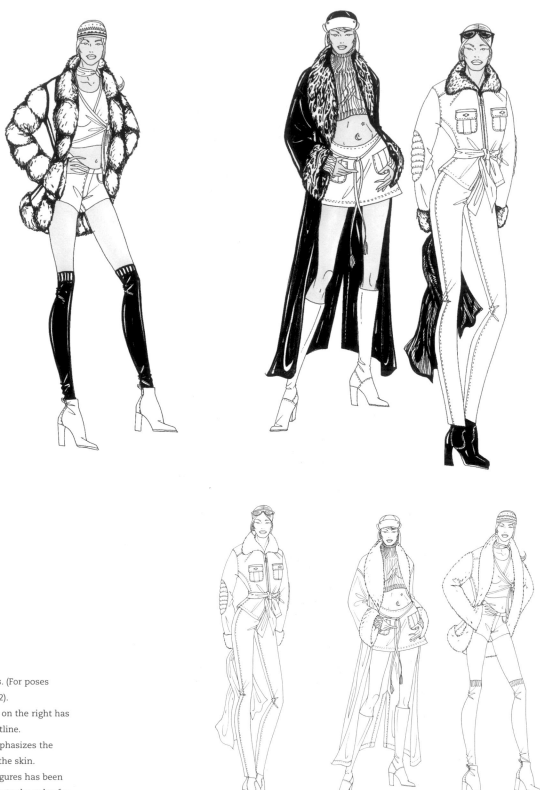

Picture sequences. (For poses
used, see page 122).
The set of figures on the right has
been drawn in outline.
The set above emphasizes the
darker parts and the skin.
The third set of figures has been
finished according to the rules for
representing the fashion plate.

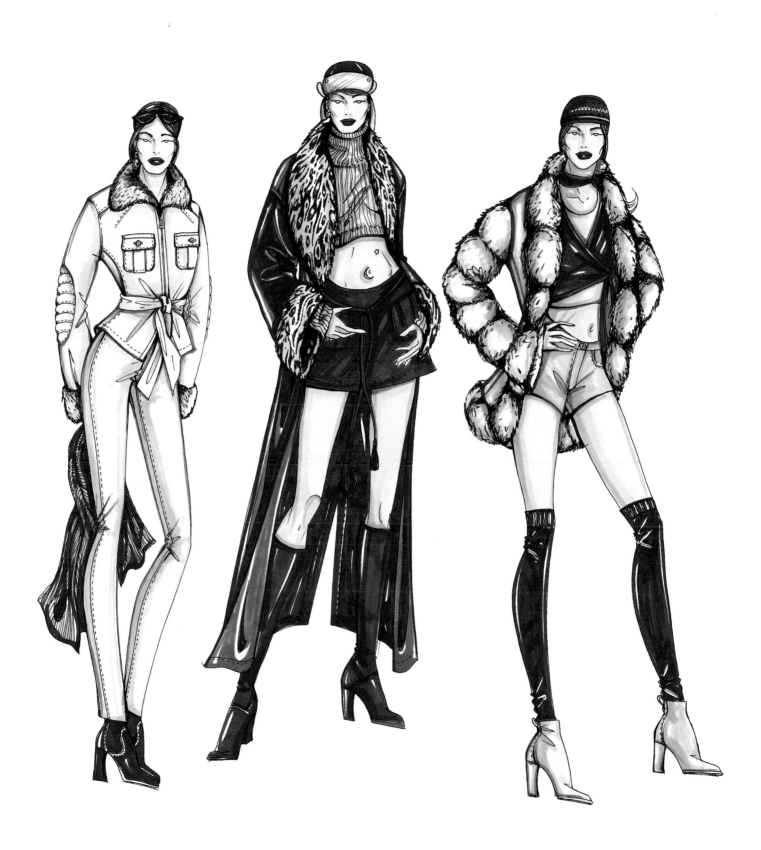

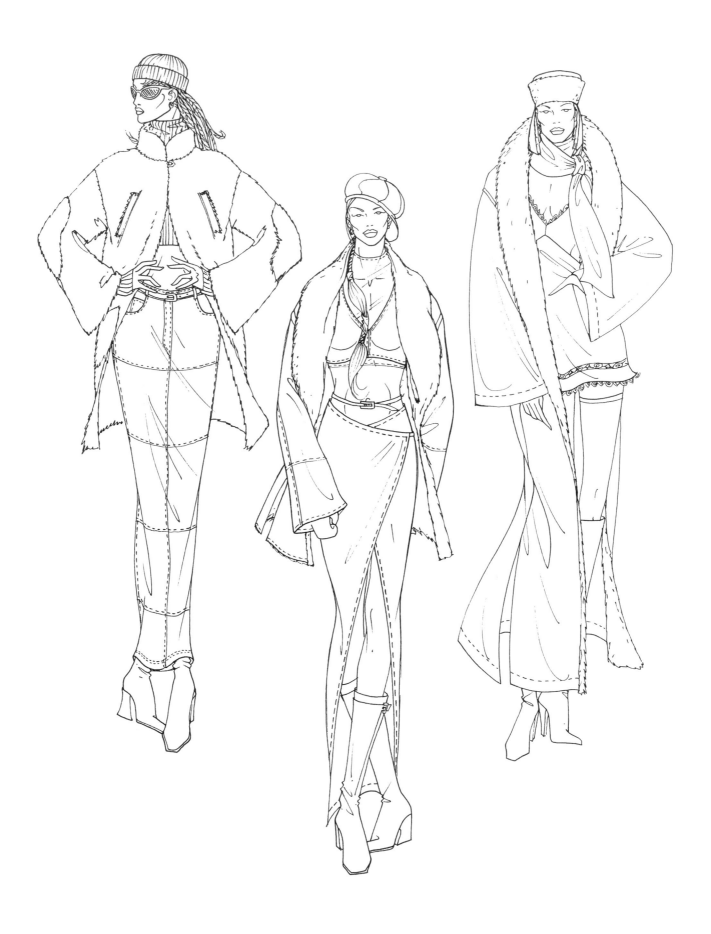

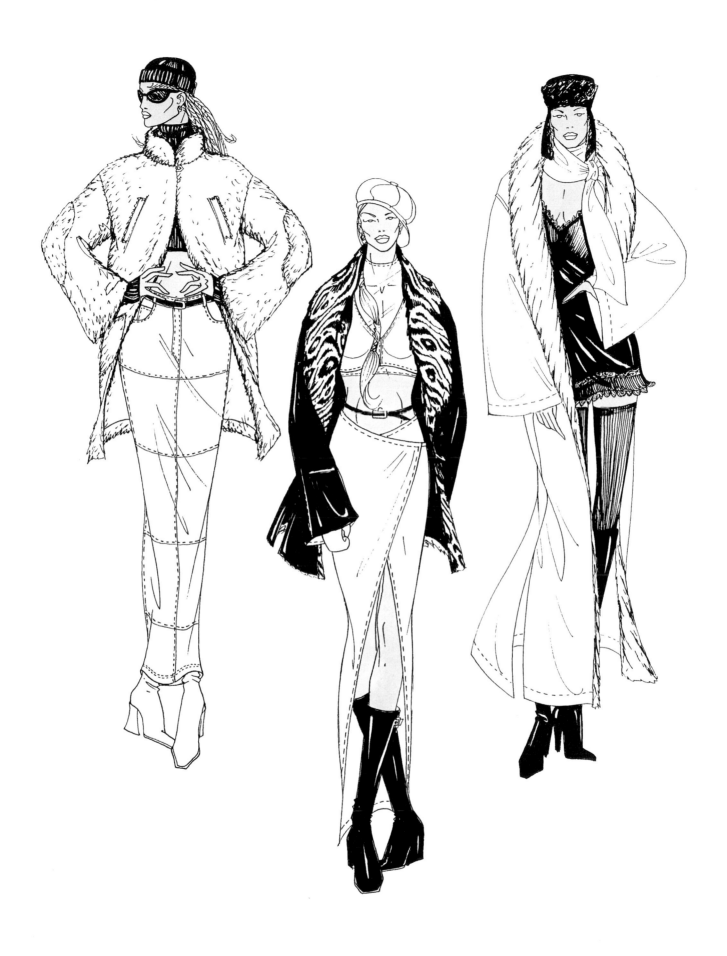

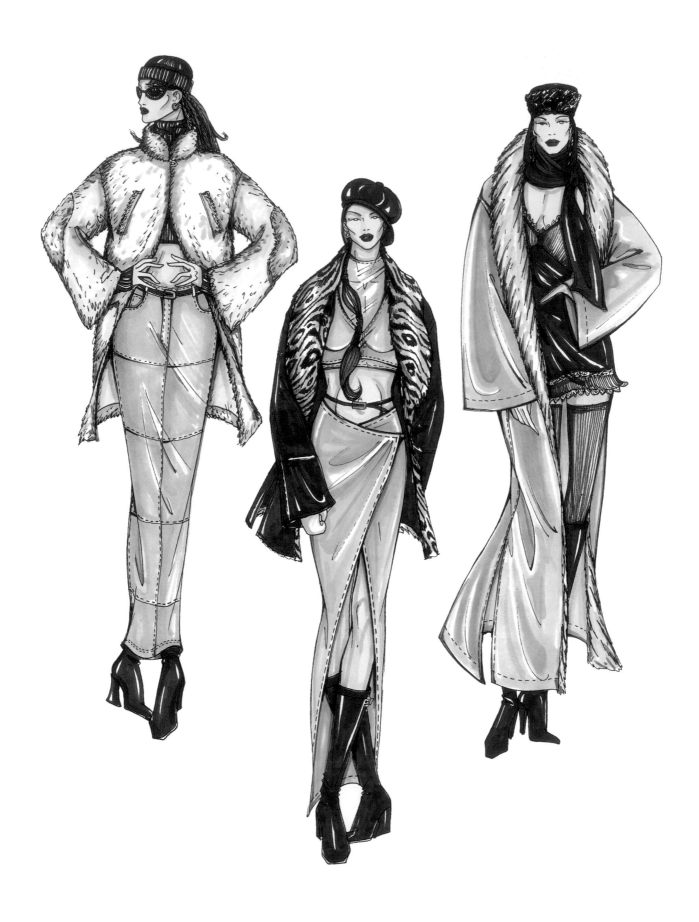

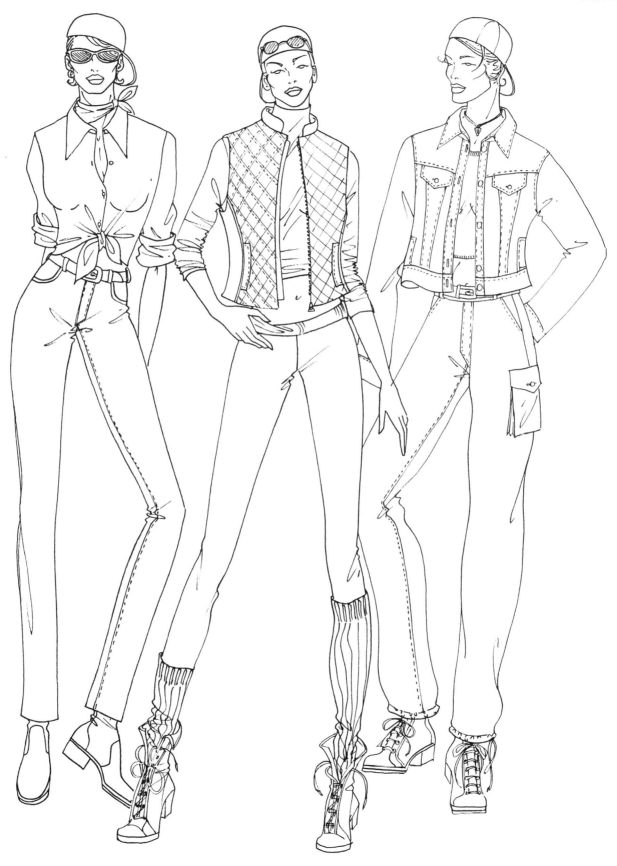

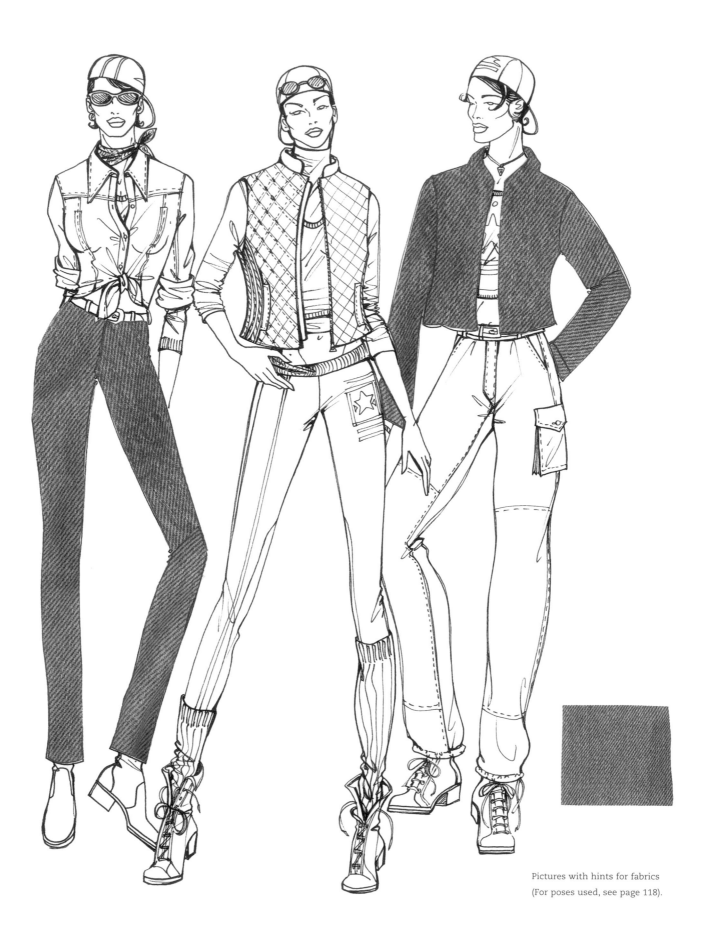

Pictures with hints for fabrics
(For poses used, see page 118).

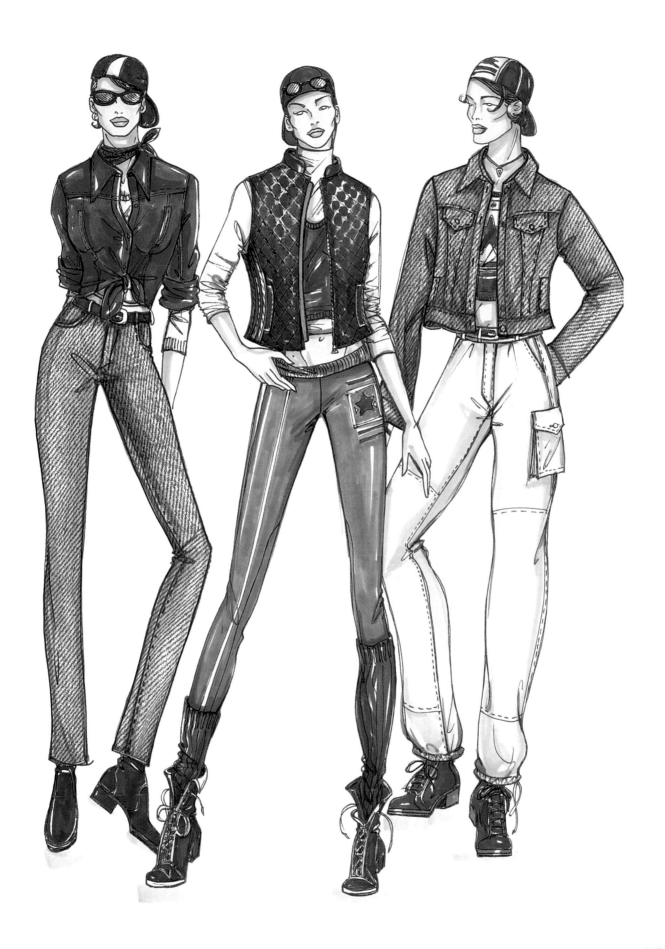

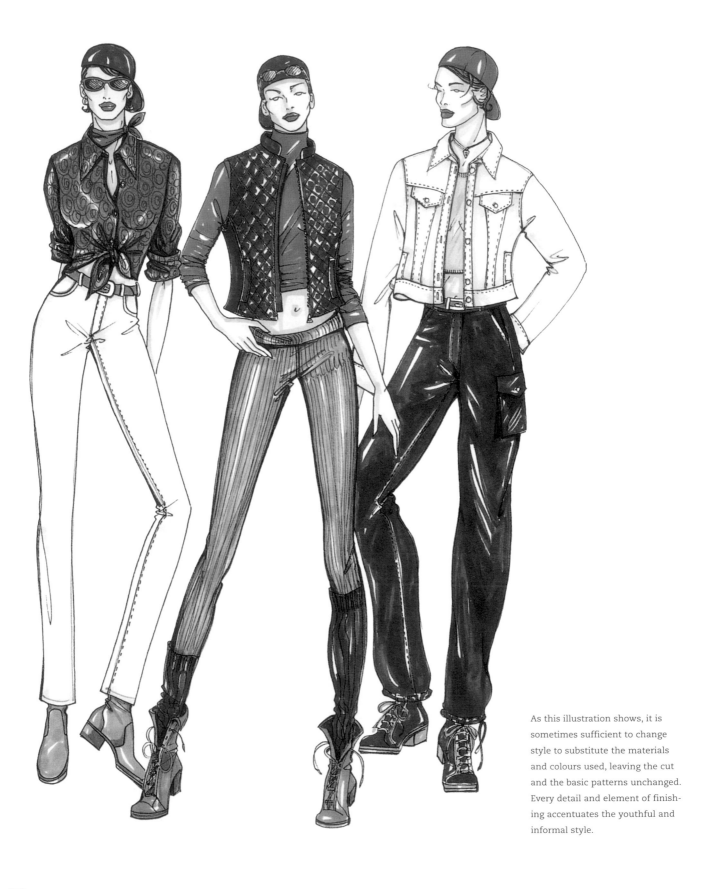

As this illustration shows, it is sometimes sufficient to change style to substitute the materials and colours used, leaving the cut and the basic patterns unchanged. Every detail and element of finishing accentuates the youthful and informal style.

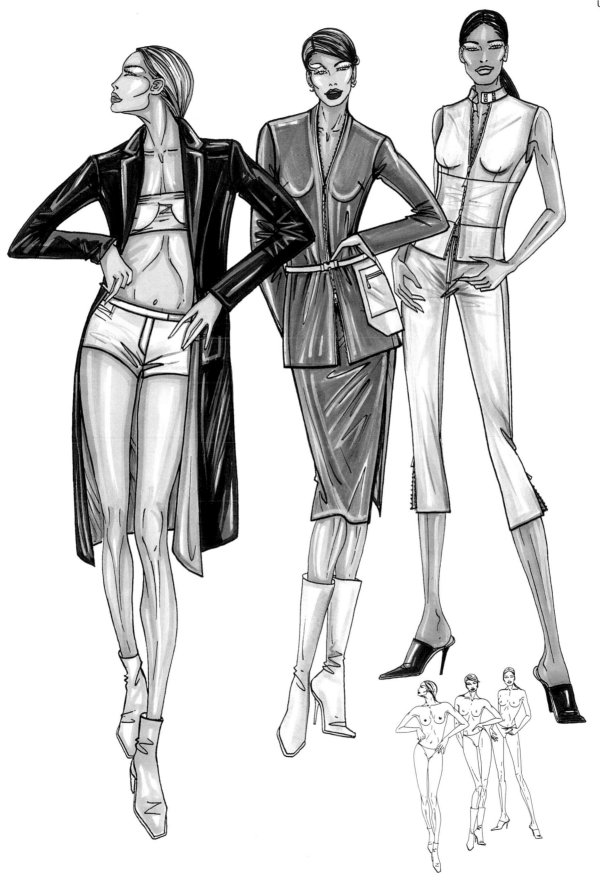

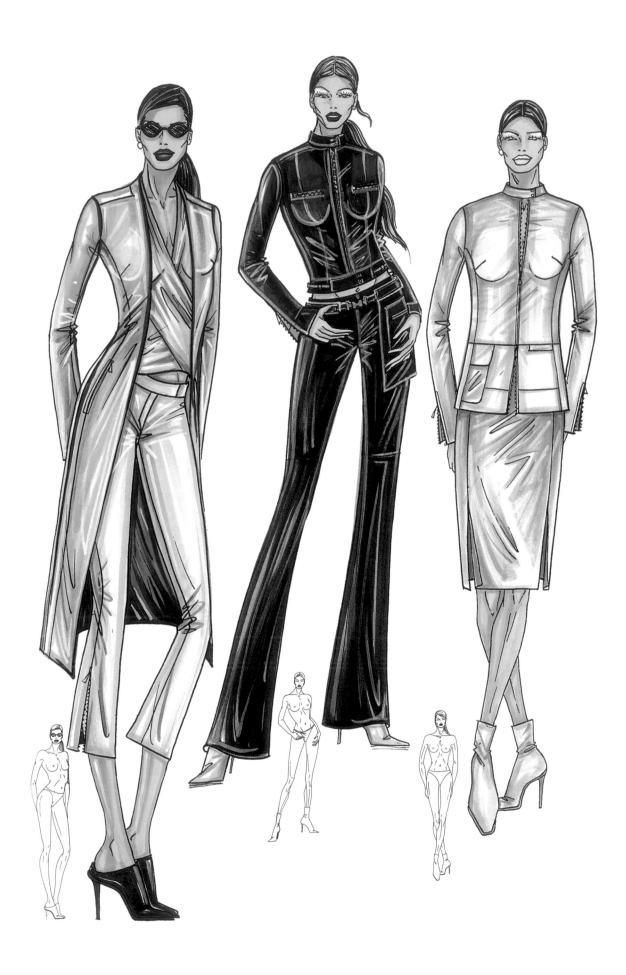

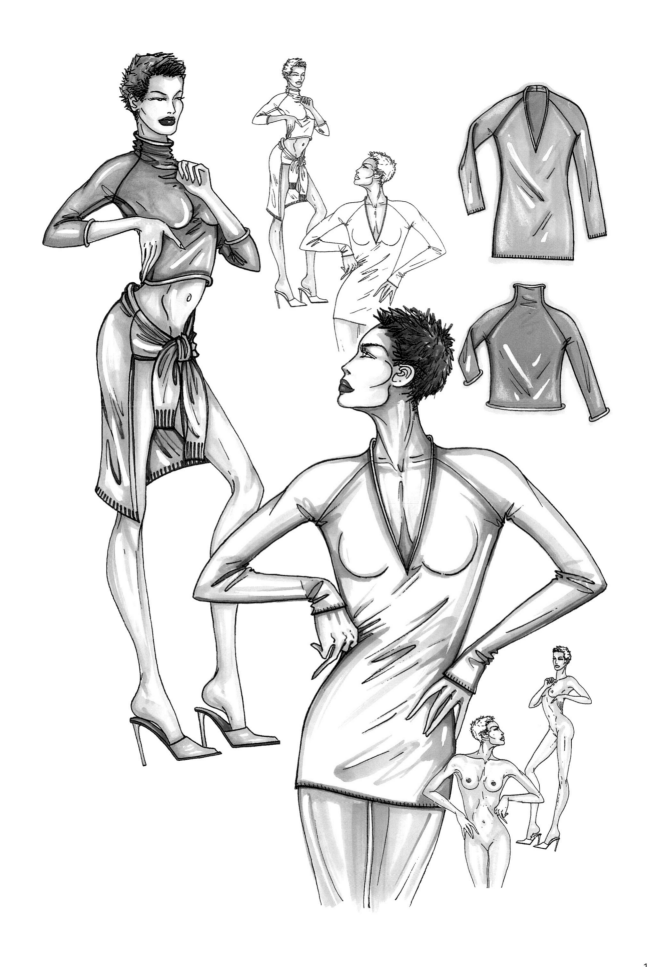

151

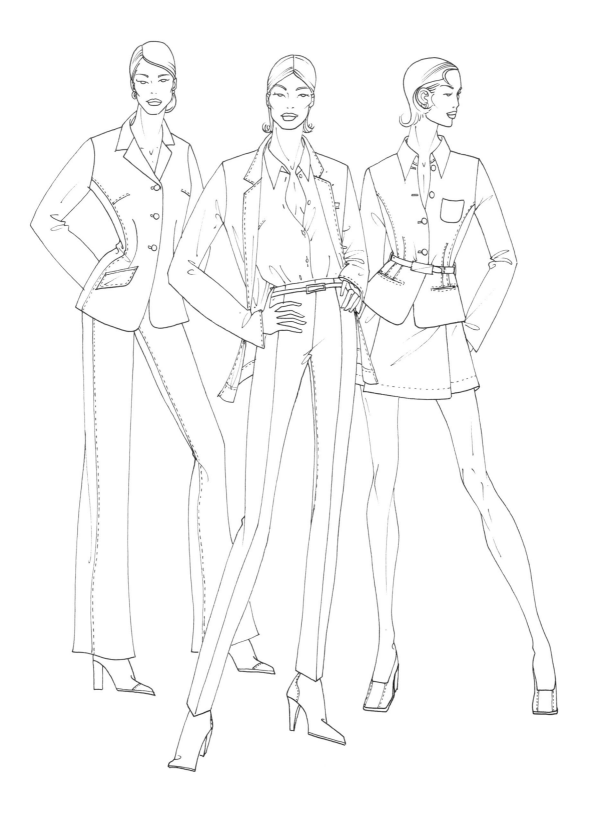

(For poses, see page 119).
The fashion plates drawn in out-
line can be used as the basis for
practising variations in colour and
particular fabrics.
Take note also in this case of the
attention to details.
For every suggested pattern it is
advisable to carry out the relative
drawings from the dress stand
and some production schedules.

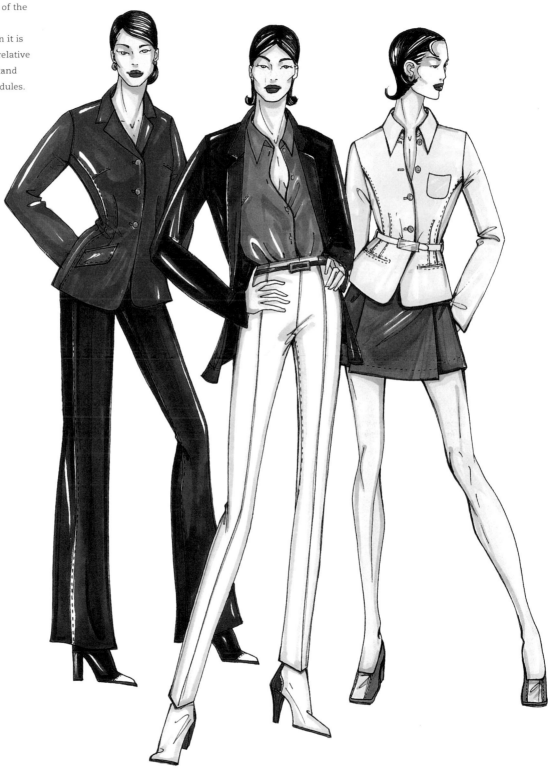

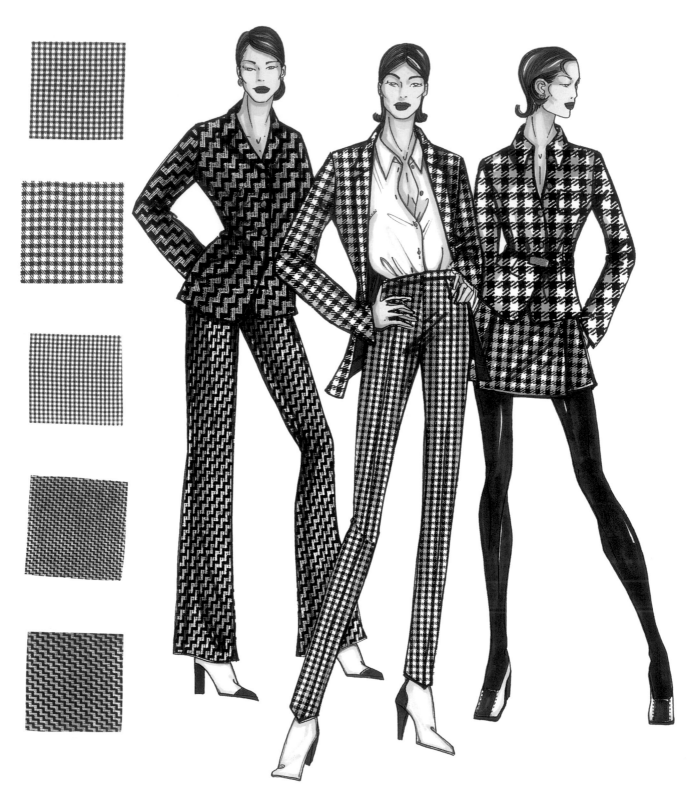

The same fashion plates have been used with different fabrics. To achieve these effects it is advisable to use special halftone screens, which are sold in specialist artists' materials shops. With the use of the computer it is possible to carry out innumerable variations in colours and fabrics. But in the absence of a computer it is advisable to use, besides felt pens, the technique of collage, through which it is possible to obtain surprising artistic effects.

154

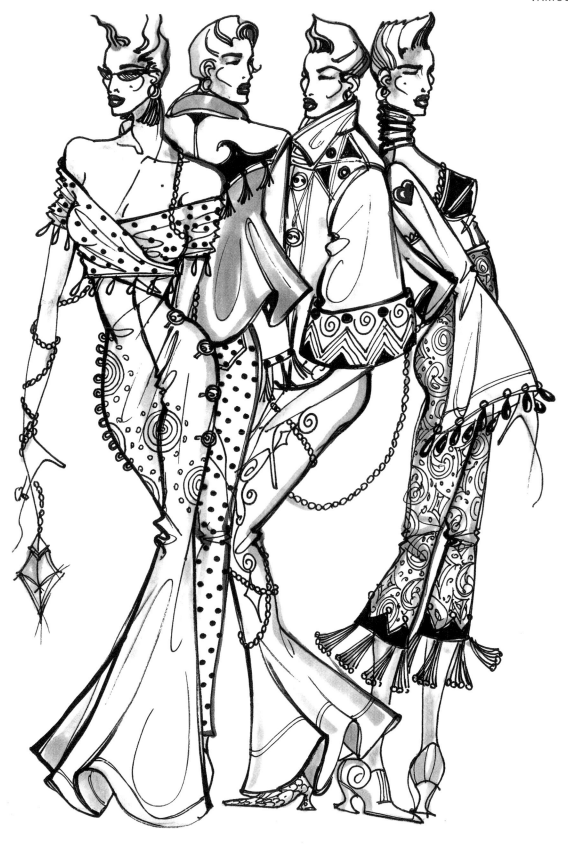

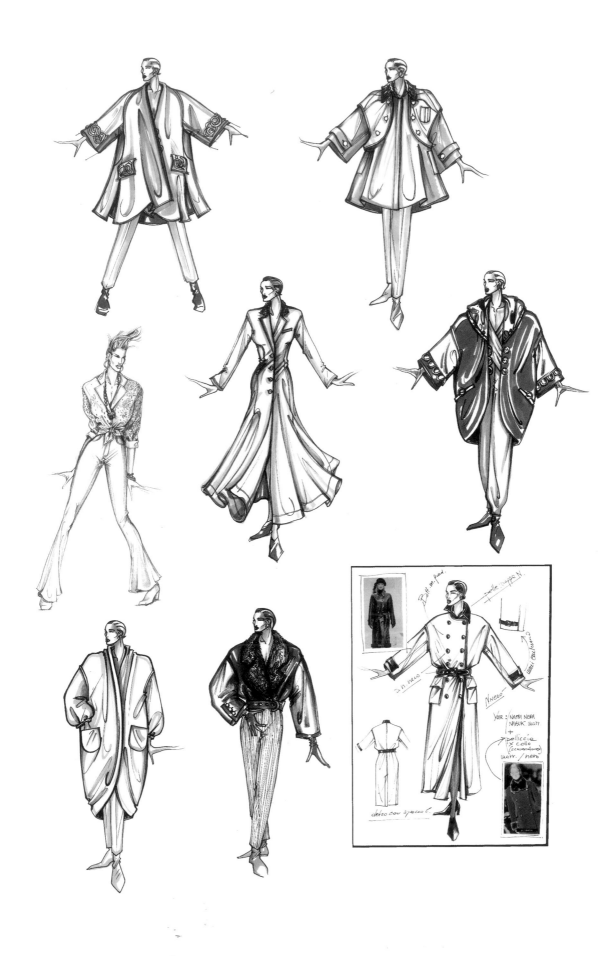

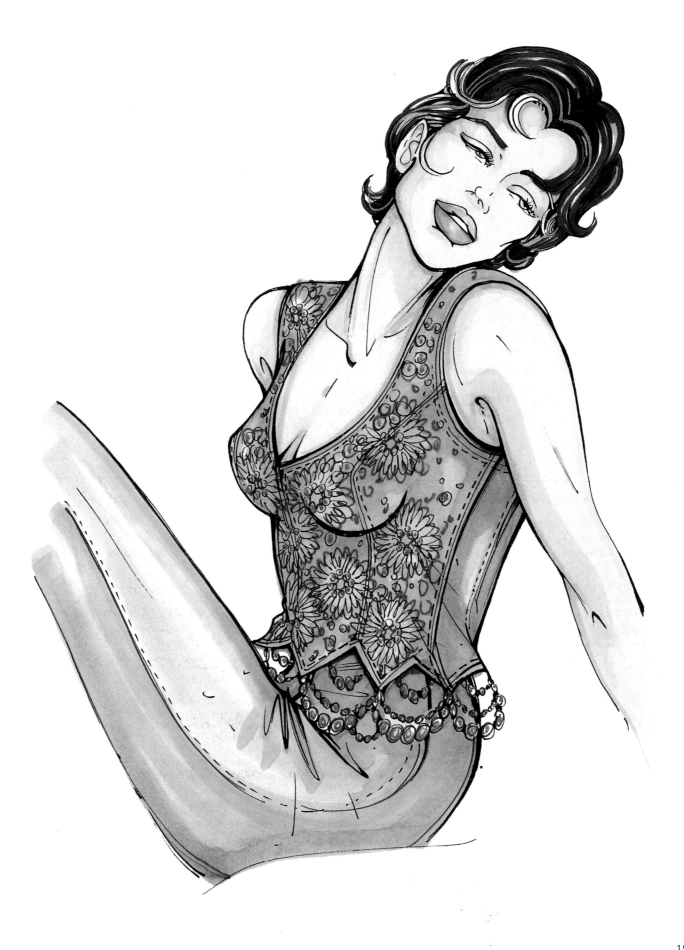

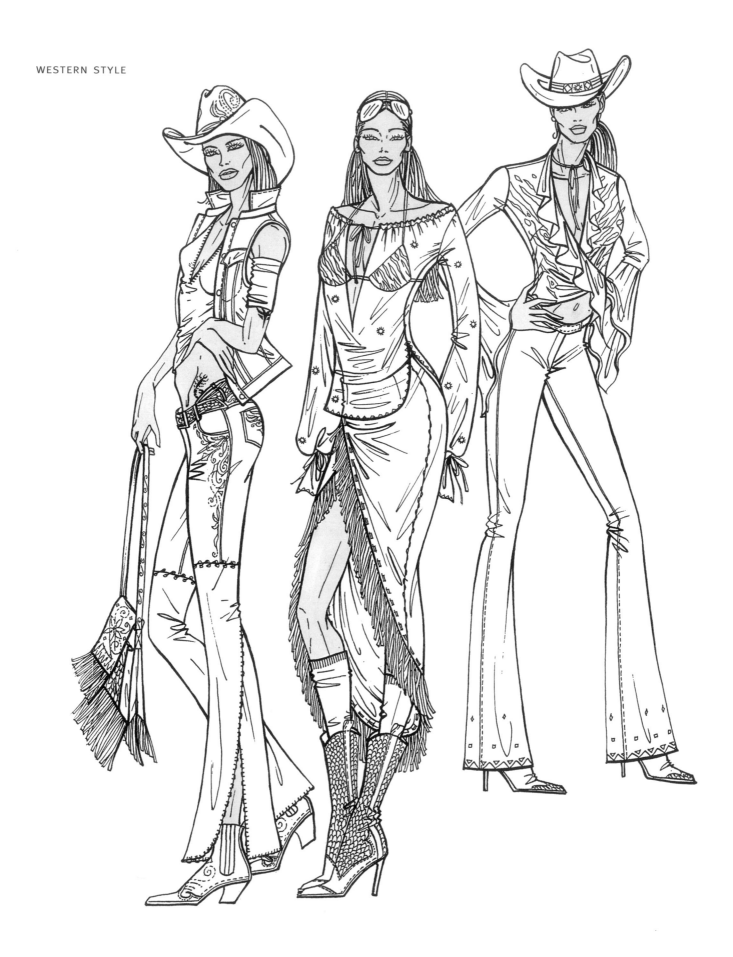

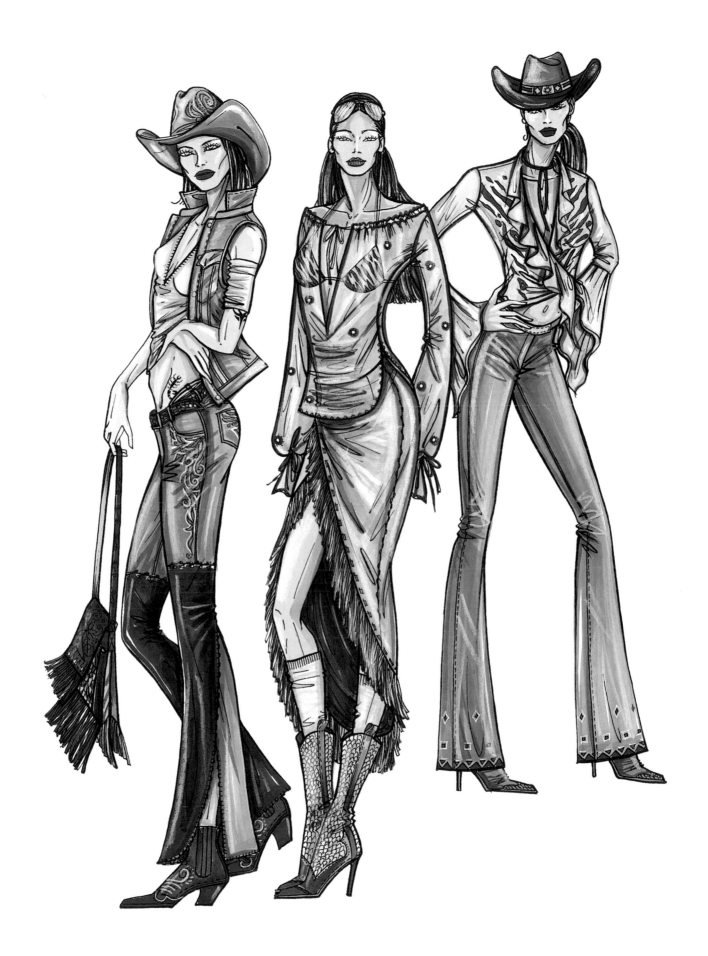

159

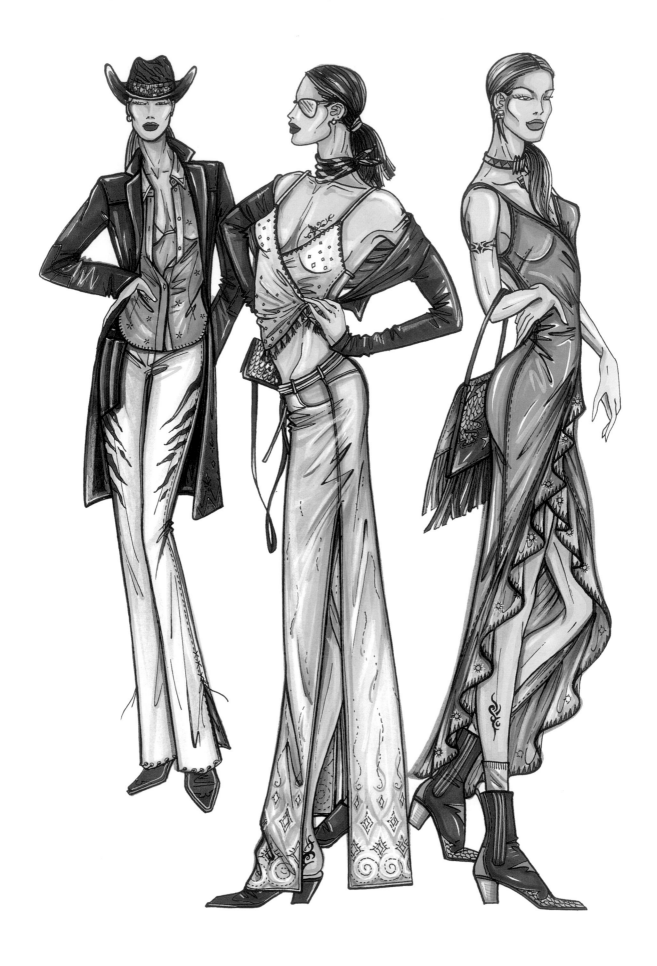

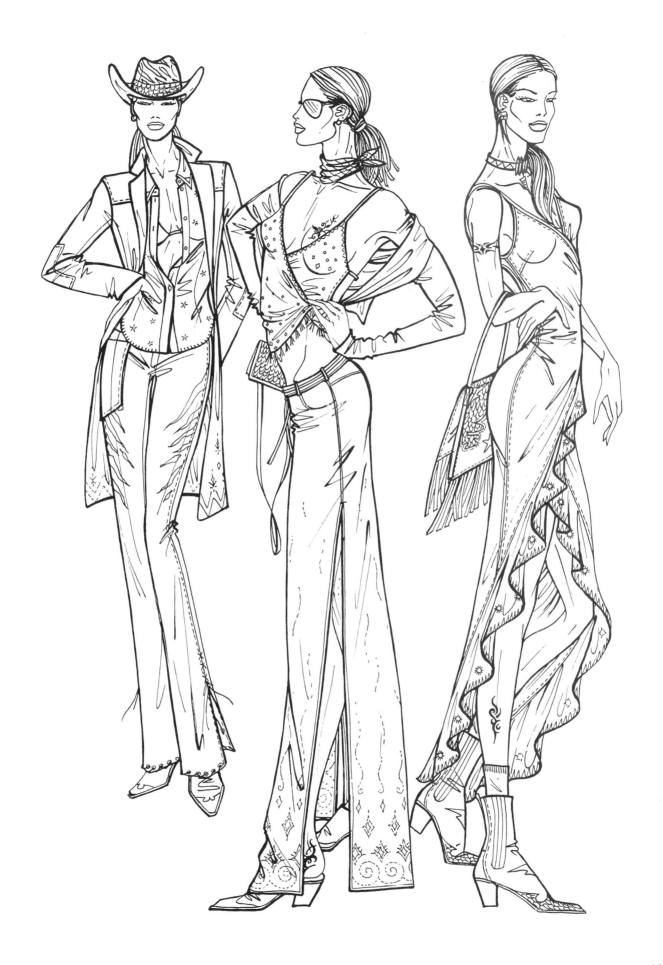

FASHION AND ITS DISSEMINATION

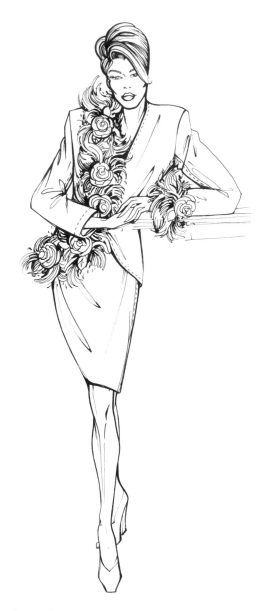

Fashion from the post-war period onwards spread and diversified in a way that was particularly striking.

The companies in the sector made themselves more responsive to changes in taste among consumers, offering in profusion products which were suited to the most varied demands of the market.

The figure of the designer became increasingly important for the success of a company in the world of fashion.

It was in the 1980s that the relationship between designer and industry assumed an absolute importance insofar as the latter had an ever greater need of the most well-known names to publicize and promote its product successfully at an international level.

It will be realized that clothing, just like other consumer products, is not just an external covering of the body, but is its living cockpit which seeks to represent through its function and aesthetic a real industrial undertaking that fully responds to the portrayal of the 'self' and to the social context in which one moves.

It was from here that the need developed for specific studies relative to the mass media, to marketing, to advanced technologies with the planning of textile fibres which were ever more comfortable and futuristic.

Fashion, therefore, is not just clothing but is an industrial product at the highest level of planning design.

In recent years many sociologists and psychologists have also analysed fashion as a 'mass phenomenon'; Konig for example defines fashion as a fundamental force in social life that has found profound roots in the collective unconscious, not only in wealthy societies but in all types of civilization.

In his analysis he adds that one of the strangest characteristics is that the more it is studied, the greater the increase in importance that is attributed to it and adds that at first sight it seems to influence only the exterior aspect of people and things, but by observing it in greater depth it is revealed as one of the great principles of transformation in society.

The phenomenon that is fashion assumes a symbolic value and it is by means of transference that it reveals itself in clothing and every group, every individual expresses a part of himself through what he wears: dreams, needs, desires, taboos etc...

To conclude this brief psychosocial excursion we advise you to read specific texts which are useful in understanding the language of the body in non-verbal communication, to enter into the infinite space of the psyche.

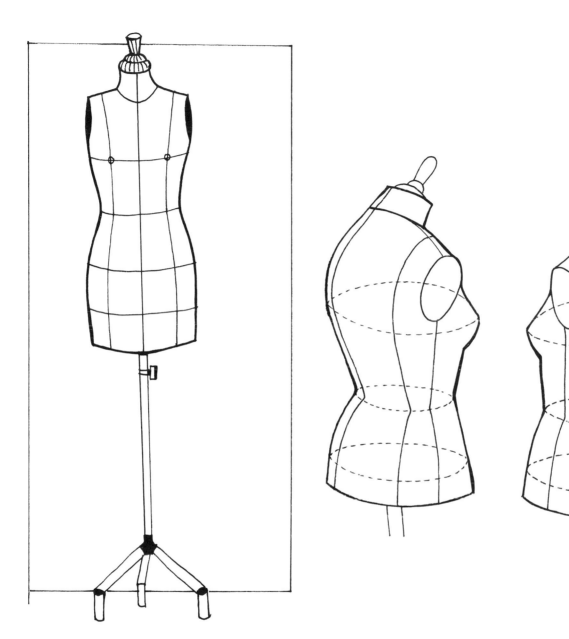

Some decades ago before the arrival of mass production, clothes were made by specialist couturiers who had on the premises everything that was necessary to realize any request for an item of clothing.

The couturier knew exactly the tastes and the physical characteristics of his own clientele.

Sometimes in the most prestigious fashion houses dressmaker's dummies were made, reproducing the exact measurements of the most discreet and fastidious women, who with every confidence in their couturiers sometimes had precious, finished items of clothing delivered directly to their homes. The item of clothing was therefore unique, completed almost entirely by hand, with much attention paid to the details and the style and made with materials of the highest quality.

Today this kind of product is reserved wholly for *haute couture*, which precisely because of its exclusive nature takes care of the clothing for a clientele that is very sophisticated and élite.

With the development of the textile industry and *prêt-à-porter* many fashion houses have turned themselves into companies rendering consumers homogeneous by segmenting them according to type, dividing and manufacturing clothes in relation to predetermined and uniform sizes.

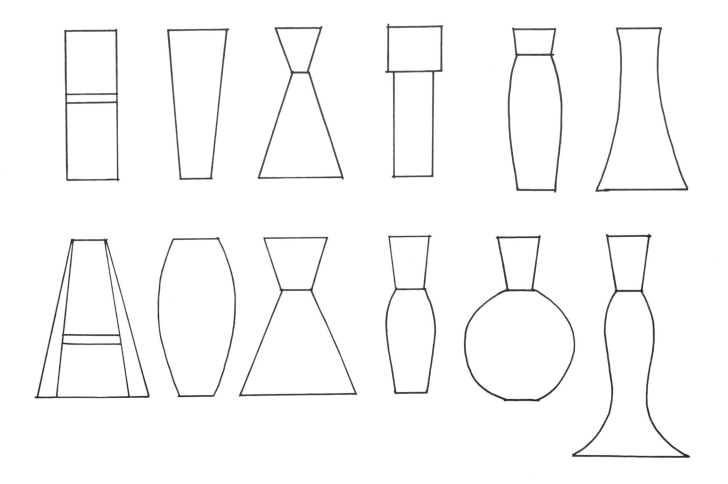

The cut is the silhouette of the item of clothing and shows the dimensions and length, whilst the style by contrast is what gives it character and makes it unique. Clothes which have their own cut can differ in style by means of details, finishes and taste.

For centuries an infinite number of cuts and different styles have been followed, but the dimensions most frequently used can be summarized in a few examples and from which innumerable variations dictated by taste and the trends of the moment can be derived.

The examples which follow show some fundamental patterns with diagrams that are very basic and geometrical, with the aim of emphasizing primarily the dimensions and the type of cut.

Top left to right: H, upside-down truncated cone, hourglass, column, empire, convex
Bottom left to right: Trapezium, barrel or bag, redingote, amphora, puff, siren

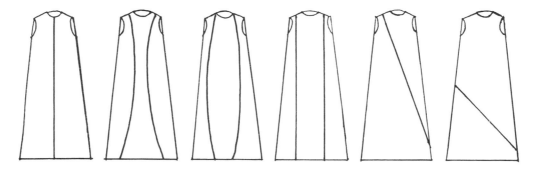

Left to right: Reduces, lengthens and reduces, widens and makes stocky, lengthens, lengthens, lowers and makes stocky

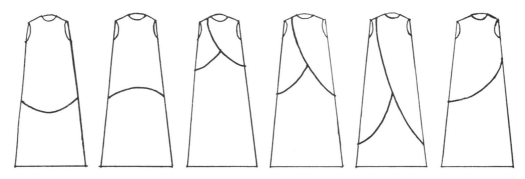

Left to right: Lowers and widens, lengthens and reduces, lengthens, widens, shortens, widens and shortens

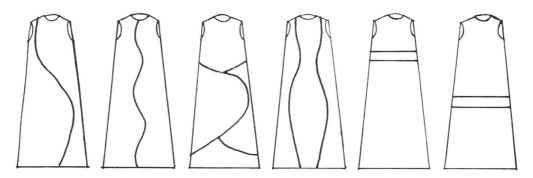

Left to right: Widens and shortens, makes slimmer, widens, makes slimmer, lengthens, lowers and makes stocky

The drawings shown here emphasize how the cut influences the proportions of any design.

Beyond the cut the dimensions are influenced by the stitching, by the colour of the fabric, by its quality, by the matching of styles and different colours among themselves, by the type of finishings used such as fringes, flounces, pleats, necklines, fancy sleeves etc.

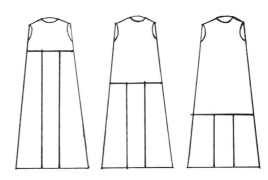

Left to right: Projects, widens, lowers

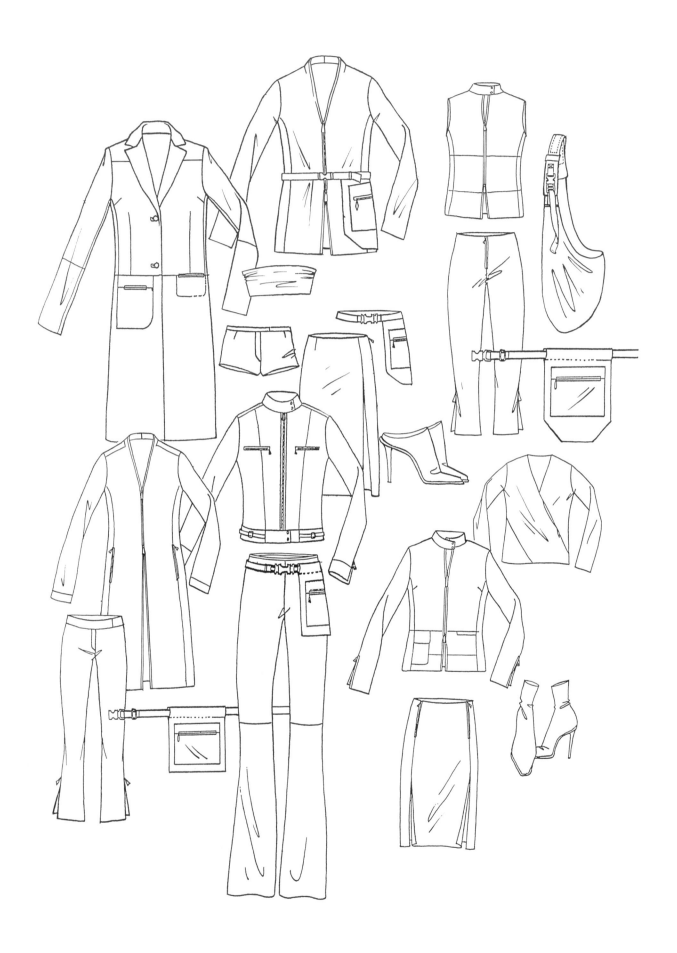

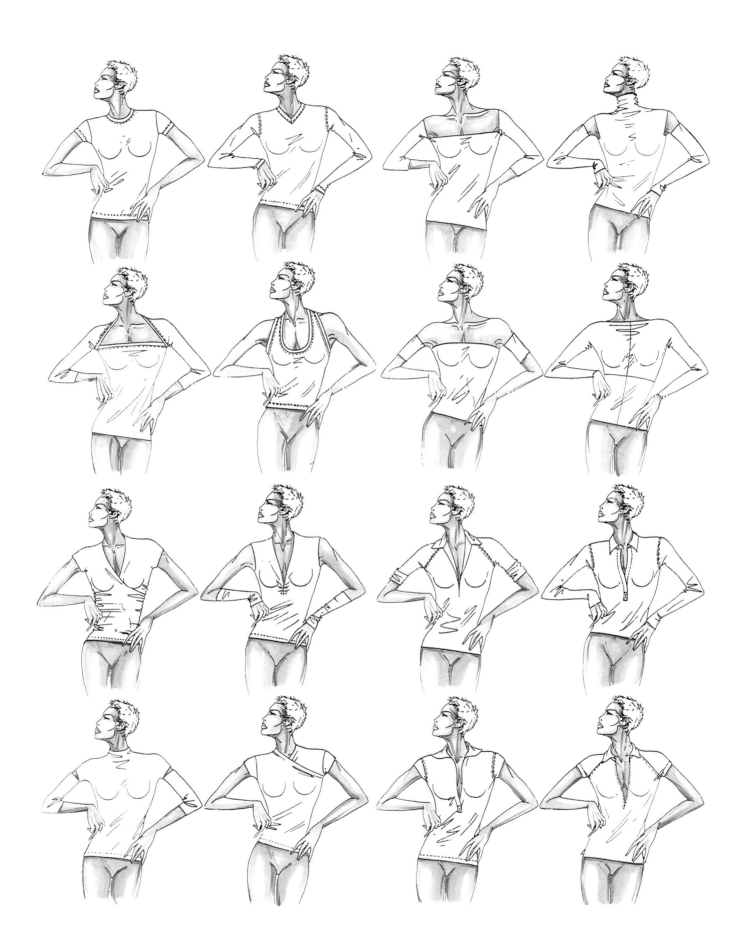

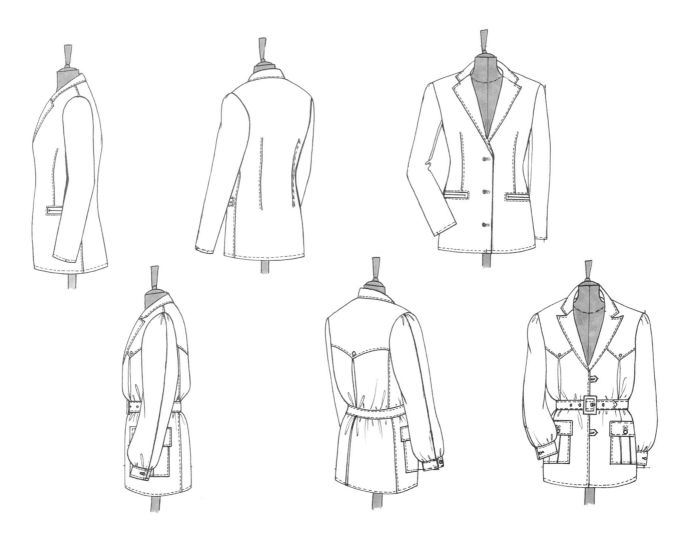

Drawings from the dress stand or explanatory drawings are a particular type of drawing on a geometrical basis that show the projected item of clothing as if it were supported upon a plane surface or hung on a hanger.

In such a design creases are reduced to a minimum or eliminated completely with a view solely to emphasizing the dimensions, the cut and the details of the garment.

This type of drawing is very useful, whether it is for the designer who must analyse every detail before passing the design on for verification in the workroom, or for the patternmaker who has to 'read' and realize with maximum fidelity the designer's creation.

This type of design functions as a link between the sketch and the finished item and many creative people sometimes use it in preference to the complete design of the fashion plate.

It is therefore logical that the acquisition of this visual planning technique is fundamental for the student who is training for the profession of designer, and practising the faithful reproduction of our explanatory diagrams will certainly help in carrying out the correct visualization of every planned item of clothing.

It would be opportune to have an understanding of descriptive geometry and perspective because drawings from the dress stand represent a finalized project to clothe an area which must be analysed principally from basic perspectives: from the front, in profile or three-quarters and from the back.

Every depiction will emphasize the cut, the wearability, the finish and the trimmings, the necklines and the sleeve holes, the buttonings and every other detail necessary for the interpretation of the proposed pattern.

The basic poses drawn here show a classic jacket and a casual jacket.

Note the attention to detail, emphasized by a neat and simple drawing style.

The production schedule is used in the clothing industry to set out a pattern for manufacture in all of its technical aspects.

We propose a generic schema made up of a useful panel for portraying the garment with technical headings. In this instance the design is for a pair of casual drainpipe trousers.

Note also the accuracy of the drawing in this instance and the precise representation of detail.

Completing the schema will allow one to verify the sample pattern in the workrooms.

	Pattern			Originating office	Season	Collection	Sketch No.	Code-No.
Shoulder width								
Sleeve length								
Total length								
Pelvis size								
Chest size								
Waist size								
Sleeve								
Shoulder strap								
Trouser								
Covering								
Lining								
Back								
Facing								
Collar								
Collar bottom								
Buttonholes								
Backstitching								
Stitching								
Yarn								
Hooks								
Zip								
Trimming								
Decorations								

Explanatory diagram

Waist	Buckle		No.	No.

Buttons	Line	Article	Number	Width	Line	Article	Number	Width

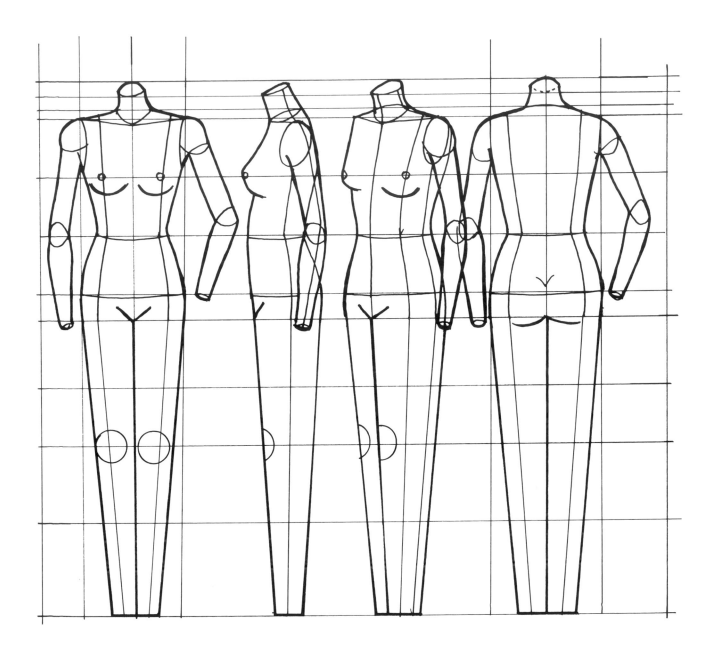

The diagram above portrays the
dressmaker's model in basic posi-
tions, which can be used to model
any item of clothing.

The drawing on the opposite page
portrays the same basic positions,
but the figure is more detailed.

The movement of the lower limbs
can simplify the explanatory
drawing of the trousers or the
skirt.

Also the arms being moved away
from the body give clarity to the
line of the fitted sleeve.

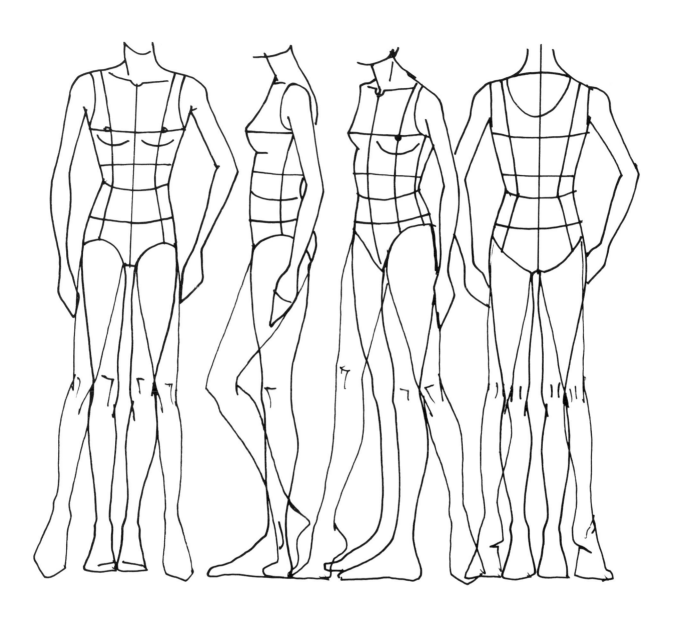

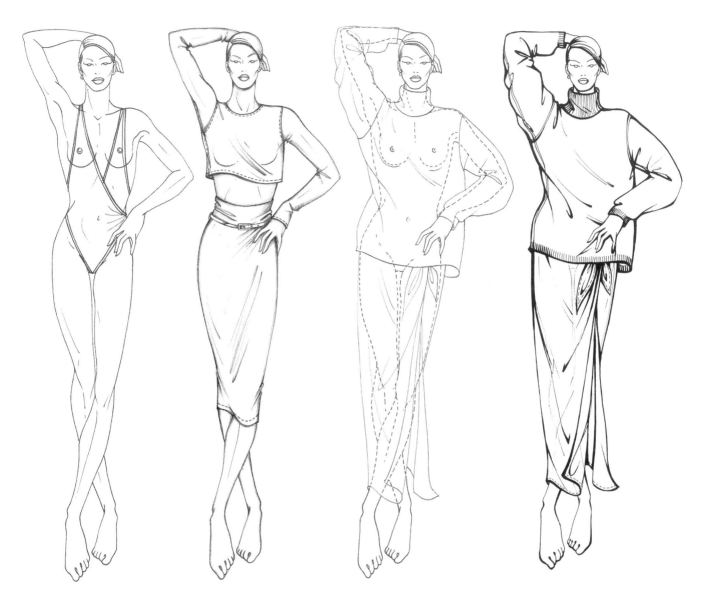

Elasticated costume – wearability reduced.

Sleeveless top – Close-fitting skirt minimal wearability.

Loose-fitting plush pullover with loose-fitting skirt – greatest wearability.

Wearability is the relationship between the length and spaciousness of an item of clothing. It is the room for movement that exists between the fabric and the body.

Technically it is expressed in centimetres, which are added to the pattern at special points.

The degrees of wearability are expressed in specific tables which, according to the type of fabric and cut, give more or less room to the item of clothing that is to be realized.

The more elasticated a material, the fewer degrees of wearability will be applied. The heavier a fabric is, the more the degrees of wearability will be increased.

When the fabric is changed, using the same pattern, it is sometimes necessary to change the degrees of wearability. The examples in the diagrams demonstrate various degrees of wearability applied to various patterns.

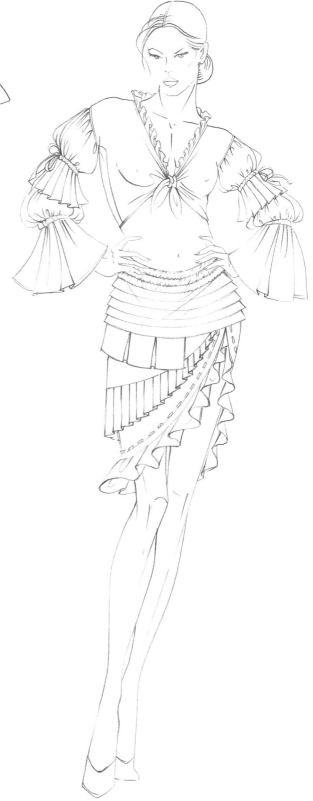

Technically by elements of finishing we understand all of those features that characterize the pattern (pleats, flounces, crimping, drapes, necks, pockets).

By trimmings we understand the individualization of particular features and accessories which make the item of clothing distinctive and elegant (buttonings, lapel facings, seams, buttons, appliqués, etc.).

In the following pages various types of patterns of finishings and trimmings both basic and sophisticated are shown.

The examples are presented in technical diagrams that are very clear and easily used for creating any sophisticated pattern.

Once you have assimilated the concepts that govern portrayal, you will be able to visualize what is necessary, emphasizing either the item of clothing or the details with the correct graphic technique.

Always define your patterns precisely with the correct technical terminology.

A novice fashion designer will have a little difficulty in arranging the various elements of finishing in a harmonious whole. Normally the tendency is to simplify the item of clothing, reducing it to something simple and basic or to exaggerate the dimensions and the details, thinking that the more complicated an item of clothing is the better the final result will be. Nothing could be further from the truth.

Years of application and work are necessary in the attempt to understand the essence of the design, to deepen the meaning of style and to understand the creations of the greatest stylists of today and of the past.

Therefore moderation, taste and a great deal of study should be your companions in this wonderful world of fashion.

PLEATS

Flat pleats

Plissé pleat

Tubiform accordion pleats

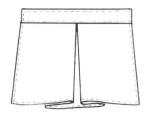

Box accordion pleat

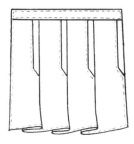

Flat pleats

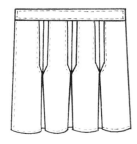

Accordion pleats

Movement of the
pleats in perspective

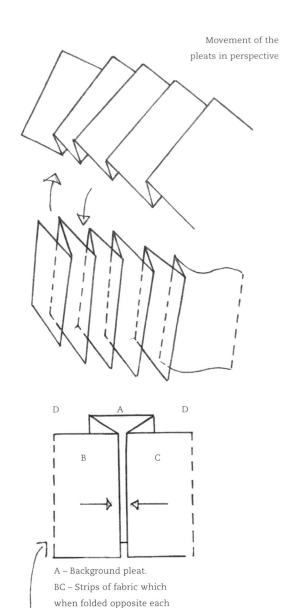

A – Background pleat.
BC – Strips of fabric which
when folded opposite each
other create a pleat behind.
D – Depth of the pleat.

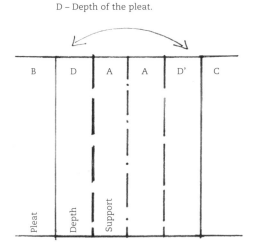

Pleats have the function of collecting the fabric around the body in modular geometrical patterns and are also used as trimming on a garment.

They are formed by one line of a fold, one of depth and one of support (A-B-C-D).

There are various types of pleats, and depending on their application, pleasing and variegated effects can be obtained.

They can be set at quite a distance, plissé, pressed or left loose, backstitched or with the inside made up of another fabric.

The best effect for pleats in dressmaking is that created by pleats which follow a straight line, because they follow the texture of the fabric.

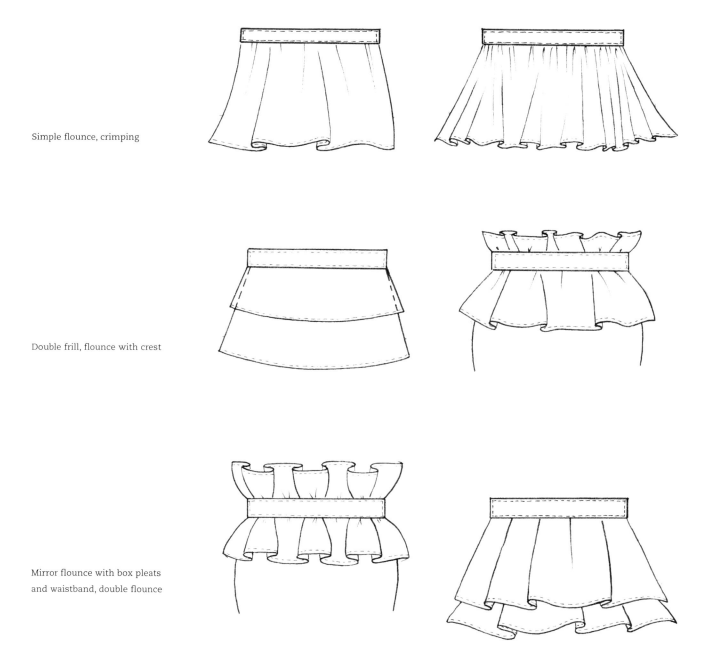

Simple flounce, crimping

Double frill, flounce with crest

Mirror flounce with box pleats
and waistband, double flounce

Frills and flounces, like pleats, have the function of collecting the fabric in decorative motifs, conferring more femininity and sweetening the cut. They are motifs suitable for a romantic and sophisticated style.

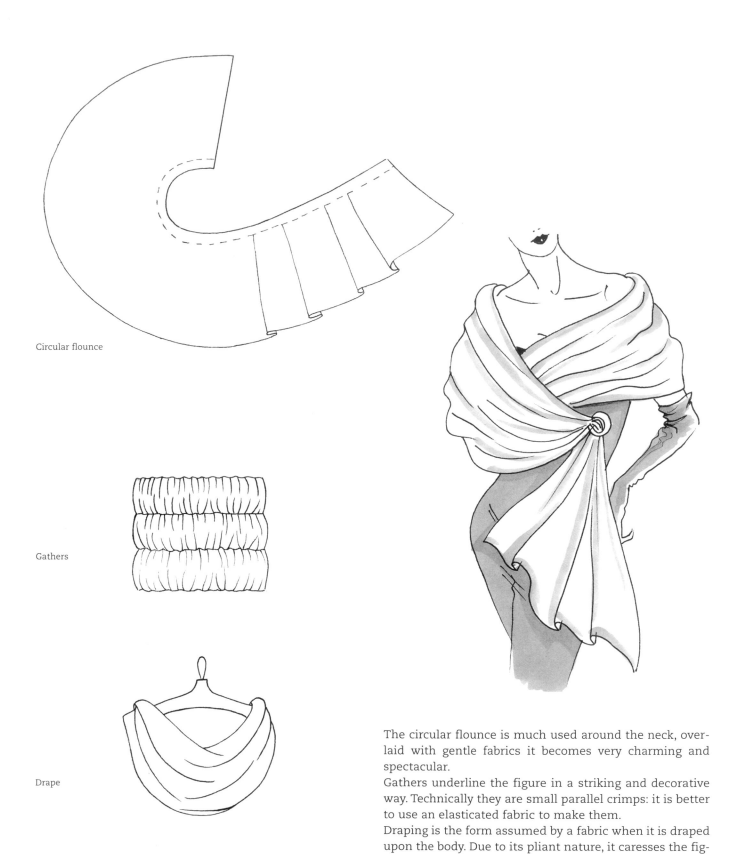

Circular flounce

Gathers

Drape

The circular flounce is much used around the neck, overlaid with gentle fabrics it becomes very charming and spectacular.

Gathers underline the figure in a striking and decorative way. Technically they are small parallel crimps: it is better to use an elasticated fabric to make them.

Draping is the form assumed by a fabric when it is draped upon the body. Due to its pliant nature, it caresses the figure providing a sensual accompaniment to the movements of the person who wears it in a choreography of seductive rhythms.

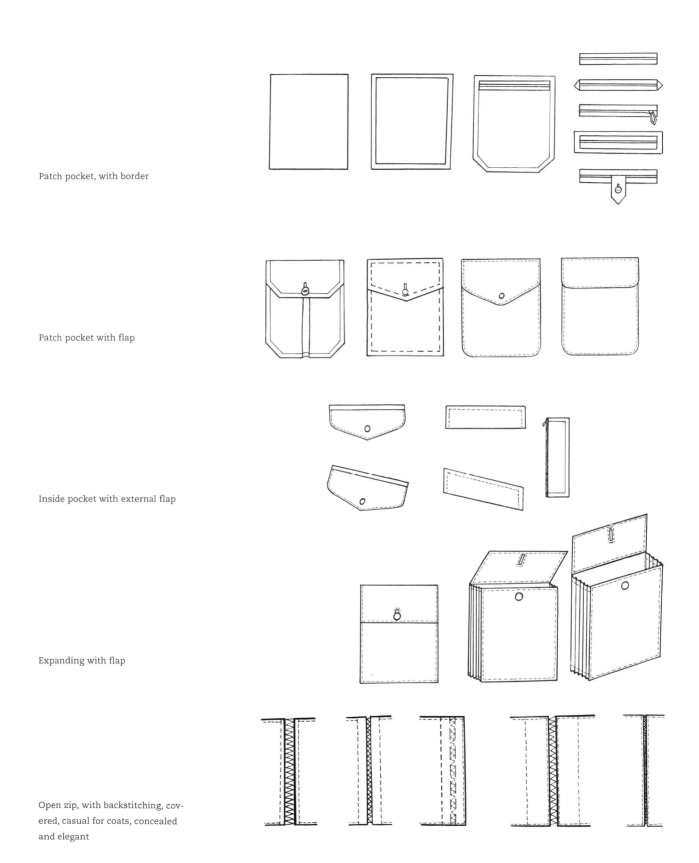

Patch pocket, with border

Patch pocket with flap

Inside pocket with external flap

Expanding with flap

Open zip, with backstitching, covered, casual for coats, concealed and elegant

177

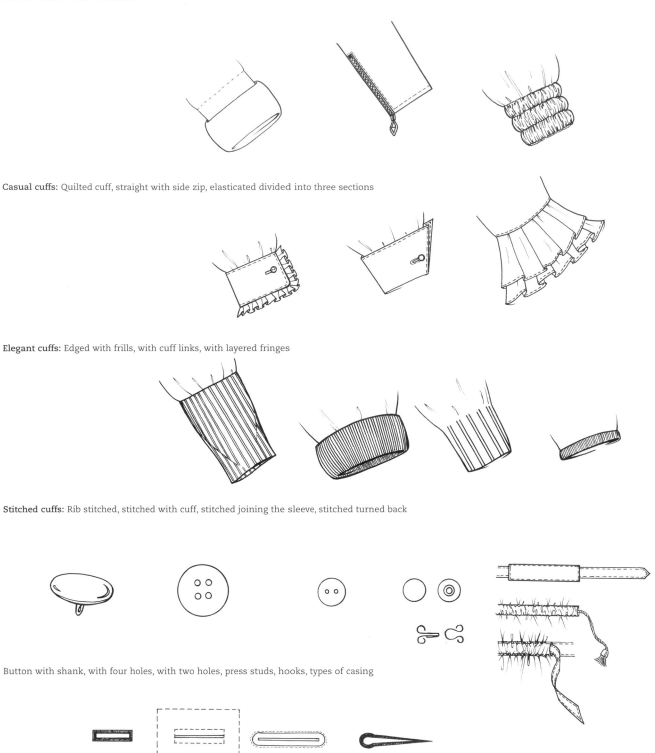

Casual cuffs: Quilted cuff, straight with side zip, elasticated divided into three sections

Elegant cuffs: Edged with frills, with cuff links, with layered fringes

Stitched cuffs: Rib stitched, stitched with cuff, stitched joining the sleeve, stitched turned back

Button with shank, with four holes, with two holes, press studs, hooks, types of casing

Types of buttonholes, velcro

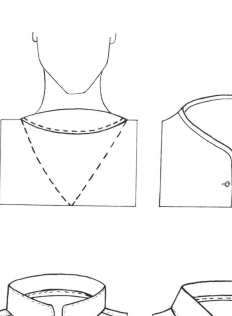

Left to right: Basic, neckhole, flat collar

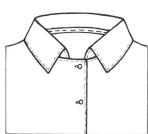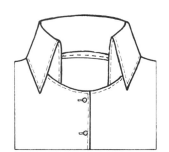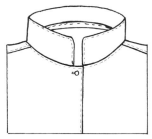

Left to right: Mandarin, classic, classic 1970s

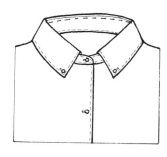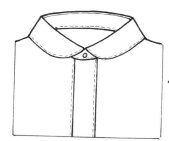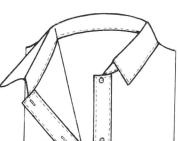

Left to right: Button-down shirt collar, rounded shirt collar, open-necked collar

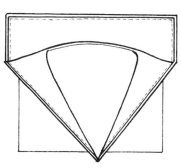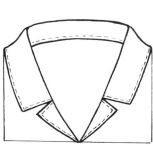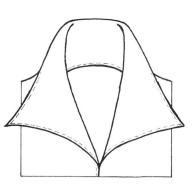

Left to right: Sailor, with small lapels, American-style with large lapels

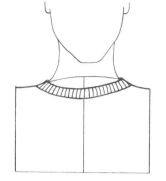
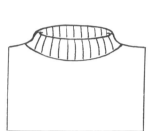
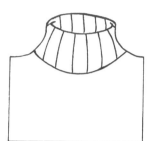

Left to right: Tailored, turtleneck, polo-neck

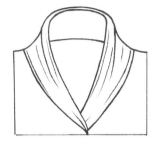
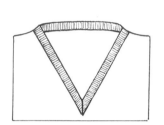
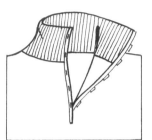

Left to right: Shawl, V-shaped, high ribbed with buttons

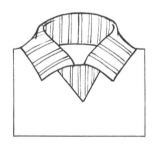
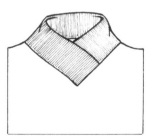
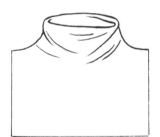

Left to right: Polo style with triangular insert, high cross-wound, funnel-shaped

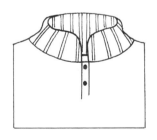
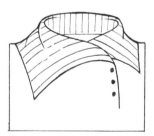
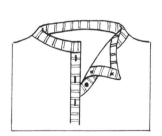

Left to right: Bomber, cross-wound, cardigan

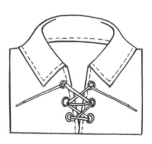
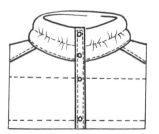
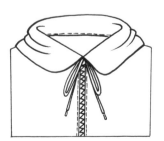

Left to right: Lace-up, double cambered, with hood

Front	Three-quarters	Profile	Rear

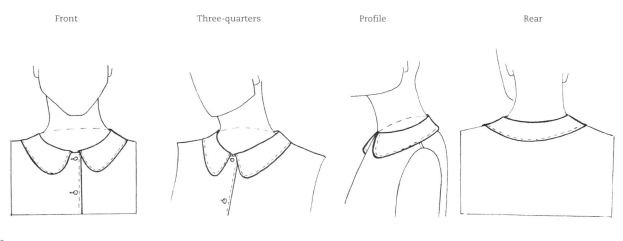

Flat collar

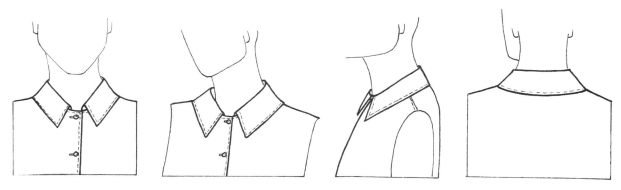

Classic collar

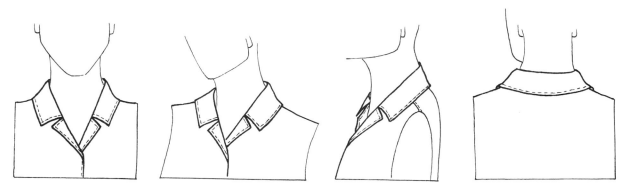

Collar with small lapels

This schema is useful for drawing any kind of collar that you can think of.

By changing the height and width you will also be able to visualize the most unusual collars.

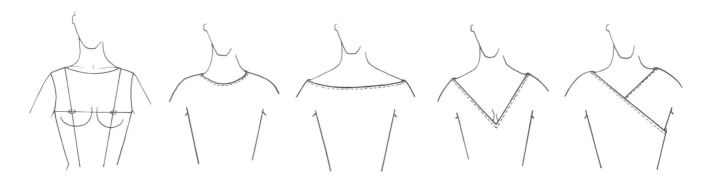

Basic, tailored, on the shoulder, V-shaped, asymmetrical

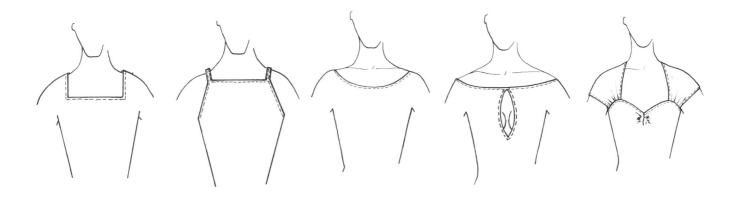

Square, square and singlet, rounded, on the shoulder with oval slit, heart-shaped

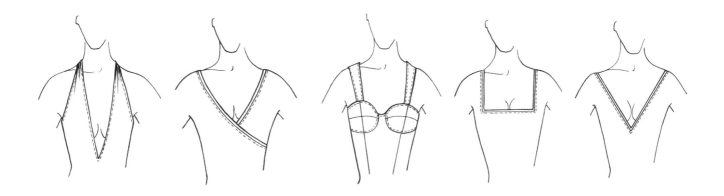

American-style, asymmetrical, balcony, square, plunge

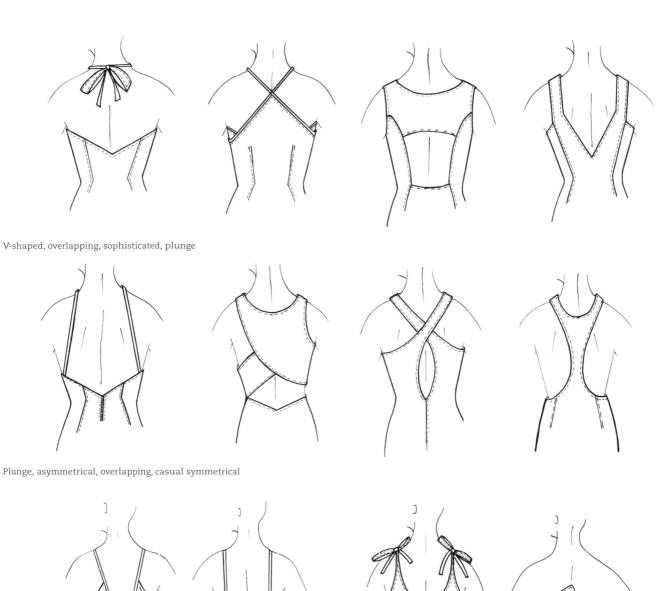

V-shaped, overlapping, sophisticated, plunge

Plunge, asymmetrical, overlapping, casual symmetrical

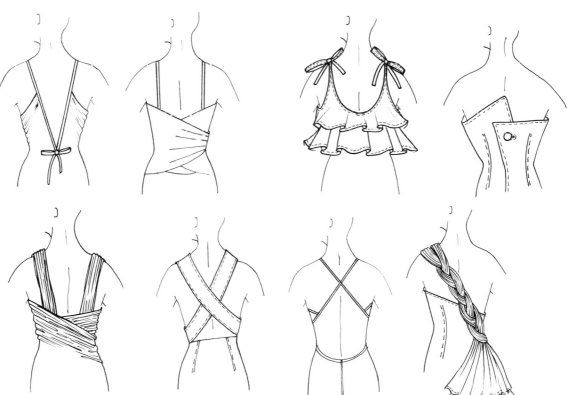

Variants in necklines

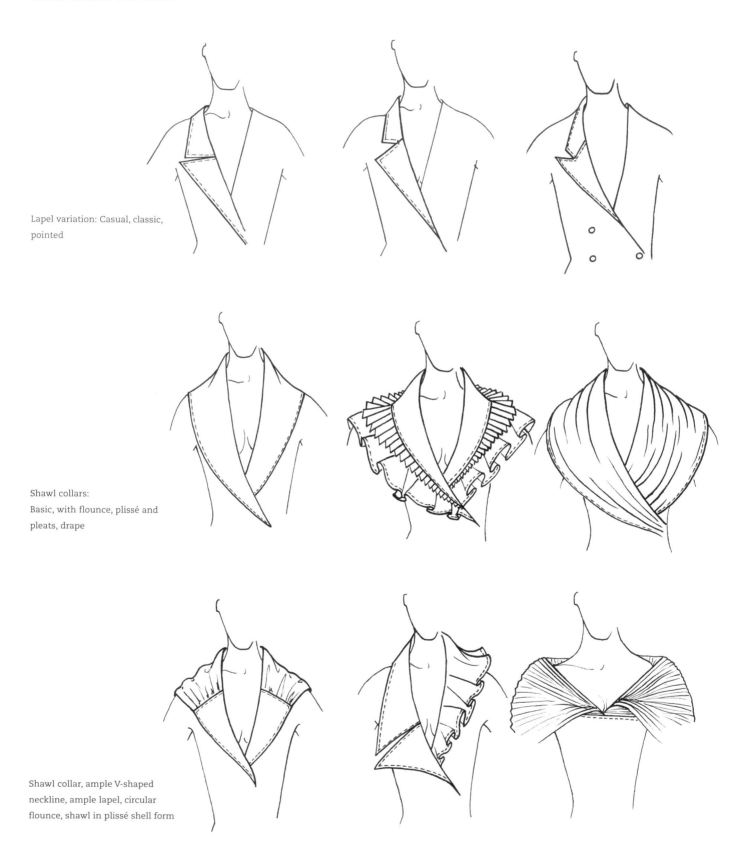

Lapel variation: Casual, classic, pointed

Shawl collars:
Basic, with flounce, plissé and pleats, drape

Shawl collar, ample V-shaped neckline, ample lapel, circular flounce, shawl in plissé shell form

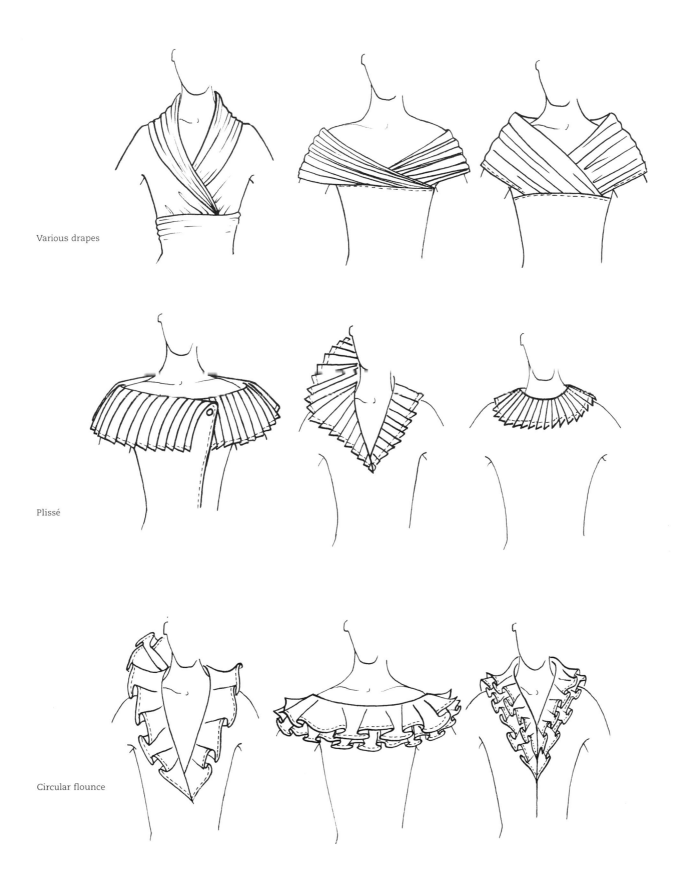

Various drapes

Plissé

Circular flounce

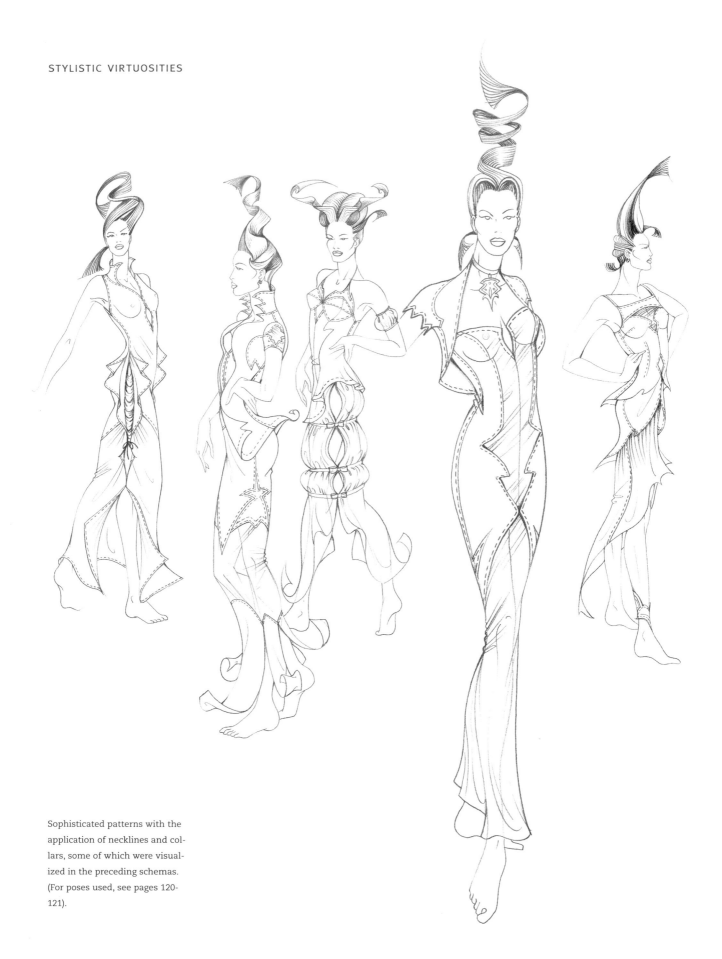

Sophisticated patterns with the application of necklines and collars, some of which were visualized in the preceding schemas. (For poses used, see pages 120-121).

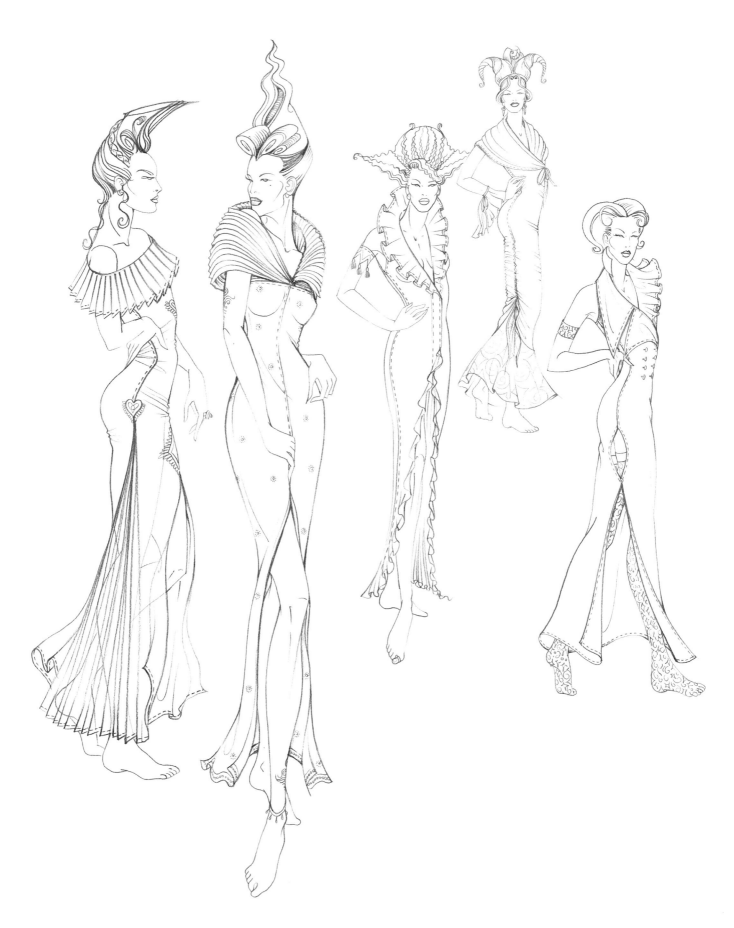

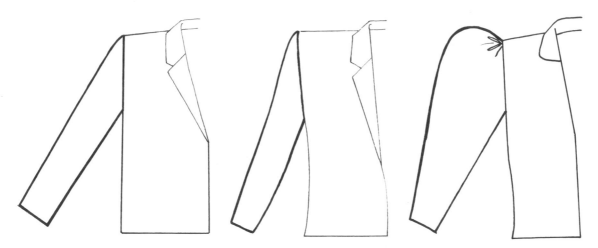

Fitted, broader fitting, fitted with crimping

T-shaped, puff sleeve with cuff, Raglan

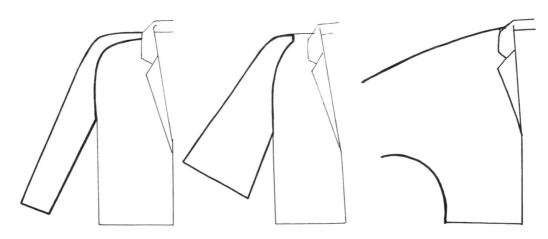

Hammer, flared Raglan, kimono

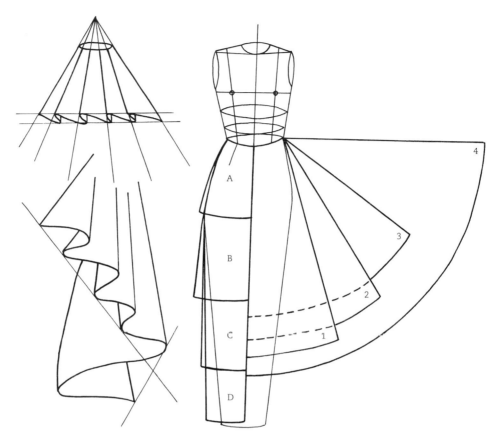

Technical diagrams for obtaining pleats and flares.

Basic skirt:

1 – Flared

2 – 1/4 bias-cut circular

3 – 1/3 bias-cut circular

4 – Full bias-cut circular

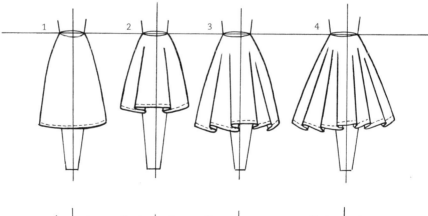

A – Basic miniskirt

B – Knee length

C – Midi

D – Full-length

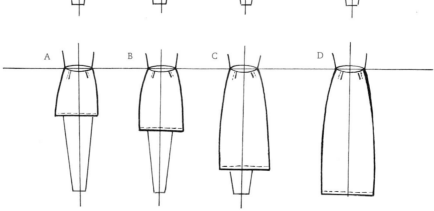

Close-fitting, straight, wrapover,
flared, wrapover with yolk and
pleats

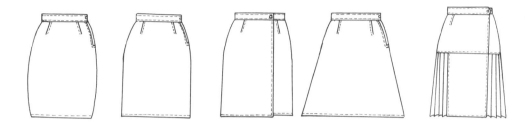

Half bias-cut circular, puff, puff
with fitted hem, plissé pleats

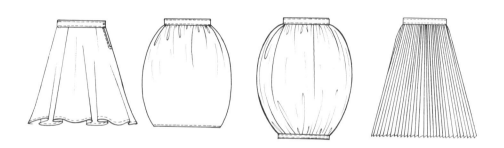

Tiered frills, tiered flounces, asym-
metrical with flounces,
straight with large pleat and
accordion pleat

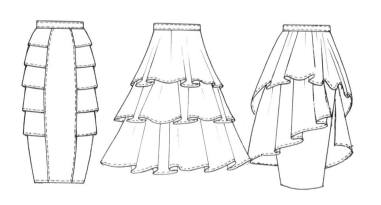

Half bias-cut circular with yolk,
full bias-cut circular with yolk, full
bias-cut circular with waist crimp-
ing, flared with inserts

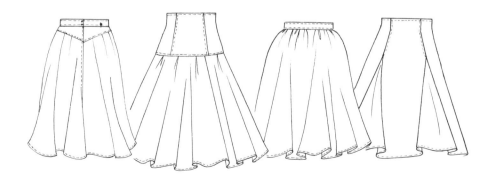

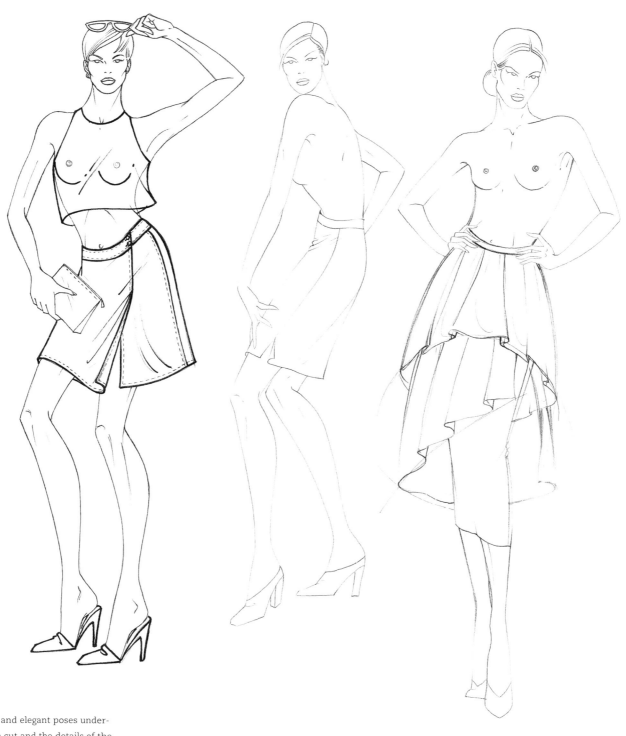

Simple and elegant poses under-
line the cut and the details of the
pattern.

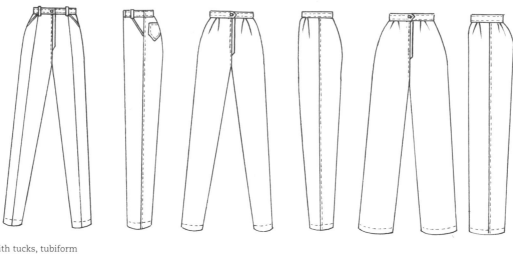

Jeans, drainpipe with tucks, tubiform

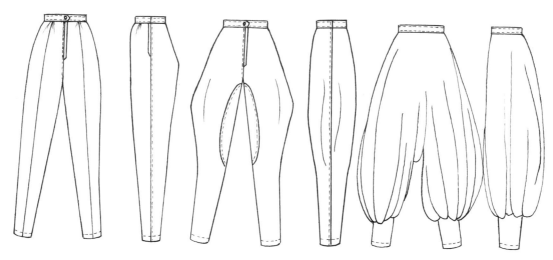

Tucks and pleat, jodhpurs, pantaloons

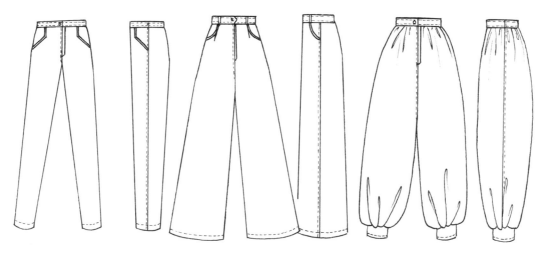

Hipsters, bell-bottom, Oriental

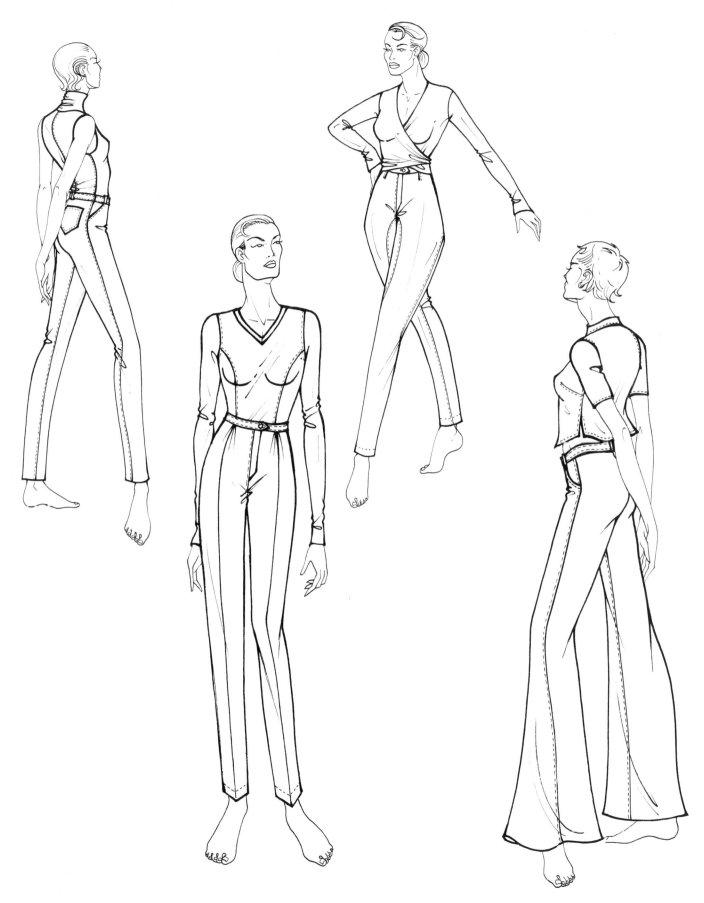

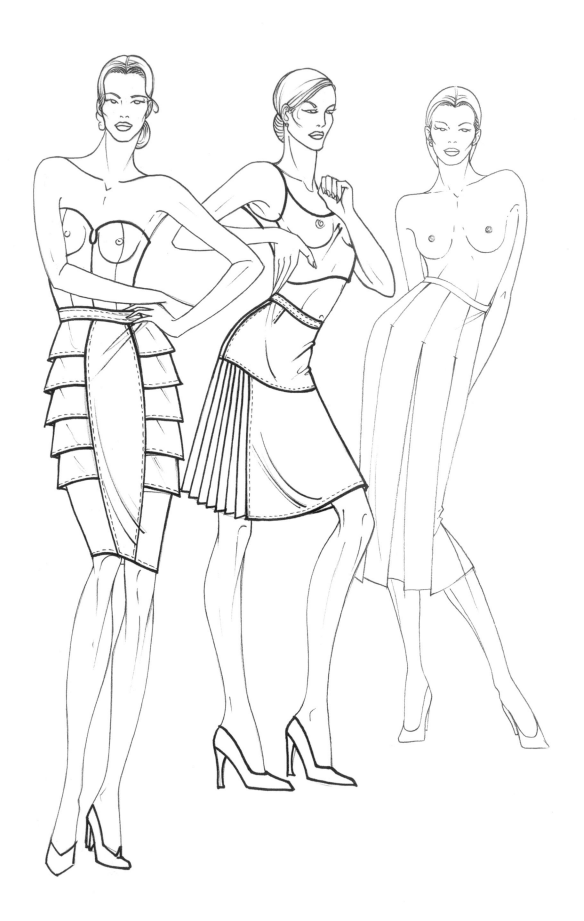

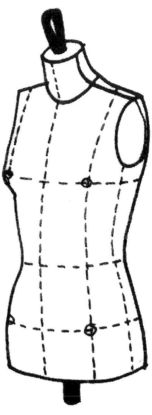

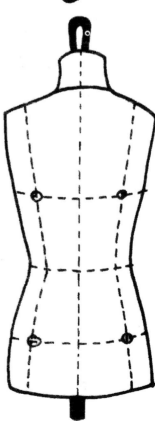

Above is seen a dressmaker's dummy from the four basic perspectives.

To mould the bodice or the costume around the body it is necessary to use tucks which reduce the fabric where it is at its roomiest and where the body is rounded, underlining the shape.

The first figure shows the basic bodice with the application of rotated tucks, both on the upper body and the pelvis.

To bring an item of clothing closer to the body, more tucks which slope down from the top as far as the flank and from the shoulder-blade to the flank can be used.

The tucks can be visible as in the basic version, inserted in the lengths of material or absorbed in the looseness of the design to confer more softness and linearity on the item of clothing.

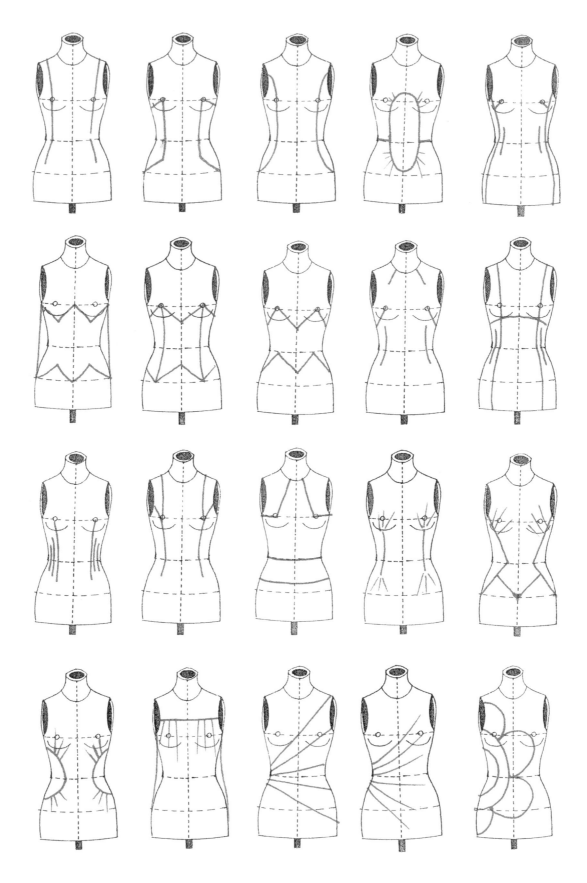

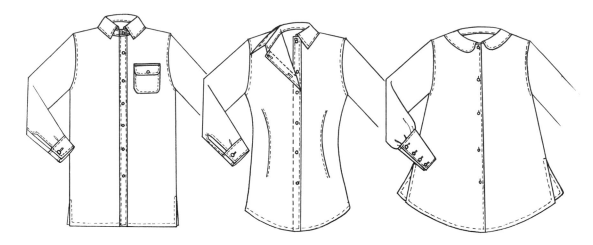

Man's, pinched, flared

Large shirt, Mandarin, romantic

Flared with short puff sleeves, 1970s style, straight double-breasted

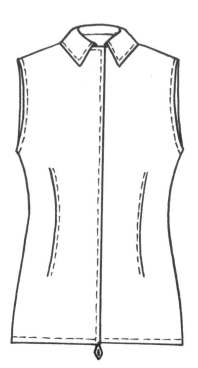
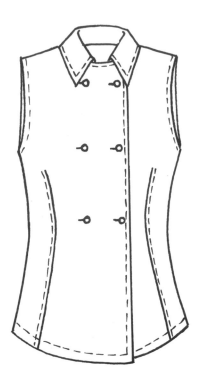

Sleeveless shirts with curving line

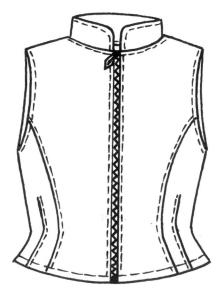

Normal gilet, pinched gilet, pinched gilet with zip

Models wearing the designs on
previous pages. The poses are
simple and suitable for the inter-
pretation of the pattern.

Creases have been kept to a mini-
mum and the outlines of the pat-
tern are emphasized in the
drawing.

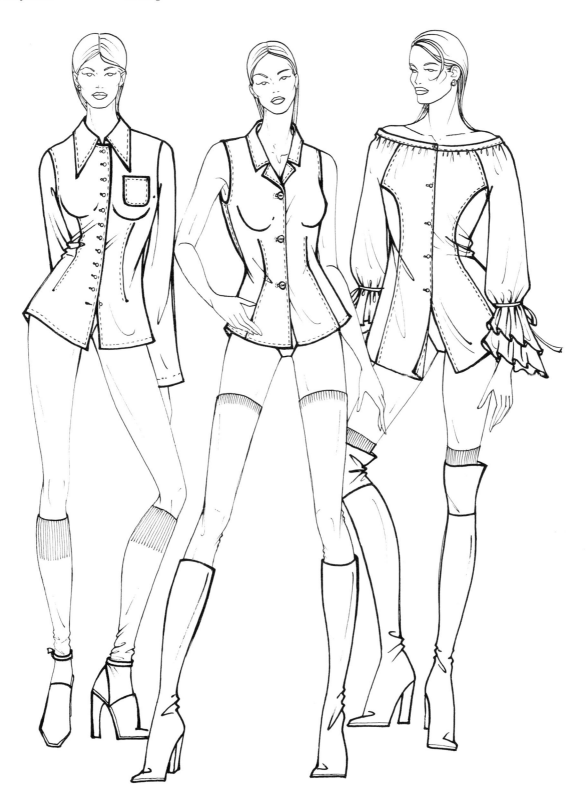

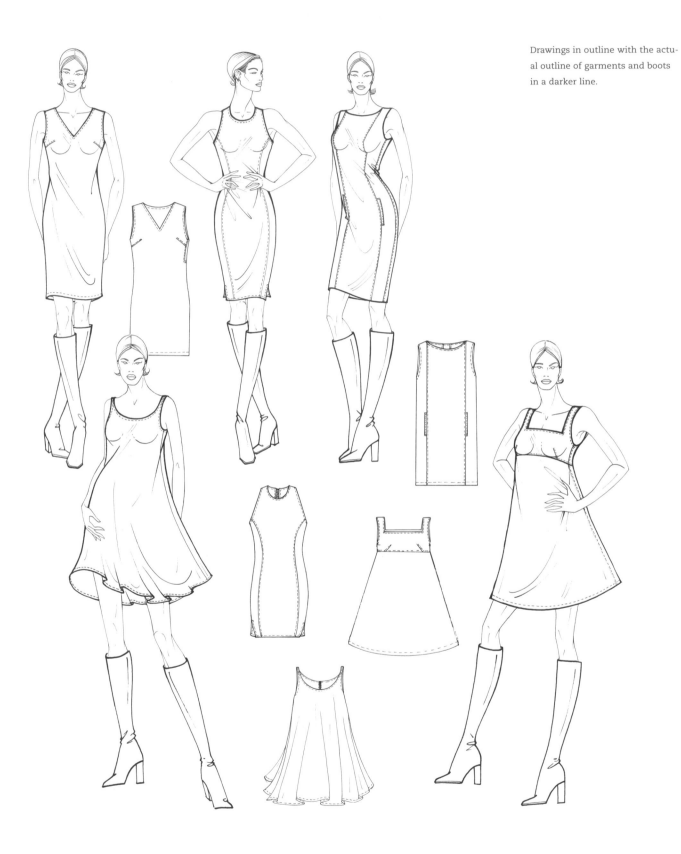

Drawings in outline with the actual outline of garments and boots in a darker line.

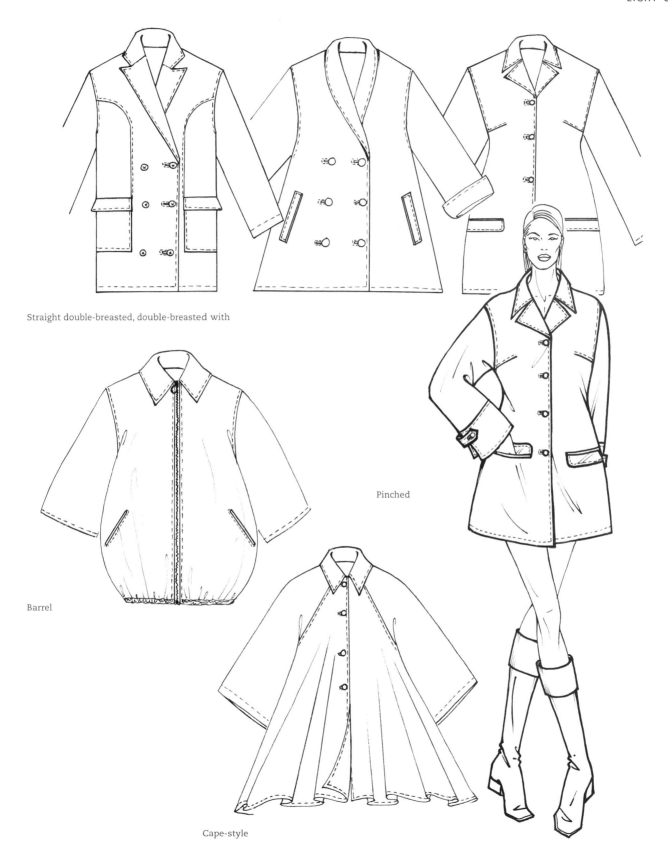

Straight double-breasted, double-breasted with

Pinched

Barrel

Cape-style

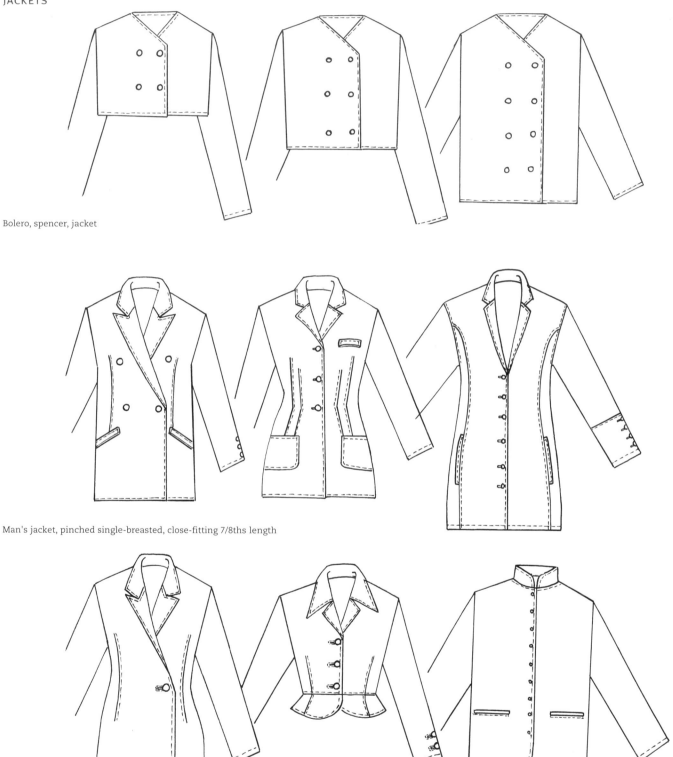

Bolero, spencer, jacket

Man's jacket, pinched single-breasted, close-fitting 7/8ths length

Pinched double-breasted, short with flaps, Mandarin-style

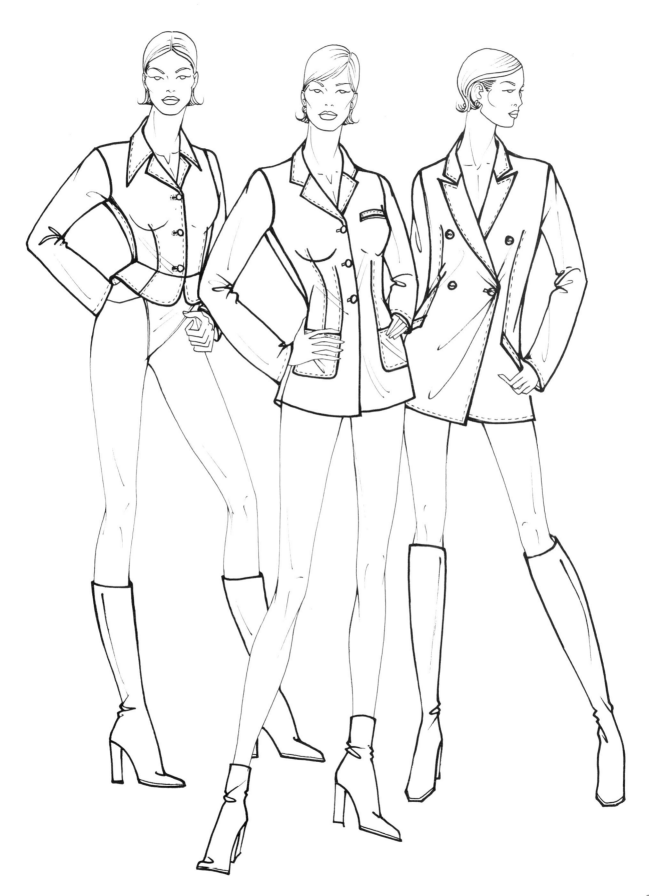

Bomber, denim backstitched

Bomber

Casual with zips

The model assumes a decisive and youthful pose like the fashion that she is modelling. The arms spread wide emphasize the fitted sleeves and the fullness of the denim casual jacket.
The simple and neat drawing style emphasizes the cut and the back-stitches.

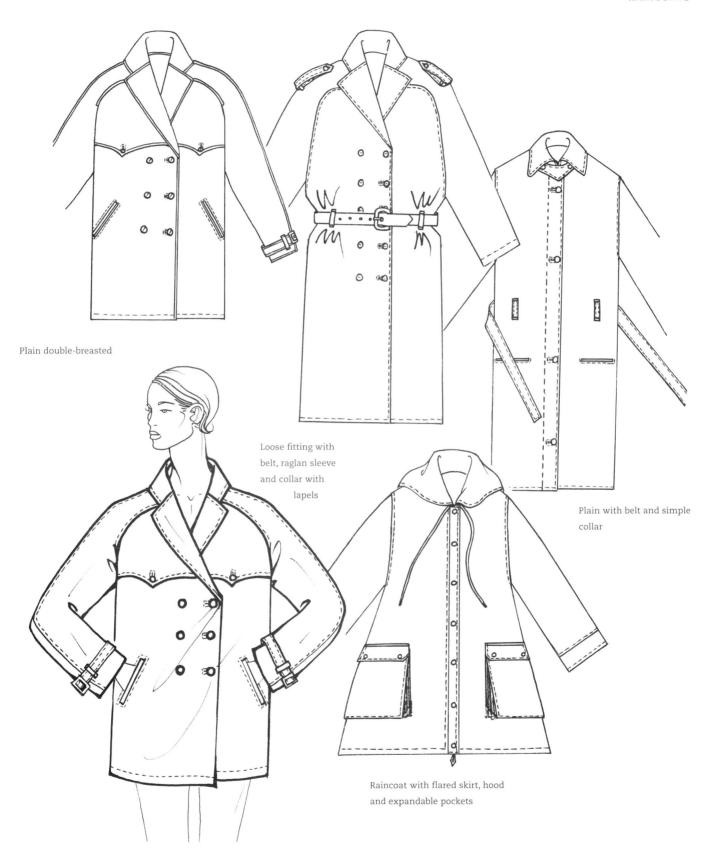

Plain double-breasted

Loose fitting with
belt, raglan sleeve
and collar with
lapels

Plain with belt and simple
collar

Raincoat with flared skirt, hood
and expandable pockets

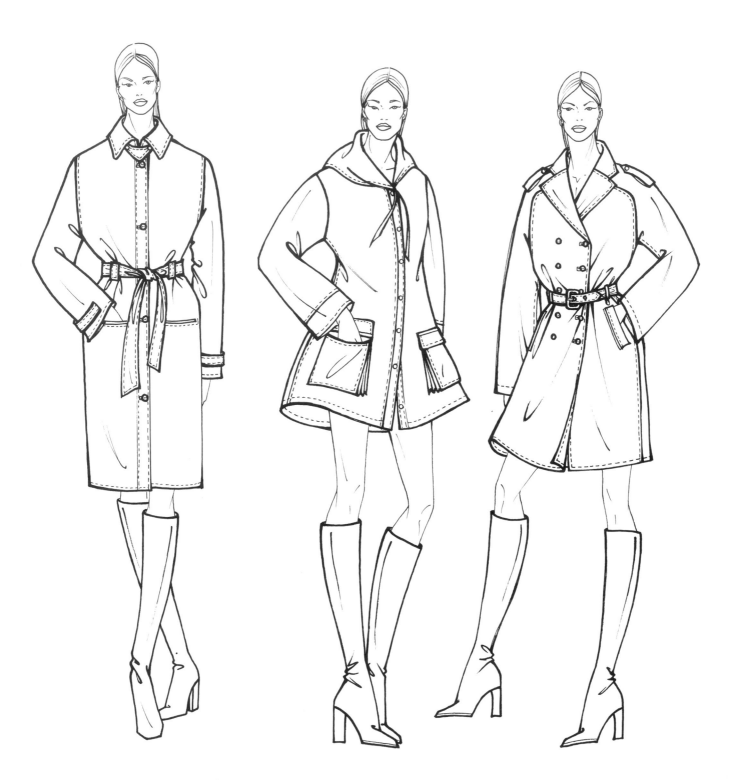

Poses have also been chosen in
this case which go with the fea-
tures of the pattern.

The model on the opposite page is
moving to stress the fullness of
the cape, which is also accentuat-
ed by the raised arm.

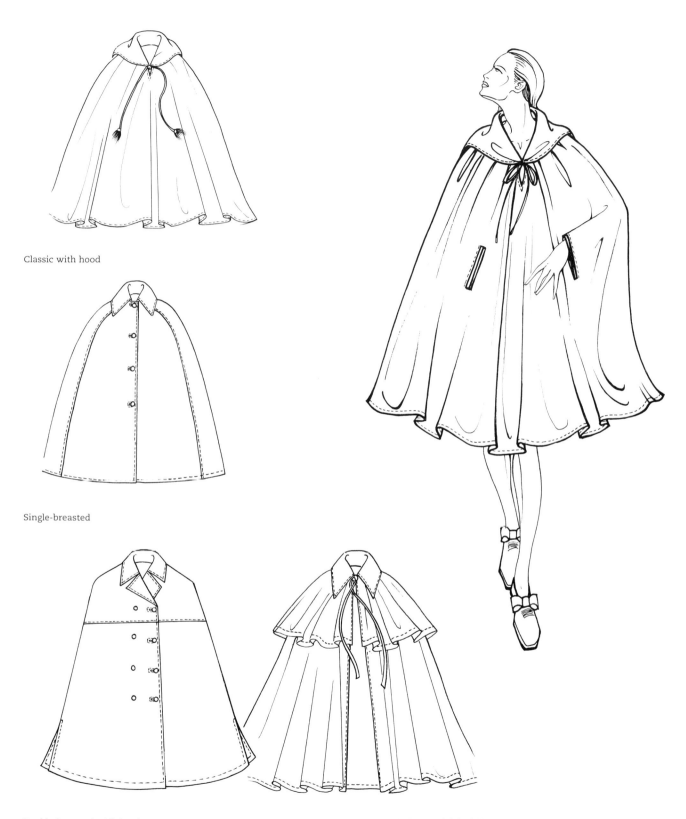

Classic with hood

Single-breasted

Double-breasted with lapels

Flared with partial doubling

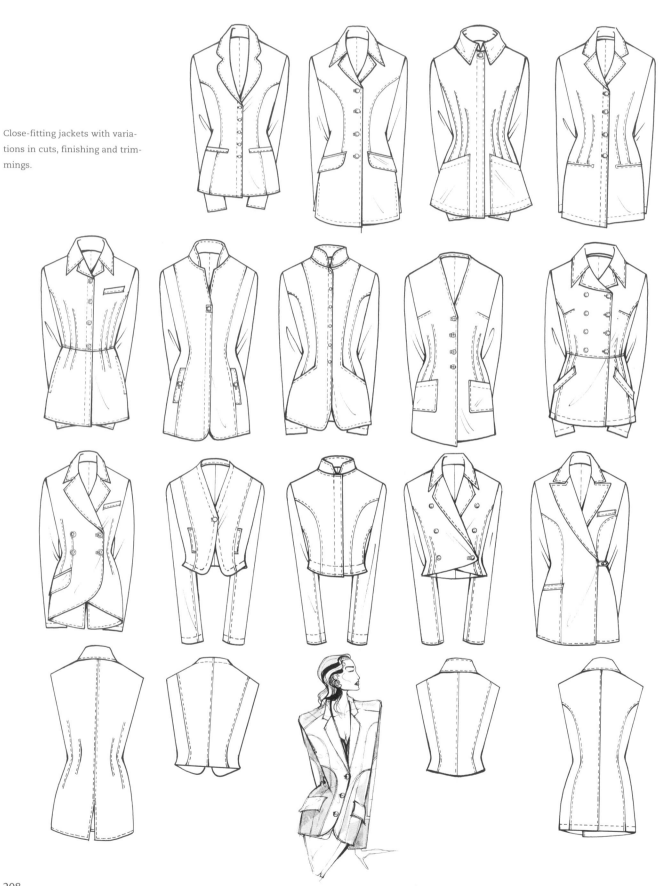

Close-fitting jackets with variations in cuts, finishing and trimmings.

Casual light coats and jackets sharing the same basic form, but varied in cuts and finishing and trimmings.

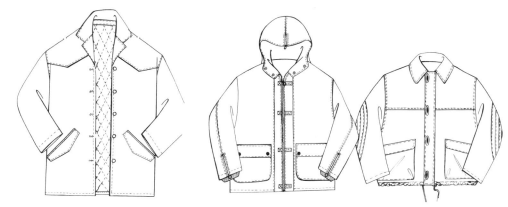

Plain coat with padded shoulders, coat with zip and hood, coat with casing

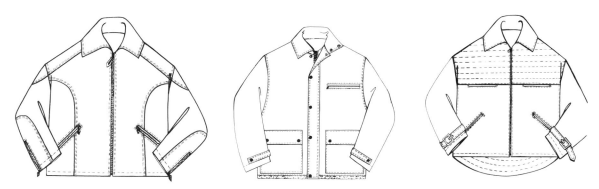

Bomber with zip, coat with patch pockets and double fastening, bomber with zip

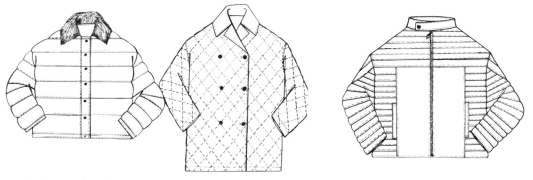

Padded bomber jacket, quilted coat, quilted bomber jacket

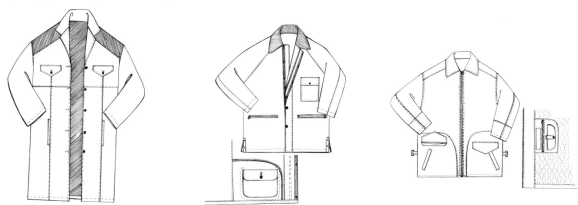

7/8ths length coat, coat with double fastening and variation in pockets, coat with zip and double pockets and inside pocket

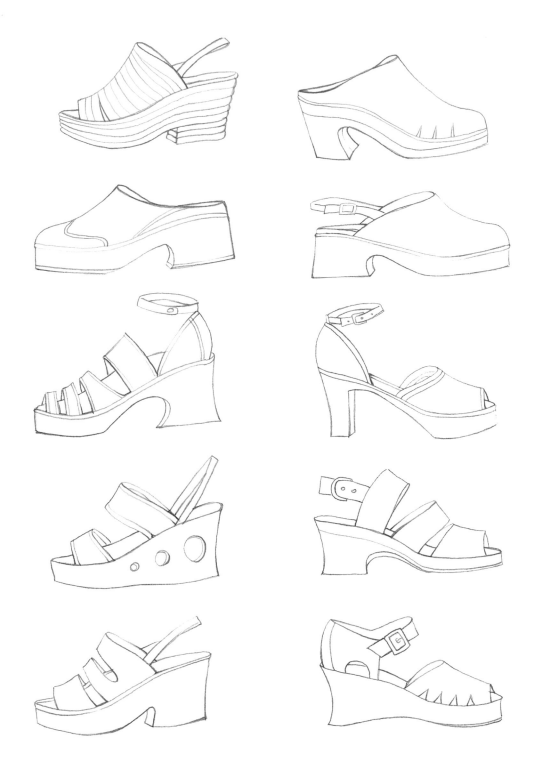

It is important to personalize a fashion plate with accessories which are suitable to identify a style or to play down an image that is too serious.

In these pages you will find many examples of footwear of various types which are suitable for the most varied fashions. The footwear is shown from a variety of perspectives.

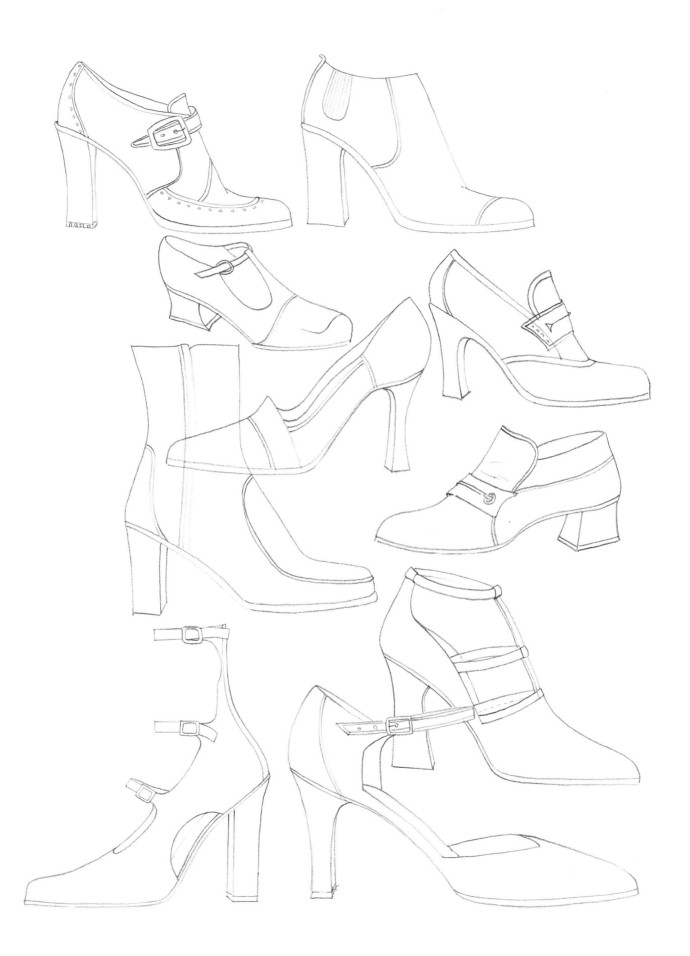

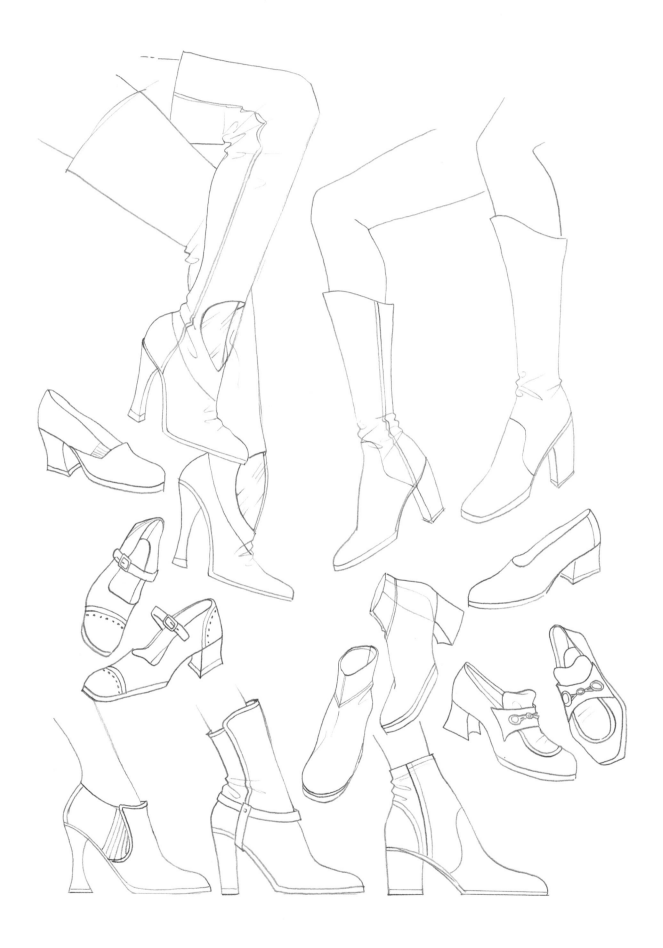

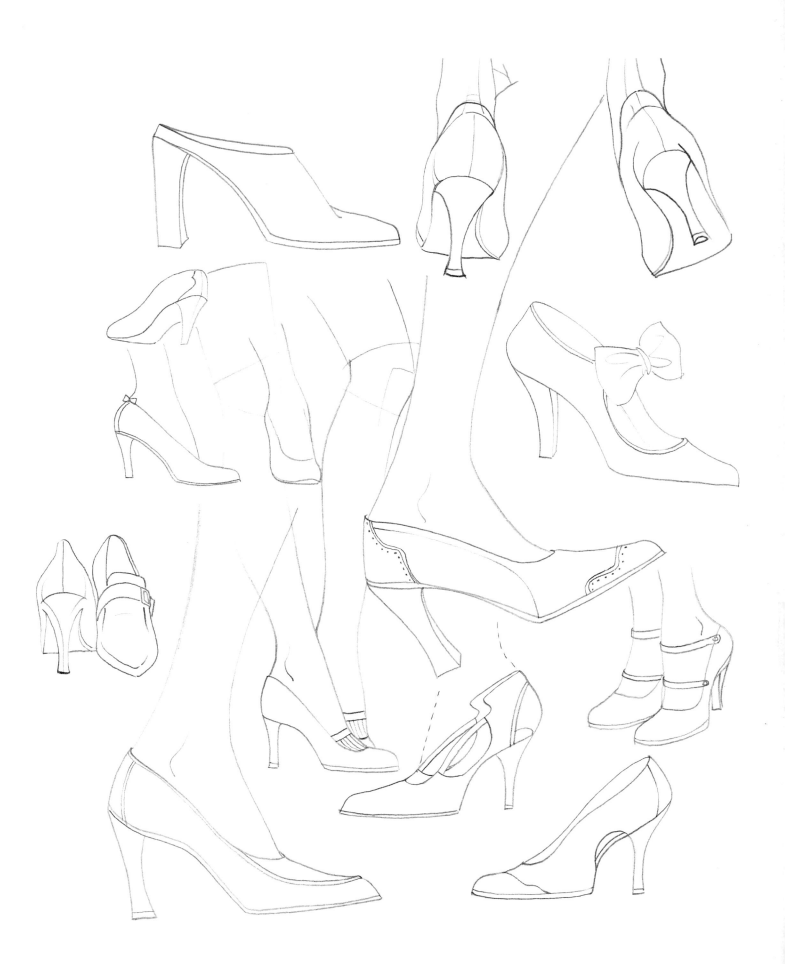

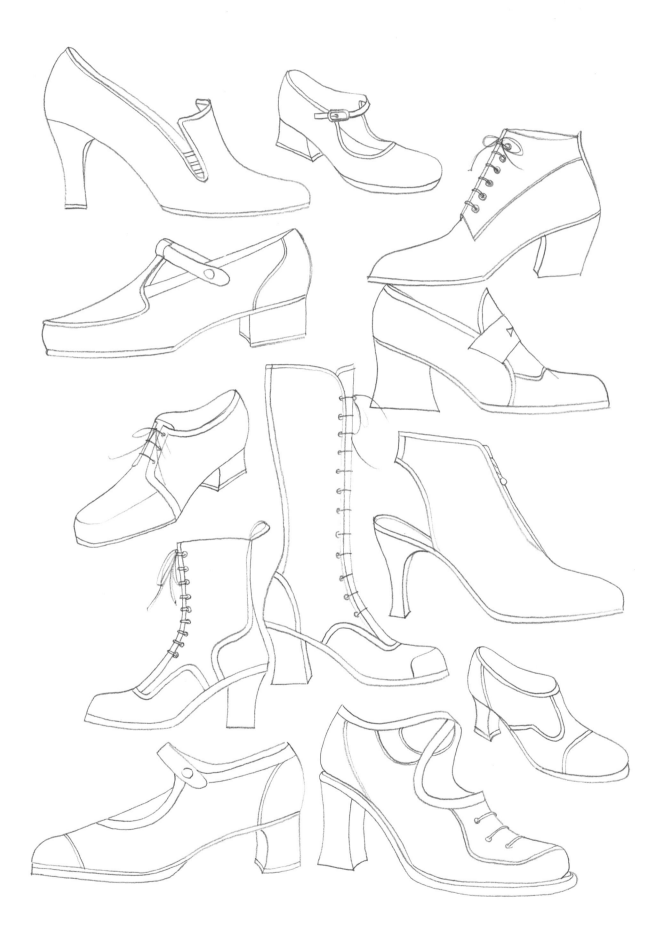

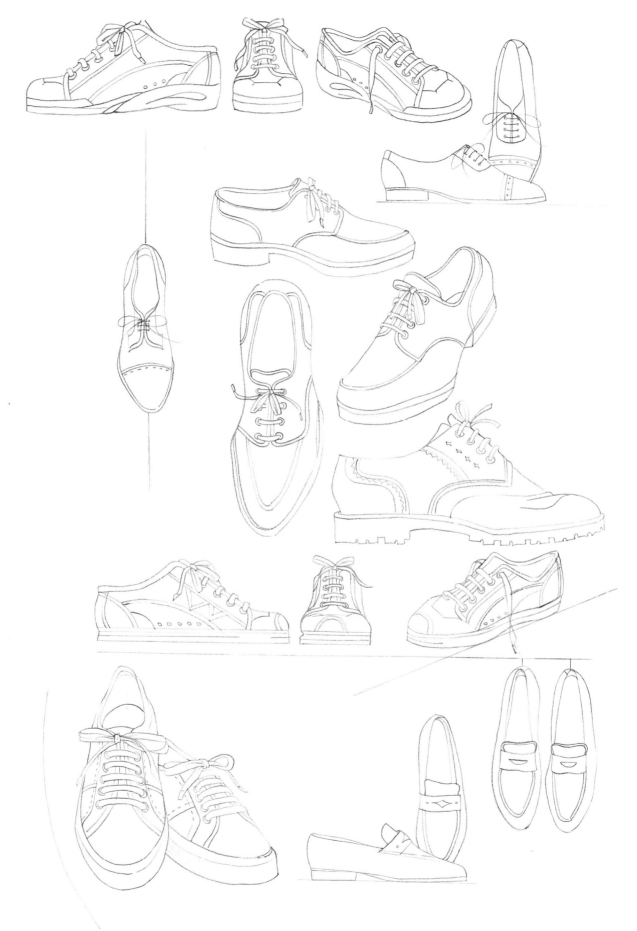

EXERCISES

Rule of proportion (p. 20)
Accurately reproduce the diagrams of the Greek canon and the fashion canon and the suggested diagrams. Then draw them again from memory.

The eyes (p. 25)
1) Make freehand drawings of the material in the book hitherto.
2) Make a series of drawings of eyes from true life at various angles in order to study their structure. Then stylize each set of eyes, emphasizing salient features.

The mouth (p. 36-37)
1) Following the instructions in the book, reproduce the drawings suggested hitherto underlining each time the structural scheme, the outline and the chiaroscuro appropriate for fashion design.

2) Reproduce mouths from life from various perspectives.

The head (p. 39, 49)
Before proceeding to the following pages, practise drawing the overall outline of the head so that you can subsequently divide it into its various constituent parts.
We advise you initially to use tracing paper, then move on to drawing paper, repeating the exercise freehand.

Using tracing paper copy the images presented here, seeking to understand every line of proportion. Then repeat the exercise drawing freehand.
Do not let your line harden and practise sketching, first outlining overall sizes with lines of construction. Then concentrate on details of expression.
Finally, trace your own designs and colour them in.

The hand (p. 54, 57)
As suggested in the preceding exercises, make several copies on tracing paper and freehand, taking these sketches as a starting point. The definitive drawing is executed in outline and with various chromatic techniques appropriate to fashion design.
Reproduce the diagram freehand with structural lines emphasizing the three-dimensionality with a light chiaroscuro.
By comparing the two images you will establish the accuracy of the freehand drawing.
1) Draw the hands portrayed in this chapter several times following the established method.
2) Make a number of drawings either using pencil or pastels accentuating the three-dimensionality with the use of chiaroscuro.

The Upper Body (p. 79-80)
1) Execute various structural diagrams from the book.
2) Repeat them from memory.
3) Free exercises from life.

Models on the Catwalk (p. 123-124)
1) Practise repeatedly on all the suggested poses, starting with the structural analysis and finishing with the drawing in outline.
2) Vary the images with artistic techniques suitable to the practice of the fashion designer.

Types of Hairstyles (p. 125-128)
As suggested in the preceding exercises, make several copies on tracing paper and freehand, starting from the sketch and proceeding to the definitive drawing in outline, using various techniques suitable for fashion design.

Pattern Schemas (p. 189-194)
1) Think up dress patterns varying the styles, the elements of finishing and the lengths. Every project should be precisely defined with the correct terminology.

2) Create the production schedule for some of the proposed patterns (see p.169).

Keeping the basics unchanged, think up five sophisticated patterns for every design suggested (p. 198) .

Keeping the basics unchanged, think up sophisticated patterns in response to contemporary fashion lines and compile production schedules for some of the patterns suggested (p. 200).

Using the poses in the book, dress the figures with some of the patterns that have been suggested, completing drawings from the dress stand and creating a production schedule.